Wayfinding

Designing and Implementing Graphic Navigational Systems

Craig Berger

A RotoVision Book

Published and distributed by RotoVision SA
Route Suisse 9
CH-1295 Mies
Switzerland

RotoVision SA
Sales and Editorial Office
Sheridan House, 114 Western Road
Hove BN3 1DD, UK

Tel: +44 (0)1273 72 72 68
Fax: +44 (0)1273 72 72 69
www.rotovision.com

10 9 8 7 6 5 4 3 2 1

ISBN: 978-2-88893-057-0

Art Director Luke Herriott
Design John and Orna Designs

Printed in Singapore by Star Standard Industries (Pte) Ltd

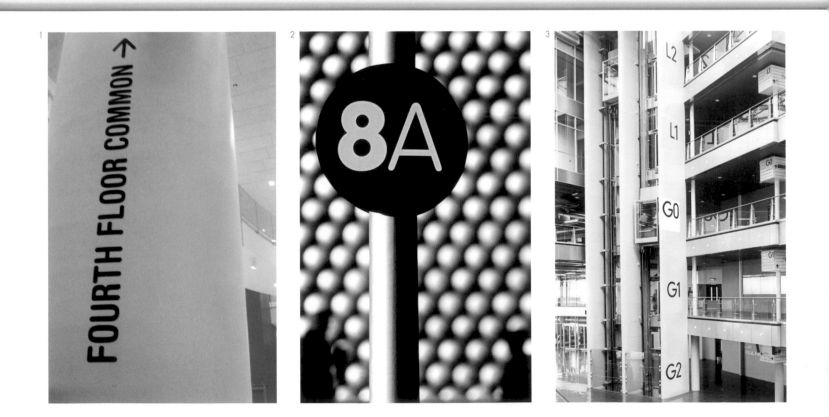

Foreword

For many years, wayfinding design was separated into professional disciplines. Planners designed the city, landscape and urban designers did the building approaches, architects planned the building, interior designers addressed the interior, and environmental graphic designers created the signs. These groups rarely worked together to meet the needs of the user.

As the executive director of an organization that believes environmental graphic design bridges all the design disciplines in the creation of successful wayfinding design, it heartens me to finally see a book that discusses the connection between all of our disciplines in a sophisticated way.

This book includes contributions from some of the best environmental graphic designers in the field. Not only does their experience enrich our understanding of the process and practice involved in wayfinding design, it also provides the example that to achieve excellence in wayfinding design we need to go beyond the sign and into a full integration of architecture, landscape, and graphics to satisfy our navigational needs.

Leslie Gallery Dilworth, Executive Director,
The Society for Environmental Graphic Design

4

Preliminaries

Wayfinding in environmental graphic design 8

The functions of wayfinding 26

Fig 1 Bullring retail center, Pentagram

Introduction
Craig Berger and Leslie Gallery Dilworth

Wayfinding is a strange word. It is highlighted as a misspelling on the spell check, is not in most dictionaries, and often elicits quizzical stares from people. This is understandable. It is rare for an issue to touch so many areas of the design community and yet be defined differently by so many people. Wayfinding, in its short definition form, is the act of finding your way to a destination. Wayfinding design, by extension, is the art of helping people find their way. It provides support through speech, touch, print, signs, architecture, and landscape.

Academics have talked about wayfinding for many years and, as a result, have developed various specialties in cognitive science, including visual detection, speech, and touch. Disability researchers have developed an understanding of wayfinding for the blind. Academic researchers in transportation have conducted extensive studies into research on legibility, color acuity, and type readability. Programs developed by Web researchers for wayfinding on the Internet have provided the philosophical underpinning for companies like Google and eBay.

Designers also have their own take on wayfinding. This usually changes according to the professional group developing the work. Architects and interior designers look at wayfinding in terms of space planning and bubble diagrams; museum and retail designers look at narrative

and at the manipulation of objects in space; planners look at route planning; and graphic designers look at the manipulation of information and graphics.

In this book we have decided to take an holistic approach, showing the marriage of all the design disciplines in the wayfinding world and how a designer can utilize the inherent language and design vocabulary in the development of their own work. The book provides an overview, with many inspiring illustrations showing how wayfinding study underpins even the most exciting projects. The best design projects have a background that goes well beneath the visual surface to cover stakeholder development, maintenance and management, and planning analysis.

The Society for Environmental Graphic Design (SEGD) has pushed to link the academic and the practical in the world of wayfinding for good reason. Our professionals develop design work that marries the world of graphic design and architectural design, and the main structure of our work is wayfinding practice. To better understand this practice in every field of design allows us to advance the design quality and work being done.

This book is not a how-to guide or set of instructions for developing graphics. The issues of financing, planning, stakeholder development,

design, and maintenance permeate every chapter. Written by the leading experts across a wide range of fields, these chapters reveal that designing wayfinding systems takes a different set of specialized skill processes for each area. Architects, graphic designers, landscape architects, industrial designers, and planners should use this book as a guide to how wayfinding is employed in various projects, and to the ways in which professional specialties work with each other.

While most of the work profiled is recent, *Wayfinding* also touches on history and theory: we want to remember our past, but focus on how the structure of past theories are affecting the leading projects today.

Wayfinding in environmental graphic design is a rapidly evolving practice area, delving into new technologies and practices at a rapid rate. We hope you are excited by our take on it.

Craig Berger, Director of Education,
The Society for Environmental Graphic Design

Leslie Gallery Dilworth, Executive Director,
The Society for Environmental Graphic Design

Wayfinding in environmental graphic design

01 What is environmental graphic design?
Juanita Dugdale

New design specializations have emerged in response to the enormous cultural and economic changes that have taken place over the past 100 years. While architecture was recognized as a profession several centuries ago, graphic design came into its own comparatively recently, in response to the changing demands of modern industry and society. The graphic designer, who charts the territory of language, image, and symbols, surfaced early in the twentieth century as the champion of intelligently shaped communication for all types of applications.

The boundaries between the two disciplines were clearly delineated until graphic design and architecture began to merge in the mid-twentieth century, with considerable influence from other fields such as industrial design and urban planning. This merger has come to be called environmental graphic design.

Fin de siècle
The year 1900 might seem an arbitrary starting point for this history. It's true that the choice was partly driven by the fact that an extraordinary 100-year period has recently ended. But in spite of the recent obsession with millennial change, covering the entire twentieth century is an obvious path for anyone trying to trace the origins of modern design—in this case, environmental graphic design.

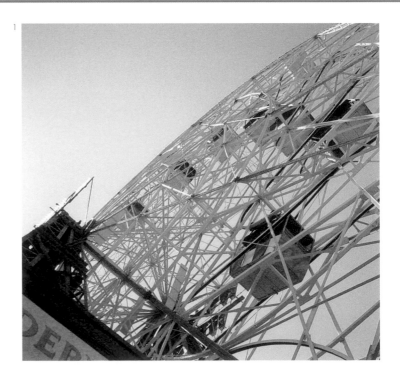
1

Fig 2 The Eiffel Tower, Paris, Alexandre
Gustave Eiffel

Many extraordinary transformations were taking place on a global level at the start of the twentieth century. The industrial revolution had firmly taken hold, with huge societal and economic implications. America was emerging as a world power, fueled by the strength of its manufacturing base. Soon, the "new" and "old" worlds would truly live up to these descriptions, as Europe gradually relinquished much influence to the young upstart across the Atlantic.

Mark Sullivan, an American historian, wrote firsthand about this period in *Our Times* (1934), describing the scene "America presented to the eye the picture of a country that was still mostly frontier of one sort or another... Only the eastern seaboard had the appearance of civilization having established itself and attained permanence."

Even though regions of America were still considered virgin territory, migration from rural communities to cities was in full flight. Mobility was enhanced by new developments such as public transportation and car travel. In 1900, 8,000 automobiles were already registered, oil was being discovered in Texas, and work was underway on the New York subway system (eventually to become one of the largest in the world). New technologies were also being developed that were to have their own impact, such as a new heat treating process for steel manufacturing, the installation of the first escalator in Philadelphia, and the invention of the mercury vapor arc lamp.

Although a haven for inventors and entrepreneurs, America in 1900 was still a cultural backwater by European standards. There is a certain irony that dramatist L. Frank Baum's *The Wonderful Wizard of Oz* is listed in one published timeline as America's contribution to the arts, while the Paris Exposition Universelle of 1900 concurrently presented the splendors of art nouveau. The *Oz* story is truly American; an unpretentious contemporary folk tale that became mythic in its popularity thanks to the entertainment industry. Art nouveau, on the other hand, was appreciated in its day as "high art," but proliferated for only two decades and was never universally accepted because of its radically organic style.

The Paris Exposition is significant for several reasons. Paul Greenhalgh, author of books on architecture and design history, points out that world fairs in this period were already borrowing from American culture. "Europe replied quickly to the initiatives taken by America in the entertainment arena. The Paris Exposition Universelle of 1900 duplicated several features of the Columbian (the Chicago Exposition held in 1893), including the famous Ferris wheel and an electrically powered moving pavement. The Eiffel Tower remained and alongside it a huge 'celestial globe' thrilled the crowds. A myriad of sideshows, cafés, and restaurants littered the site." (*Ephemeral Vistas*, 1991.)

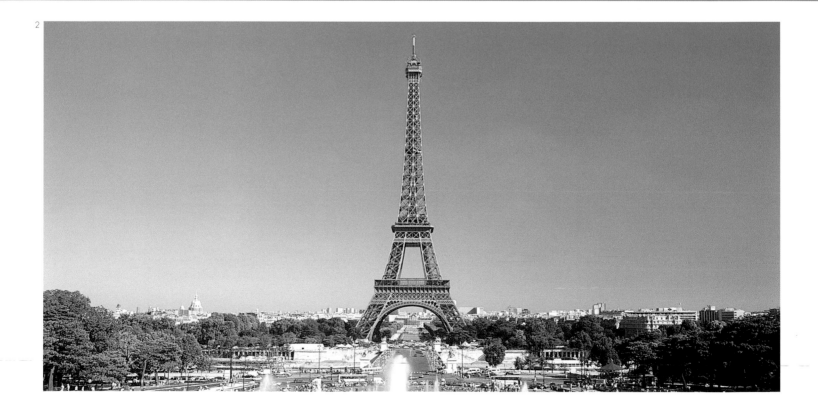
2

Fig 3 The Paris Metro, Hector Guimard
Architect Hector Guimard's art-nouveau
station entrances for the new Paris
underground railway system have become
iconic. Introduced in 1900 at the Paris
Exposition Universelle, their controversial
design inspired a local style—"Metro."

Fig 4 Park Guell, Antoni Gaudí
Gaudí combined color, type, and form in
a wonderful mix that reflected an innate
understanding of environmental graphics,
though his idiosyncratic style did not have
much influence beyond his native Barcelona.

Over the course of about 50 years, expositions had shifted from displays intended to glorify the products of industry to fantasy environments that amused crowds. As Greenhalgh explains "progress was overtaken by the desire to entertain; there were fewer promises to the visitor about improving life off the site and a heightened insistence on having a good time whilst on it …. the show of 1900 was the most developed example of the exhibition as an unreal paradise. It was the first in Europe to extensively use electric lighting to evoke a fairy-tale environment, invariably in conjunction with water cascades, glass and mirrors."

What is particularly illuminating about this narrative is that it could just as easily describe today's urban entertainment destinations.

The 1900 Paris Exposition was also significant because it showcased art nouveau, which is considered by some cultural and art historians to be the first art and design movement not rooted in European history, and so truly modern. Among a handful of art nouveau structures erected in Paris in time for the exposition were architect Hector Guimard's station entrance designs for the new metro (subway) system.

These were to have lasting influence; anyone visiting Paris today can still marvel at the sensuality and enduring presence of these iron masterpieces. Guimard's accomplishment is twofold: not only did he design a thoroughly modern structure—a subway entrance—in a highly personal style, he also successfully integrated the letters for "Métropolitain" into the architecture. Guimard's work was so popular that in France a related style called "Metro" was developed. This particular installation is considered iconic in the history of environmental graphic design; it is no wonder that it is published again and again, as few examples created since have met such a level of stylistic integration.

Bauhaus roots

Art nouveau had waned by about 1905, although the style influenced the work of artists and architects including America's Louis Sullivan (key work: 1887–1910) and Frank Lloyd Wright (early work: 1893–1924), and Spain's Antoni Gaudí (key work: 1890–1926). While Sullivan designed idiosyncratic buildings (in some cases precursors of the early skyscraper) known for lyrical surface ornamentation, Gaudí's fantastical and highly personal structures came to be identified with the entire city of Barcelona. Examples of lettering and symbols by these three can be found in their work, although they are not as compelling as that of Guimard's metro station entrances.

The designs of these architects and others provided the foundation for environmental graphic design in the early twentieth century. While itinerant or anonymous sign painters were creating signs now

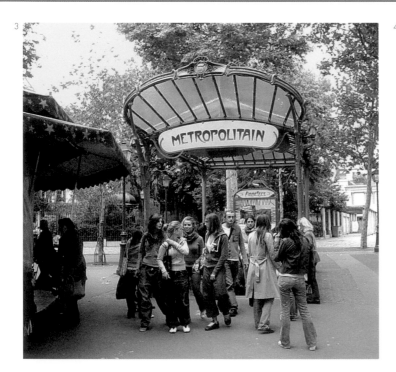

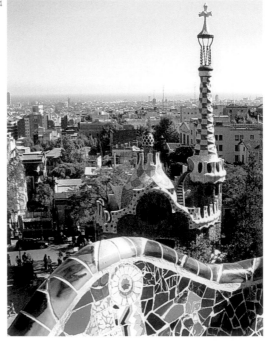

Fig 5 The PSFS Building sign, Lesaze and George Howe This landmark building was one of the first to express type as intrinsic to architectural form. The building is an architectural and environmental graphic icon.

Fig 6 CollageweltenII, Herbert Bayer In 1924 a student at the Bauhaus in Germany, Herbert Bayer, designed experimental prototypes including kiosks, advertising displays, and an exhibition pavilion that communicated to the senses through image, sound, movement, and smell. Bayer later emigrated to America and became a leading practitioner of art, architecture, and design until his death in 1985.

considered prime examples of vernacular art, and billboards were starting to litter the landscape, architects with varying degrees of sophistication were designing building signs, plaques, memorials, and inscriptions. The specialist in sign design, or "architectural graphics," as the discipline would come to be called by the 1950s, had not yet surfaced—with the very rare exception of a few artists such as Eric Gill.

As global political events such as WWI (1914–1918), the Russian Revolution (1917), and the spread of socialism unfolded, the European status quo was undermined and attitudes to art were irrevocably changed. By the 1920s, a number of influential figures in modern design came to be associated with the Bauhaus, the legendary German school for fine and applied arts run by architect Walter Gropius. The Bauhaus has a distinguished history, not to mention a profound and often disputed impact on modern design.

For the purposes of this study, one Bauhaus student has special significance—Herbert Bayer. Bayer's career is without parallel in the twentieth century; he moved fluidly between the roles of painter, sculptor, architect, advertising art director, muralist, typographer, graphic designer, photographer, corporate consultant, and environmental artist. He explained his mission in 1951. "My aim is the total design process, because it is a vision which I am pursuing, not perfection or specialization in a technique."

Bayer rose quickly through the ranks in the Bauhaus, eventually teaching there. During his student years (around 1924), he produced a remarkable series of drawings for proposed kiosks, exhibition spaces, and advertising displays, in reaction to the rigid prevailing style of German industrial exhibitions of that period.

One design for electrical products shows a tower with a series of rings suspended in space on vertical supports. Another, for an exhibition pavilion, incorporates speakers, photomurals, large-scale typography, and even what appears to be controlled puffs of smoke for effect.

Although never constructed, these designs represent a conceptual breakthrough—that graphic and symbolic elements need no longer be applied to the surface of a structure, they could become the structure. This idea was later exploited by architect Robert Venturi, the pioneer of postmodern architecture. In the 1960s, he developed a series of projects that integrated graphics into building design.

Bayer achieved in the 1920s what most designers did not grasp until well after WWII. In 1984, the year before his death, Bayer revealed his design ideology (the lack of capitalization in this quotation is intentional) "although the bauhaus has once again acquired tremendous contemporaneity, the idea of working in multidisciplines was not especially singled out, promoted, or taught there. this idea simply evolved through the belief that the total environment should be a focus

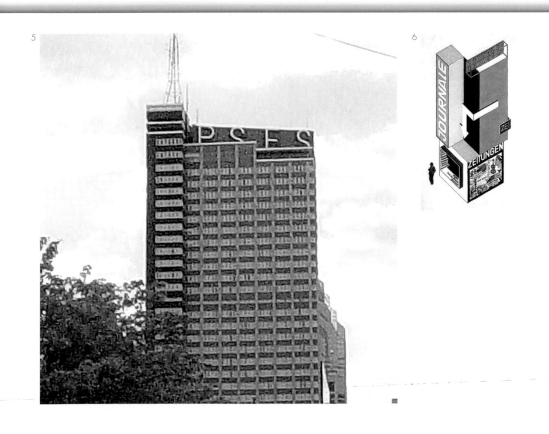

5

6

Fig 7 London Underground, Harry Beck
Early wayfinders included Harry Beck,
whose 1933 map for the London
Underground simplified route lines
and eliminated surface detail in a style
influenced by electrical engineering.

Fig 8 Lester B. Pearson International
Airport, Toronto, Pentagram Design, Inc.
The area of complex transportation systems
is one for which wayfinding graphics
have developed a highly sophisticated
integration of architecture and graphics.

of art. it is through the collaboration of artists, scientists, and engineers that the large tasks of shaping our surroundings, creating images of businesses, and forging corporate identities will be accomplished. The artist of the future will then to a greater degree be part of the human scene."

Bayer, who was born in Austria, was a pioneer of modernism, a loaded term for a design movement that is often mistakenly thought of as a design style. He and several other modernists abandoned Europe for America during the unrest of the 1930s, to practice in comparative freedom. Bayer worked at a number of advertising agencies and designed the "Bauhaus 1919–1928" exhibition for the Museum of Modern Art in New York before moving to Aspen, where he later became a founder of the Aspen International Design Conference. While his reputation as a leading designer and artist was already well established, the breadth of Bayer's work was largely revealed when Arthur Cohen wrote his definitive biography in 1984.

Pioneers and wayfinders

With the exception of a few early pioneers, such as Harry Beck, designer of the London Underground map in 1933, environmental graphic designers did not surface as specialists until after WWII. Many, like Bayer, emigrated from Europe. Others, including Alvin Lustig, and Ray and Charles Eames, were born in America. By the

1950s these designers were starting to benefit from the postwar economic boom; by the 1960s, a second generation of designers were following hot on their heels. American-born design generalists—including Paul Rand, Saul Bass, William Golden, Ivan Chermayeff, Thomas Geismar, Rudolph de Harak, and Deborah Sussman, among others—were generating a prolific body of work in magazine, packaging, advertising, book, poster, corporate identity, film, and exhibition design. Most of them, recognizing the need for improved building signs, started to work with architects and developers on projects from retail complexes to corporate headquarters.

As developments, complexes, transportation systems, and superhighways proliferated, the need for graphic design consultation became apparent. Comprehensive directional sign systems became essential as architectural spaces grew larger and more complicated. New types of hybrid structures like gas stations combined with convenience stores required special treatment. Visitors and occupants were having difficulty navigating spaces on their own; they needed visual prompts to find their way around. Architects also found that graphic designers had the ability to transform a space very economically with colorful murals and other graphic treatments.

New terms entered the lexicon as the design specialization matured in the 1970s: wayfinding, signage, supergraphics, and, of course,

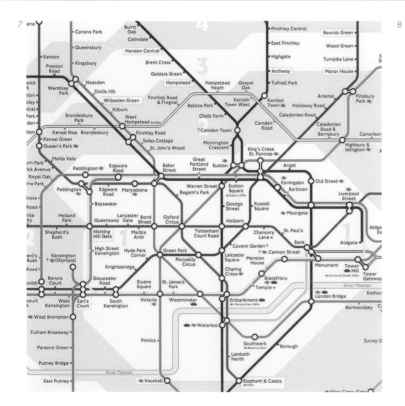

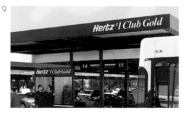

Fig 9 Hertz brand signage,
Lebowitz Gould The modern equivalent of the coat of arms is the corporate logotype. The work of Lebowitz Gould incorporates the corporate brand from print to digital to environmental graphics.

Figs 10 and 11 Smithsonian National Zoological Park, **Lance Wyman and William Canaan** This innovative and friendly wayfinding program created for the Smithsonian in the 1970s reflected the designers' interest in symbolic language and indigenous cultural influences.

environmental graphics. It was during this decade that the Society of Environmental Graphic Designers (later renamed the Society for Environmental Graphic Design, or SEGD) was formed, in direct response to the sudden growth of the field and the need to share technical information and business advice. Among the founders was an Alvin Lustig protégé, John Follis, who was named an SEGD Fellow in recognition of his influential leadership in the field.

Many designers from extremely varied backgrounds came to be associated with groundbreaking environmental graphic design projects in the 1960s and 1970s. Lance Wyman, who trained as an industrial designer, gained recognition for his contributions to the 1968 Mexico City Olympic Games, the Mexico City subway graphics, and the National Zoo in Washington, D.C., which drew heavily on the language of pictograms. Massimo Vignelli, who emigrated from Italy after studying architecture, developed comprehensive sign programs for the subway systems of New York and Washington, D.C.

Paul Arthur, who taught English literature before becoming a leader in wayfinding theory and practice, designed a precedent-setting road sign system used for decades in Vermont. These designers, and many others, applied principles of architecture, planning, product design, interiors, color theory, typography, and symbol design to solve communication problems unique to the built environment.

Universal design in the postmodern era

In the mid-1980s, as a new economic boom drove the next wave of building development by the private sector, environmental graphic designers experienced a rush of corporate design and new retail projects like those created by the Rouse Company. The urban scene was soon transformed by bustling theme marketplaces and stores, grandiose corporate headquarters, and new or improved zoos, botanical gardens, and museums. In the middle of the decade, Sussman/Prejza & Company, Inc. had huge success with their total environment design for the 1984 Summer Olympic Games in Los Angeles, as did Apple Computer, Inc. with its release of the popular Macintosh line.

Environmental graphic design was being practiced on a new level. The bar had been raised due to increased competition between firms and advances in fabrication methods and materials (not to mention the advantages that desktop computers provided for drawing, file management, and scheduling for complex sign systems). For instance, gorgeous baked porcelain enamel panels could now display full-color, vandal-resistant photographs, while LED (light emitting diode) signs were no longer mundane visual intrusions—they became art in the hands of Jenny Holzer and the designers who revitalized New York's Times Square.

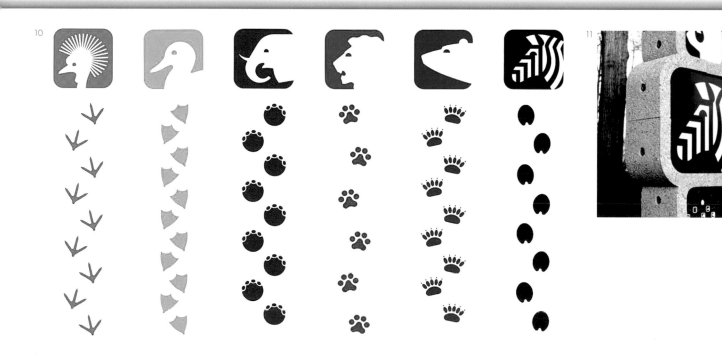

Fig 12 1984 Los Angeles Olympics, Sussman/Prejza & Company, Inc.
Total environmental design of the late twentieth century includes retail projects by Sussman/Prejza's 1984 Los Angeles Summer Olympics program (detail shown), superstores by Nike and Disney, and new urban environment destinations.

Fig 13 Reuters Building, ESI Design
Electronic design is the new palette for environmental graphics, and Times Square has become the playground for design innovation in this rapidly expanding field.

The lines of demarcation between design and architecture continued to blur as total retail environments were designed by firms such as Sussman/Prejza and Communication Arts, and by corporate entities along the lines of Nike and Disney. Likewise, the boundaries between design and art became less apparent, having already been challenged by earlier movements like pop art.

Graffiti, which had been in and out of vogue during the 1970s, resurfaced with a vengeance, finding its ultimate champion in artist Keith Haring. Public space became Haring's palette for playful, powerful urban images based on street culture. His symbolic language permeated the environment and gradually worked its way into the mainstream after his untimely death in 1990.

Throughout the 1980s, the tenets of modernism were furiously disputed by parties who claimed the movement promoted international neutrality of style at the expense of regional cultural identity. Some of this controversy filtered into environmental graphic design. Although it is not true across the board, many practitioners seemed to split off into one of two stylistic camps: those inspired by the more rational aspects of modernism who had a penchant for information-driven problems, and those happy to pull out all the stops to create designs for purposes of persuasion, experimenting with an eclectic range of motifs and historic references.

In the United States, the information designers (or, as Richard Saul Wurman titled them, information architects) quickly responded to new guidelines mandated by the Americans with Disabilities Act (ADA) of 1990, which affected architectural projects across the board. In many cases, project budgets were severely impacted and projects had to be reformulated in order to comply with the new law.

Several firms, including Whitehouse & Company and Coco Raynes Associates, capitalized on the ADA's strictures by turning them into opportunity. Both firms became specialists in developing signs and other graphic tools, such as tactile maps, to aid people with sight or hearing impairments to navigate spaces.

Meanwhile, designers steeped in postmodernism were soon feeling the heat, as reaction set in to the over-the-top extremism of many projects. Too many designers were using inappropriately coy references to historic styles or simply visually "overcooking" their solutions. The late Daniel Friedman, designer and close friend of Keith Haring, suggested in his autobiography a different way of thinking about modernism. "I view Modernism in design as a broad, potentially open-minded, and inexhaustible way of thinking that began in the nineteenth century and continues today among the majority of us who believe that we should use all existing means to understand, improve, change, and refresh our condition in the world… What I propose is a radical modernism—a

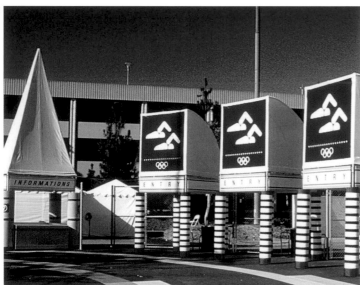

12

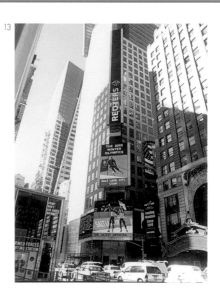

13

Figs 14 and 15 Hollywood Shadow Project, Cameron McNall Today, many artists are following in the footsteps of Keith Haring, using public art as a medium of communication for politics, social activism, and cultural commentary. This project is also a piece of placemaking focused on the art of moviemaking.

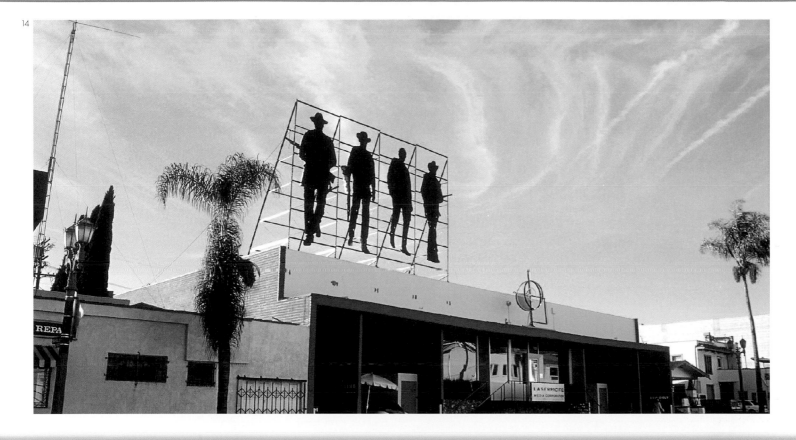

Fig 16 Taiwan National Museum of Pre-History, Ralph Appelbaum Associates, Inc.
Appelbaum's work combines art and technology to evoke a visitor response beyond the mere display of artifacts or information. His work forces the museumgoer to become an active participant.

Figs 17 and 18 The Palms Hotel, Sussman/Prejza & Company, Inc.
Even with the increase in interactive content, designers have increased the sophistication of social spaces.

Las Vegas is leading the way with designers creating entire worlds defined through print, interiors, fashion, and environmental graphics.

reconsideration of how modernism can embrace its heritage along with the new reality of our cultural pastiche, while acknowledging the importance of a more humanistic purpose."

Novelist Garrison Keillor put it another way in "The Future of Nostalgia" (*The New York Times Magazine*'s "The Next One Hundred Years" issue, 1996). "In the '50s we looked to the future, which we imagined would be streamlined, shiny, modern, and then suddenly modernism died. The past got preserved left and right, historic buildings, old street lamps went up like weeds, and Victorian theme malls… the past was copied, quoted, constantly evoked until one day the country looked more like it used to than it ever had before. I say forget it. Just get over it. There's a future out there, go live it."

The virtual future

While the future of environmental graphic design is difficult to predict, it is almost guaranteed that firms will need to embrace an even broader cross section of projects and capabilities. By the 1990s, we finally caught up with visionary thinkers like Herbert Bayer, producing practical examples of total design that integrated architecture, interiors, exhibitions, graphics and the like into holistically conceived environments. But just as environmental graphic designers come closer to really honing their skills, new environments made possible by virtual reality, cyberspace, and smart

materials have been introduced into the mix. Architecture of the future will undoubtedly be engineered with an increasing emphasis on electronic and digital technologies—the new Times Square and Las Vegas being cases in point.

The biggest challenge facing environmental graphic designers now is not how to respond to real places that are being transformed, but rather how to deal with the nonreality of new, synthesized space. Already designers working on Web sites are successfully applying basic wayfinding fundamentals lifted right out of "real time, real space" practice.

The loss of a sense of place that designers face now is not so different from the sense of disorientation that occurred when cities grew so far beyond a comfortable scale that new tools were required to help guide people around and to revive a sense of belonging. In 1971 Charles Hilgenhurst, a planner and author of urban policy, wrote in *City Signs and Lights*, "Today we are the strangers in our towns. We do not know and cannot see how things work. Our support systems … are remote. The information supplied in the environment is largely irrelevant to our immediate purposes or to an understanding of the world in which we live." He might well have been describing the experience of the newcomer to cyberspace.

16

17

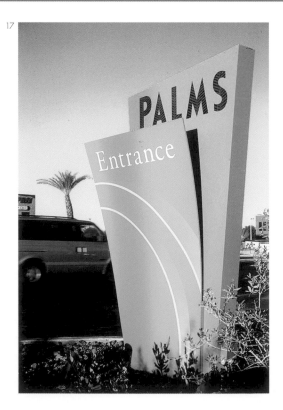

Figs 19 and 20 Mala Bay, Hunt Design Associates, Inc. With the growing hunger for increasingly advanced urban and themed environments around the world, designers must continue to work hard to ensure that international and multilingual projects are legibile and comprehensible to the full range of their target audience.

Designer Deborah Sussman is optimistic that physical realities will prevail in some fashion. "… the digital revolution in a certain way has isolated people: even though you can reach the world on the Internet, you're still in a room all by yourself, with no other fantasy than what's on your screen. But there's a sense that gathering places will become even more important because people will need to be with other people again. The need for physical, tactile presence may be increased by those deprived of hands-on experience." This would suggest that environmental graphic designers may have an even more vital role in the next century as shapers of all types of environments, whether fabricated or programmed.

What is also clear is that the appetite for spectacular urban entertainment destinations cannot be satisfied. Serious research projects in subjects like legibility and wayfinding are being overshadowed by the rush to design retail, restaurant, theme park, and casino environments. And the tables have turned: now American "new world" cultural tendencies prevail on a global scale, although many despair the consequences. Environmental graphic designers should grasp this moment, and ensure that the built environment is enhanced, not marred, by their efforts.

Our thirst for fantasy is not new, so perhaps the 1900 Paris Exposition isn't that far away, in either time or place. At that event, crowds came together to be amused, transported, fed, and entertained.

They required maps to follow around, signs to identify displays and captions to educate or amuse, and designers rose to the occasion. The following chapters show that while new design specializations may evolve, the needs of the public they serve remain remarkably constant.

18

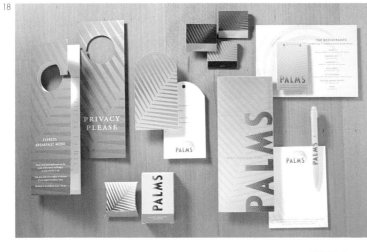

20

Fig 1 Barcelona Pavilion, Ludwig Mies van der Rohe

Fig 2 *Chicago Tribune* competition entry, Adolf Loos Early twentieth-century designers wrestled with the form of buildings. Were buildings signs, abstract sculptures, or supporters of tradition?

Fig 3 Crown Hall, Ludwig Mies van der Rohe

02 The need for environmental graphic design
Craig Berger

Where did it all come from? How did this need for such extensive sign and identity support come about? This is clearly an issue that did not exist before the twentieth century. Before then, signs were simply advertising added on to buildings, maps were something that you read on a sheet of paper, and banners were something that announced a parade.

Even today there is very little discussion about the roots of wayfinding in the discipline of environmental graphic design. At the core of the rise in the need for wayfinding and identity graphics lies the needs of the fast-paced modern world, with its high-speed transportation, globalism, technological advances, and social activism. The leading developments that triggered the need for environmental graphic design are discussed in this chapter.

The rise of modern architecture
Until the twentieth century, the motto of building designers everywhere was "style follows function." A building communicated its layout to the user through a series of very specific conventions. A church's layout, for example, was known by heart to its worshipers through centuries of tradition embedded in the collective memory. Such architectural traditions, however, began to strain under the weight of modern technologies and new uses and finally broke with the advent of modern architecture.

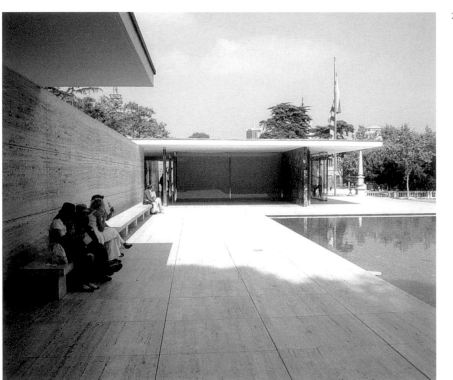

Fig 4 University of California, Los Angeles (UCLA) Campus, Biesek Design

Fig 5 University of Cincinnati wayfinding district signs, Kolar Design/Shortt Design with Hargreaves Associates/Glaserworks and the Univerity Architects Office

Fig 6 University of the Sciences, Cloud Gehshan Associates As buildings became less traditional in design, identification switched from the building form to external identification.

Ludwig Mies van der Rohe and Walter Gropius used the term "form follows function" to explain their stripped-down, rational approach to building design. This logical creation of spaces was meant to create a better understanding of wayfinding needs, but the opposite proved to be true. The collective memory was broken and buildings became detached from any innate understanding of them that people had. Supplemental wayfinding devices such as signs and maps began to appear soon after.

This trend became most evident in the university setting. The nineteenth-century university environments of Oxford, Harvard, and the Sorbonne were developed around symmetrical quadrangles and dormitories intermingled with classroom buildings. The modern university, typified by Mies van der Rohe's Illinois Insitute of Technology campus, broke the traditional structure of campus planning, to be replaced with a campus on which buildings looked exactly alike and there were no clear entrances and gateways. From this point on, signs, kiosks, and maps became the key support of university wayfinding.

A complex yet specialized world

Today's world has become fast-paced, complex, and subdivided into specialized parts. Where once cities were only a few miles apart, they now sprawl for miles, but are subdivided into specialized districts and sections.

In an environment where grocery stores have become supermarkets, hospitals healthcare centers, and stadiums sports complexes, wayfinding signs play a crucial role in tying together an ever-increasing number of specialized parts in a coherent way.

The increase in complexity and specialization is most evident in transportation terminals. Once consisting of basic services like ticketing and arrivals, the new transportation facility is an airport or railway terminal that is the gateway to hundreds of destinations. Graphics are becoming the tie that binds these elements together.

Transient identity

Before the twentieth century, the identities of churches, schools, and government institutions were meant to last a lifetime. They were carved into stone, etched in stained glass, or encapsulated in public art. Today, identities are transient. The department store meant to anchor a city may change hands three times in 10 years. The bank or stadium may change names every few years. Buildings that once could not be separated from their identity now serve merely as frames for a constantly changing set of institutions.

In ancient Rome, medieval Paris, or even nineteenth-century London, buildings signaled their use through their architectural design. Now buildings change names, functions, and identities quickly.

The need for environmental graphic design 21

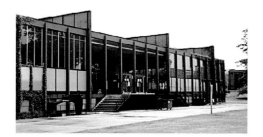

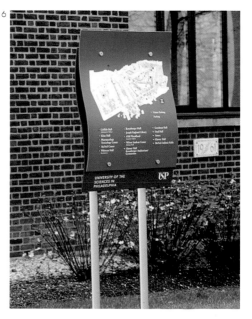

Fig 7 LAX Airport public art, Selbert
Perkins Design With facilities becoming
more complex and less architecturally
defined, graphics and arts are often
becoming the new tie that binds disparate
elements together.

Figs 8–10 Wachovia Bank signs,
East Coast Sign Advertising Today,
branding and identity have taken the
place of architecture to illustrate the
corporate brand.

New terminologies like "branding of places" and "functional obsolescence" have grown to explain and adapt to the trend through temporary elements. Even companies today have detached themselves from any real sense of place. At one time, a McDonalds was known primarily through its distinctive architectural form. Now, a Starbucks can be located in a historic mill, gas station, mall kiosk, or supermarket. Graphics and branding have supplanted architecture as the key means to identity.

Additions, renovations, and restorations

Not so long ago, buildings were simply torn down when they no longer served their original function. This is no longer the case. Now buildings can change function, add extensions, and produce renovations. Stewart Brand, in *How Buildings Learn*, calls this the "learning process." Over time, changes are made to buildings to improve or expand on their original functions. It can also be that the entire building is reworked in order to function better. A new industry has risen to meet this need, together with a new profession—the facilities manager—whose job it is to manage a facility as it expands and is reworked over time.

Another aspect of building change is that architectural form begins to take on a secondary role to wayfinding signs and elements. Massuchusetts Institute of Technology campus is a particularly good example of this trend. Over time, a one-building campus has grown into a mass of more than 20 interconnected buildings. The individual buildings have begun to lose their identity, consumed into one long collection of corridors and public spaces. Maps, information kiosks, and signs become the crucial glue that holds these elements together.

Addressing the needs of the disabled

Not so long ago, the needs of the disabled were not considered in the design of public spaces. In recent times, a more developed social consciousness and increased regulation has focused on the wayfinding needs of disabled people. This has included everything from a better understanding of lighting for visibility to using multiple tools, from floor treatment to braille rails and raised maps, to assist the visually impaired.

Vehicular speeds

One-hundred years ago, the fastest that a human could travel was about 20 miles per hour (c. 30k/h). Now, with the advent of cars and highways enabling far greater speeds of travel, outdoor signs need to be larger, clearer, and more in tune with the environment around them. This development has changed the entire outdoor environment. Store signs need to be enormous to command the attention of the road user, and must also be spread further apart, while directional signs are usually required by government regulations to have high legibility and

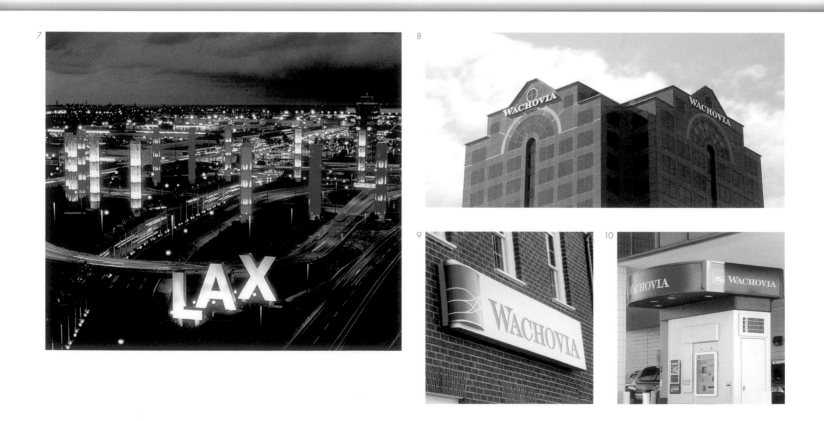

Fig 11 Philadelphia turnpike marker c. 1820
Fig 12 Philadelphia turnpike marker c. 1929
Fig 13 Philadelphia turnpike marker c. 2004

Fig 14 Universal City Walk,
Sussman/Prejza & Company, Inc.

color contrast. This transition can clearly be seen in the design of highway markers. Often low to the ground and made of stone, these road markers were replaced with larger road signs in the 1920s and finally large-scale highway signs for the high-speed travel of today.

Higher expectations

Let's face it; we want more and we want better. Museums, for example, are not just supposed to educate, but also to entertain and to serve as a community focal point. Stores are not just places to shop in, but places that serve as an extension of our personalities. Design is constantly striving to keep up with these higher expectations in an era where hotels have a star rating, airports are rated every day, and stores go out of business if they are not kept up-to-date.

The use of graphics as a prime competitive tool is clearly evident in the casino industry. In 1995, the Treasure Island Hotel in Las Vegas was the prime. Seven years later, the hotel was renamed the TI and given a complete overhaul in branding and graphics in order to compete with the new casinos being built around it.

Explaining the landscape around us

With the end of the frontier in most countries, there is a desire to understand the developed world around us, from what was lost in the past, to nature, to geography, to future developments.

Nowhere is this seen more than in the advances in visitor centers. Once a simple cabin building, the visitor center has now expanded into a building with a museum facility and multimedia shows interpreting the outside world.

A multilingual, multicultural society

With the rise of global tourism and immigration, buildings have to serve an ever-increasing number of different language groups. This includes the need for graphics and signs that can be read nearly universally, through symbols, numbers, letters, and multiple text listings.

This trend appears most often in health care and transportation environments—places where people from different countries congregate frequently. In these environments, there has been a movement toward breaking places up into simple parts, from the simple terminal numbers and letters at an airport, to the use of symbols in health care facilities.

Integration of the design professions

The final issue is that of greater collaboration and sharing of knowledge between the design professions. Until the twentieth century, there were only architects; master builders who oversaw a variety of craftspeople. Increased specialization saw the division of designers into different groups, from landscape designers, to interior designers, to urban planners. With greater collaboration between all these groups, design

Fig 15 Opryland Hotel,
Lorenc+Yoo Design As competition
increases, so does the quality of the
design environment.

Fig 16 Desert Passage at the Aladdin
Hotel, RTKL

Fig 17 Louisiana Historic Trail sign

work itself has grown more complex and sophisticated. Where signs and wayfinding projects were once the realm of sign designers and builders, wayfinding design has increasingly become the realm of planners, consultants, researchers, graphic designers, and architects, thereby increasing the knowledge base and producing ever-higher levels of design work.

This is most evident in retail and shopping center design. Beginning with bare shopping centers in the 1950s, with few design details, the shopping mall today integrates extensive graphics, planning features, and sophisticated wayfinding elements.

The world is constantly changing, and wayfinding and identity design evolves quickly. In the future, electronic design and miniaturization may open up a new era where the environment will dynamically change and we will be able to carry the tools we need to orient ourselves in the environment with us. The trends that created the need for environmental graphics in wayfinding are not static, but will evolve with new technologies, and with cultural and economic changes.

Figs 18 and 19 Retail Center at Madrid Xanadu, Kiku Obata & Company
New malls today use graphics to create a much higher-level shopping experience.

Fig 20 Motor Cities Heritage Trail, Selbert Perkins Design

Fig 21 Minneapolis, St. Paul International Airport, Apple Design, Inc.

Fig 22 Connect 12 Central Hong Kong pedestrian bridge system signage, Calori & Vanden-Eynden

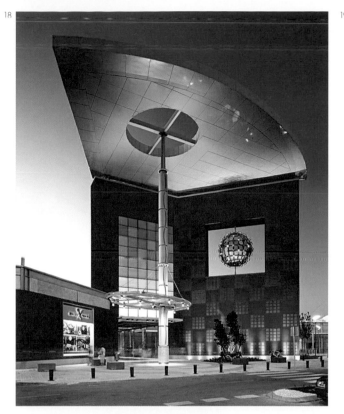

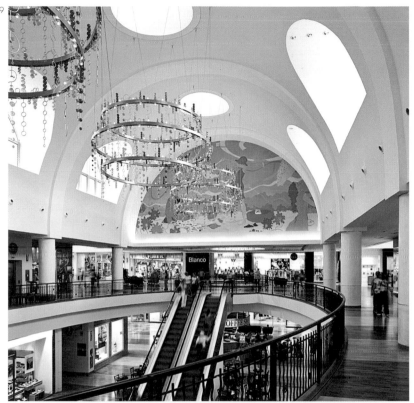

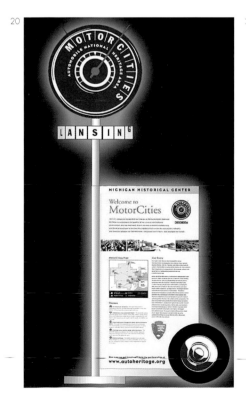

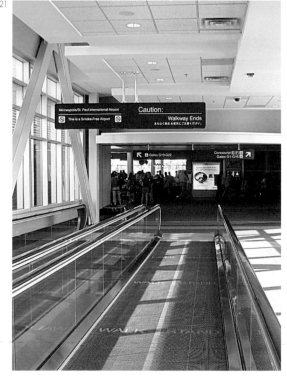

The functions of wayfinding

Fig 1 Atlanta transportation map
Print maps were meant to carry as much
information as possible on one sheet
of paper.

Fig 2 Washington, D.C. map,
Lance Wyman and William Canaan
Inspired by the London Underground map,
successor maps used similar notations,
making for an international vocabulary
that is understood on transit systems around
the world.

03 The design of maps

Craig Berger, Jeffry Corbin, Massimo Vignelli, and Joel Katz

Open any map designed before 1920 and you will see one common element—complexity. Because maps were meant to be studied at leisure, while standing in place or sitting at a desk, those from the eighteenth and nineteenth centuries had to include enormous amounts of information jammed onto a single page.

This approach to print maps began to break down with the advent of large-scale mass transit systems. These systems required maps to be used inside of trains and in stations instead of on the printed page.

The London Underground map, designed by Harry Beck in 1933, changed everything. By borrowing a simple set of rules from electrical engineering diagrams, this map showed a simple yet highly defined transportation system. Since then, designers have used maps to convey information simply and effectively in the environment. Later, designers like Massimo Vignelli and Lance Wyman extended their map skills to environmental graphics in transit environments. Today, the rise of the Internet and guidebooks have created the need to acknowledge the differences between maps that are viewed in the environment and printed maps.

A map in the physical world is very different from a map on the printed page. You cannot carry it with you, manipulate it, or orient it to the direction you want. You cannot study it for lengths of time. The design

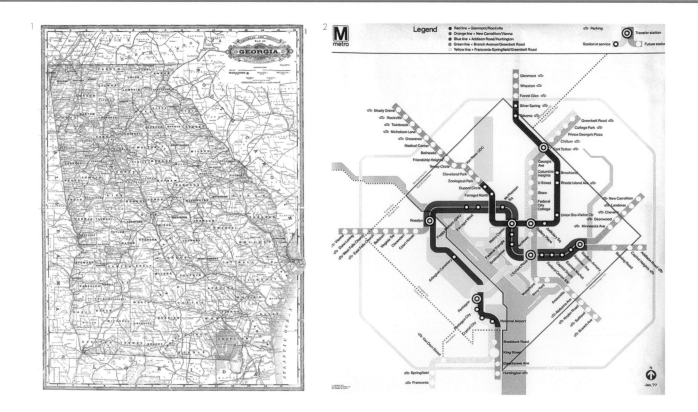

Fig 3 Atlantic City, New Jersey transit map
A map on a piece of paper is often ineffective out in the physical environment. This sign, placed 8 feet (c. 2½m) off the ground, is too high for people to be able to read the small-scale type.

Fig 4 Downtown Baltimore sign, Two Twelve Design Associates

Fig 5 Downtown Baltimore map, Two Twelve Design Associates This map shows redundancy in action, using color, symbols, and alphabetical hierarchy that is reflected in the whole wayfinding system.

limitations on the environmental map require much more sophisticated design skills, especially if integrating with the print environment.

The three designers who are profiled below have wrestled with the issues of environmental maps in transportation, urban design, and facility design. The mapmaking methods they have developed were meant to fit into overall wayfinding design projects, not to stand alone.

Jeffry Corbin: The specific map designed for the specific environment

Jeffry Corbin and his firm Corbin Design have developed sign systems for cities, universities, corporations, and hospitals, with a core philosophy regarding mapping—the right map for the environment at hand.

This belief is supported by a number of rules for environmental map design, including: seeing maps as yet another, and sometimes redundant element of the entire wayfinding system; tailoring the level of detail for the intended use of the map; balancing the amount of detail with the size of the area to be depicted; and creating a map that fits the context of the specific environment.

Regarding redundancy, the map user will be perceiving the map as part of an overall system, so the map elements need to depict the elements of information consistently, including similar terminology, color, symbols, and type styles. It is important to use as many visual cues as necessary to deliver the message to the user, even though these cues may not end up on every element.

With redundancy being the rule, it is important to realize that different design elements need different design standards. Signs and environmental maps need to use bolder colors, simpler and larger type, and less detail, while a paper map might be able to use more subtle contrast and depict much more detail. In contrast to maps in print, maps displayed on plasma and digital screens (with their lower resolution) require the use of larger type and typefaces with more negative space in their letterforms. Corbin advises that signs, environmental maps, and paper maps should be designed at the same time and be viewed next to each other to ensure that they portray consistent information, while taking advantage of the attributes inherent in each sign type.

Maps must also be tailored to the scale of the environment they depict. The average map user cannot perceive or comprehend their environment much beyond 600 foot square (c. 56m^2); three blocks in most cities. Most environmental maps, therefore, should not extend beyond that distance if showing any level of detail. In a smaller city, this area might encompass an entire downtown; in a university, it can represent the environs of a specific campus; and in a large city, it might represent only a small section of a larger district. As a rule, the larger the area represented, the less the detail that can be successfully presented.

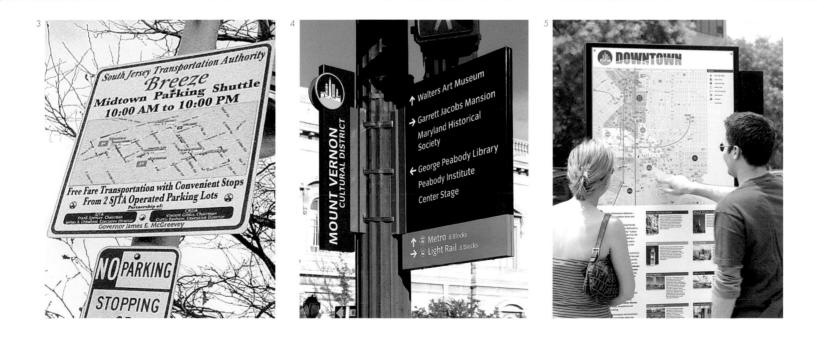

Fig 6 Connect 12 Pedestrian Bridge, Hong Kong, Calori & Vanden-Eynden Design Consultants Having a key map of the larger area is crucial to making the in-depth map system work effectively.

Fig 7 Pennsylvania State University, Corbin Design A map area 600 foot square (c. 56m²) is the largest that most pedestrians can comprehend effectively.

Fig 8 Rolling map on the LA Walks sign system, Corbin Design A rolling map allows the pedestrian to find specific information about where they are in the city in detail, and can also provide in-depth information on the entire city.

Especially in large campuses and cities, Corbin advises the use of "rolling maps." These site-specific maps represent a small area, but can contain deeply detailed information, and should be keyed to a large overall map of the urban area. Rolling maps also provide consistency for the user, allowing them to visualize the larger area, while focusing on the more immediate environment. Corbin advises that in addition to the map of the immediate area, a listing of the most sought-after destinations should also be included, so that the user can more easily find important destinations that might be located outside of the boundaries of the map at hand.

Finally, maps must be logically designed to fit the context of the environment. An urban grid can be represented as a rectilinear grid, while a hospital corridor may only need to be represented by a simple line. Corbin suggests looking at maps more as "map diagrams," or specific visual forms that reflect their surroundings. Map users in the environment do not need superfluous visual detail when they are already surrounded by that detail. They need the specific information necessary to orient themselves to their surroundings and move in the right direction.

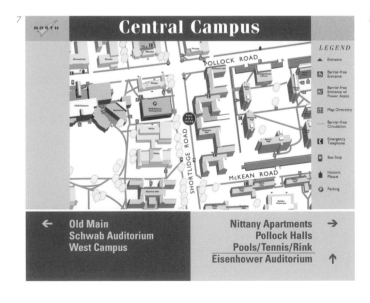

Fig 9 New York subway system map, Massimo Vignelli The original subway system map was designed to meet a very specific goal—understanding where all the transit lines went and how they connected.

Fig 10 Current subway system map based on the 1972 map Because the map needs to be used both in print and as a sign, the current subway map is a hybrid of a system map and a geographic map.

Fig 11 New York City subway system verbal map, Massimo Vignelli The verbal map is a set of directions to connect places. Vignelli used the now-famous train line symbols to differentiate train lines.

Fig 12 Mexico City subway system, Lance Wyman and William Canaan In Mexico, where literacy is low, symbols stand in for text on the verbal map.

Massimo Vignelli: No map should do any heavy lifting

Massimo Vignelli, of Vignelli Associates, was a map pioneer. He developed the first modern subway map in the United States, for the New York City subway system. Massimo established an innovative system for New York that is the standard for nearly every large-scale transportation system around the world. This system is based on the philosophy that no one environmental map should do all the heavy lifting for an entire system. Massimo realized that paper maps fell apart in real-world settings because they tried to provide all the information a user would need even when they needed only limited information to find their way. This holds especially true in the public transportation sphere, where the user is either a pedestrian with extensive orientation needs, or inside a public vehicle with few environmental clues for orientation. Instead of one map, a transportation system should rely on four different map systems for orientation. These four are discussed below.

System map This map illustrates the specific metro system routes and lines, with special notations for pricing zones. Similar to the original London Underground map, it used a simple, symbolic language known internationally. Ideally, these maps should contain almost no geographic information, focusing almost all their energy on showing the connection between train lines.

Geographic map This map shows all the geographic and physical information in a specific area around the train station. This should include specific station floor-plan information, and is important to use in station hubs and complex environments.

Neighborhood map area around station This map shows the specific pedestrian district that surrounds the station, including cultural destinations, landmarks, and other specific information for the area.

Verbal map This map is purely linear, containing only the information for each station next to the other. This information is perfect in situations where the user is tightly focused on where they are and needs only a small amount of additional information, such as distance and hierarchy.

With this vocabulary for alternating maps, the user gets to navigate their environment effectively while focusing on specific elements when needed. Ironically, while Massimo's map system is now employed in cities from Washington, D.C. to Rome, the system is not in wide use in New York City, which later went back to a one-map-fits-all approach.

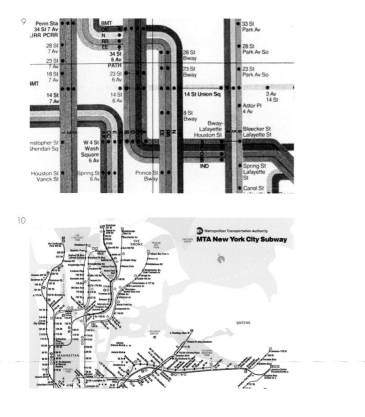

9

10

11

From 57 St-Av of Americas to:

12

Fig 13 Boston transit map system, Chermayeff & Geismar Train stations around the world follow the Vignelli approach, creating structural frames for a wide variety of map types.

Fig 14 MIT campus map for the Massachusetts Institute of Technology, Joel Katz Design Associates, consultant Olin Partnership Because the map is meant to be set diagonally in a desk-like setting, and to be looked at close up, it can include extensive and highly detailed information.

Fig 15 Portland pylon for the Portland Development Commission, Joel Katz Design Associates In Portland, the tall, thin sign element combines both directional information and a map. Because it is at eye level, detail can be increased, and typography can be modest in size.

Figs 16–18 Urban Icons, Joel Katz For his personal project "Urban Icons," Katz creates circular glyphic maps of cities including Rome, London, and Philadelphia.

Joel Katz: human factors and heads up

Joel Katz, of Joel Katz Design Associates, has designed maps as part of wayfinding systems for a university and for urban environments using a simple approach that affects how environmental maps should be designed everywhere: fitting the specific map to the way the user interacts with it. He uses two approaches to achieve functionality in map design: a consideration of human factors, and capturing the "essence" of a place.

His principal approach to human factors is to observe how the reader will use the map and design an object that will facilitate this. If the map must be read from a distance, it must be large and iconic, with simple design elements and large type. If the map can be read up close, as with the MIT and Portland systems, it can be placed at a more conducive angle for reading and include greater complexity and detail.

A fundamental component in all Katz's map design is "heads up." In reading printed maps, many people orient maps to the direction they are facing instead of the traditional north. This changes everything about the way a map is designed. No longer meant to be seen from just one direction, the map must be able to look correct when viewed from multiple directions. This means designing a map that can rotate to reflect the position in which the viewer is facing.

Signs in the environment are also constrained by human short-term memory. The user must walk away from the map and remember its key elements. Katz begins with a glyphic map, a map that simplifies and captures the essence of a place. Glyphic maps were developed by early societies to give directions through a symbolic vocabulary; the design approach is similar today. The key to these maps is to strip away extraneous information and emphasize only the elements that the user absolutely needs and can remember. Katz states that glyphic maps can take on a variety of different forms, including the combination of 2-D maps with 3-D landmarks, as in the MIT campus map, or the creation of a symbolic language, as in his personal maps of Rome and London. With additional support, through banners, publications, and other design elements, glyphic maps create an image of a place and help the user retain a clear and lingering vision of the place to which they have been.

The maps that Joel Katz Design Associates have developed go beyond the idea of a map as simply a way to get from point a to point b to a fundamental extension of identity and personality for a facility, campus, or city.

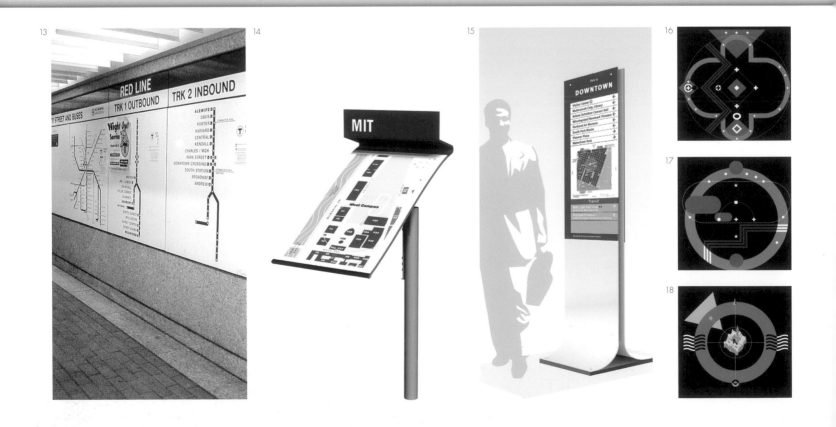

Walk!Philadelphia© Joel Katz Design Associates

This extensive map system, developed for the Center City District, utilizes a simple, bold map, creating a cartographic brand that permeates nearly all of Philadelphia's graphics.

Katz began by looking at the essence of Philadelphia, a city planned by William Penn in 1682 as a street grid between two rivers, two miles apart. Penn added four neighborhood squares to split the city into four quadrants, with a central square in the middle that later became City Hall. The only change was the early-twentieth-century addition of a diagonal French boulevard. The map that Katz developed for Philadelphia encapsulated all these elements using a simple set of symbols to reflect the rivers, squares, boulevards, and street grid.

Katz then placed this map in a disc that suggested rotation to make every map heads-up. This "diskmap" was placed on nearly every street in the central city, so the central city map contained only key information. The main map was also broken into more detailed district maps that contained more extensive information about lodging and attractions.

Katz also reconfigured the basic map form to serve different purposes. For a historic area interpretive program, the map was used to highlight a small, defined area in the city. At the city's convention center, the map was enlarged to include more specific details and urban information. Even with all these highly specialized maps, the key elements of the glyph were still included, as well as the heads-up approach.

Over the years, the main glyphic map has worked its way into graphics on banners, visitors' maps, T-shirts, and other products. This, in turn, has turned the image of Philadelphia's squares and grids into an urban icon known throughout the world.

19

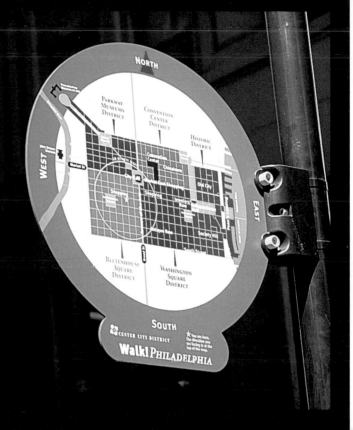

20

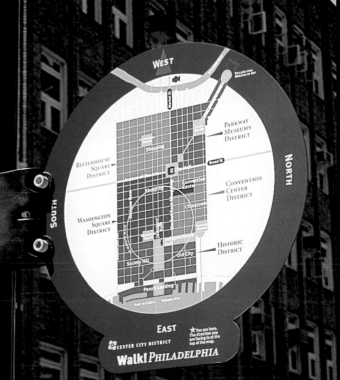

Figs 19 and 20 Walk!Philadelphia© diskmaps Heads-up maps help orient the pedestrian in their surroundings.

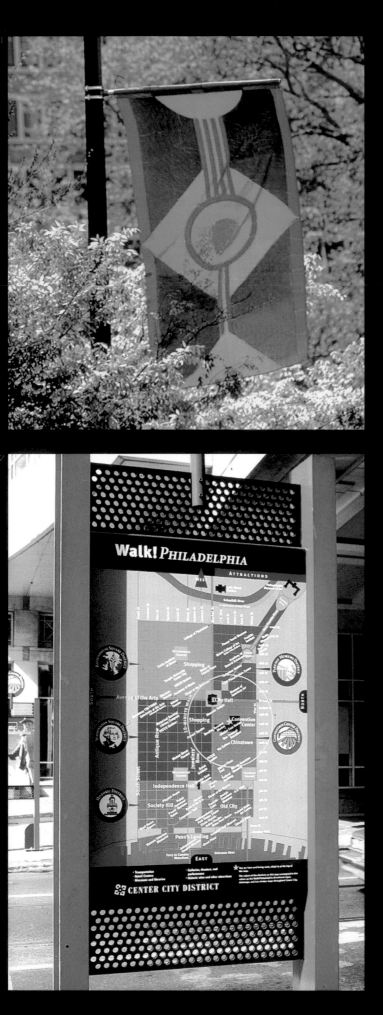

Fig 21 Diagrammatic map banners of the Benjamin Franklin Parkway for the Logan Square Neighborhood Association, Joel Katz Design Associates

Fig 22 Walk!Philadelphia© Convention Center accommodations map

The language of map design

→ **Axonometric map**
 A 3-D map

→ **District map**
 Detailed map of a specific neighborhood or district

→ **Glyphic map**
 A diagramatic map explaining the essence of a place

→ **Heads-up map**
 Map pointing in the direction the map user is facing

→ **Key map**
 Basic geographic map of an entire area

→ **Rolling map**
 Many maps of small geographic areas that are spread throughout a city or facility

→ **System map**
 Diagrammatic map abstractly explaining a transportation system

→ **Verbal map**
 A linear map listing destinations in order of arrival

Map design recommendations

From Massimo Vignelli
→ Do not try to do too much with any one map in the environment. Be simple and specific.
→ A map is not just a graphic device. Written directions can also create appropriate maps under certain conditions.

From Jeffry Corbin
→ Users can only comprehend a geographic area of about 600 foot square (c. 56m^2). Any detailed map in the environment should only address that area or less.
→ Do not use maps as the only wayfinding support device. Directional signs and identity elements should also be closely coordinated with maps.

From Joel Katz
→ Orient maps around human orientation to the site, not geographic map references.
→ Design maps and their orientation respecting the user's interaction with the environment.
→ It is always important to start with a simplified or iconic map to understand the essence of a place. Simplest is best, given movement mode. Rail maps can be more diagrammatic and simplified than pedestrian maps because of the user's limited options. Start with the simplest image possible, and add geographic and other detail as necessary.

Fig 1 Hong Kong street scene.

04 Road and other external signs
Craig Berger

Legibility is the key issue affecting wayfinding, and commands nearly every decision a designer will make. Other chapters in this book have been oriented to wayfinding issues of different types, including symbols, wayfinding for the disabled, and maps. This chapter will focus on one sign type—the outdoor sign meant to be seen by the motorist. No area of environmental graphic design has seen more research and development as the vehicular environment with its highway signs, scenic byways, commercial storefronts, and building-mounted signs. Being able to see signs at vehicular speeds is crucial to both traffic safety and commercial success.

A short history of outdoor legibility
Until about the 1920s outdoor legibility for signs was not an issue. Cities, towns, and highways were built for pedestrians, horse-drawn vehicles, or cars that went no faster than 20 miles per hour (c. 30k/h). In this environment, traffic signs could be small and hand lettered. With the rise of paved roads, increased car ownership, and faster cars, the environment began to adapt to the car. National governments began to rationalize the road environment by creating limited access highways, city governments began to modify their existing one- and two-lane roads to the needs of the car, and towns developed four-lane suburban roadways reserved for commerce. Subsequently, efforts were made to rationalize directional and commercial signs to be legible in this landscape.

Fig 2 American interstate sign.

Fig 3 Shanghai road sign. Highway guideline standards used in the United States and United Kingdom have made their way around the world.

Fig 4 Direction Philadelphia© gateway sign, Sussman/Prejza & Company, Inc.

Fig 5 Jersey City sign system, Hillier Environmental Graphic Design

The rules of the driver affect highway signs

J.R. Hamilton and Louis L. Thurstone, in their 1937 book *Human Limitations in Automobile Driving*, established the basic psychology of the driver driving at high speeds on limited-access highways. Their issues include:

→ As driving speed increases, drivers focus most of their attention much farther down the road. At 25 miles per hour (c. 40k/h) a driver is focused on a point 600 feet (c. 180m) away. At 45 miles per hour (c. 70k/h) that point is 1,200 feet (c. 370m) ahead of the car.

→ As driving speed increases, peripheral vision decreases.
→ As driving speed increases, foreground details begin to fade.
→ As driving speed increases, perception of scale and speed decrease and reliance on visual cues such as signs increase.

This basic psychology was taken to heart in the United States first with a National Conference on Street and Highway Safety in 1924. This eventually resulted in the first *Manual of Uniform Traffic Control Devices* (MUCTD) in 1935, which standardized letter styles, sizes, sign colors and shapes, and was followed with the British Transport Sign System in 1958. These sign standards have been revised constantly, but the fundamental forms of the systems have held up remarkably well over time and have been emulated by countries around the world.

The rise in urban sign systems in cities and towns

In the 1970s and 1980s cities began to adopt their own unique wayfinding programs (see chapter 11) on narrower, more cluttered city streets. Designers of these sign systems have tried to extend the design of vehicular signs beyond the guidelines provided in highway and road sign manuals. These designers are working with cities to produce sign systems that meet the special needs of specific cities and towns, but are still easy to read and navigate with.

Putting order back into the commercial roadway

For most of the twentieth century the commercial suburban roadway often developed according to the survival of the loudest; as signs became larger and more packed with information, an illegible streetscape environment was produced.

In the late twentieth century a backlash occurred in cities and towns weary of enormous, cluttered roadway signs. New regulations often went in the opposite direction, virtually banning all large signs from roads, which made finding commercial destinations almost impossible. Today, municipalities are struggling to balance the needs of sign visibility with the problems of clutter and information overload.

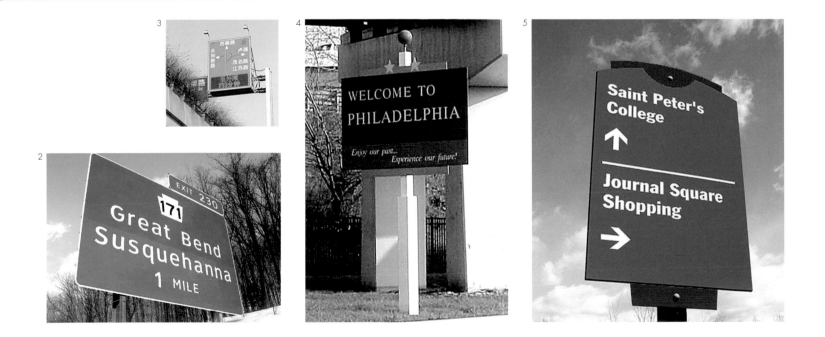

Fig 6 Irish road sign. European road signs tend to add far more information than American examples.

Figs 7 and 8 Clearview typeface, Meeker Associates, Inc. and James Montalbano

The leading legibility issues

To understand how legibility works in vehicular environments it is important to look at three different areas: the high-speed highway and wide roadway environment; the lower-speed, more cluttered urban environment; and the urban commercial environment.

The highway environment

The limited-access bypass highway has been with us for the last 80 years, and with it has evolved a science for determining legibility at high speeds. Since type is the main medium of communication at high speeds, research has focused on type style, width, and height.

Legibility for lower visual acuity and contrast sensitivity On materials like the reflective sheeting used for highway signs, the counterforms (spaces within letters) tend to fill in, which makes them appear out of focus. This phenomenon, known as halation, reduces legibility, and the problem is greater for an aging population which has less contrast sensitivity and less visual acuity. Over the years designers like Jock Kinnier (who developed the British Transport Type font), and departments such as the American Bureau of Public Roads (which developed the Highway Gothic series in 1948), developed fonts with greater stroke widths to ensure better legibility, but the halation problem required letters to be large and widely spaced in order to be legible, which limited the amount of space available on signs for messages.

It wasn't until the 1990s, with the work of designers like Don Meeker and James Montalbano, that newer fonts were developed to counter the issue of halation. Meeker and Montalbano did this by creating letters with a stroke width (letter line width) just wide enough to be visible to most motorists, but narrow enough to prevent halation. Their Clearview Highway© and NPS Rawlinson Roadway typefaces were the first new typefaces approved for highway use in over 50 years.

Upper- and lowercase text For a long time only capital letters were used on signs: block letters are much easier to apply by handpainting than lowercase. This led to extremely wide signs that were unwieldy on narrower streets and roads. In 1950, the British designer Jock Kinnear made the case that all British road signs be upper- and lowercase, based on research from the California Traffic Institute. British and most European road signs began to use uppercase letters for important destinations, titles, and emergency information; and upper- and lowercase for smaller destinations. Recently there has been extensive support for this approach to be used on American highway signs.

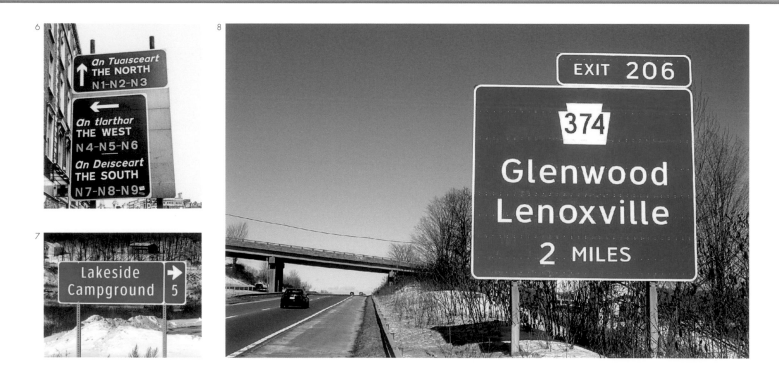

Figs 9 and 10 Houston Uptown sign system, Communication Arts Urban sign systems need to meet the needs of both smaller, narrow streets and large-scale roadways.

Fig 11 City of Dallas sign system, Hillier Environmental Graphic Design

Fig 12 Hollywood Florida sign system, Shaugnessy Hart The number of different destination directions required is a big factor in the amount of information that can be included on a sign.

Fig 13 Mekkah retail mall, Development Design Group The number of messages on a sign becomes crucial on multilingual road signs. These signs must be even simpler than signs representing only one language group.

The urban environment

The urban environment displays much variation. It could be a four-lane commercial suburban strip or a one-lane road in an urban downtown. The huge number of variables are too many to distill in one chapter, but there are a few rules that meet most of the general conditions of urban areas. These commonalities center around reaction time and clutter. In urban settings the driver is faced with a lot of stimuli and very little time to make a decision, and the environment tends to be cluttered. Therefore, clarity, simplicity, and economy of design become crucial for sign design in the urban environment.

Messages and information per sign The amount of information that may be included on a highway sign differs significantly around the world. European highway administrations have tended to allow as many as six destination messages per sign in addition to complex traffic circle elements containing many messages. American highway departments allow only three destination messages per sign, but usually allow a wide assortment of symbols.

Jon Bosio of Hillier Environmental Graphic Design has commented that the key consideration is the number of distinct elements on a sign. If there are four destinations in one direction, adding one arrow will produce only five distinct sign elements, while two destinations in opposing directions will produce four distinct sign elements (two place

Fig 14 Plaza Arena parking lot, Bureau Mijksenaar A large contrast between foreground type and background is one of the most important factors in sign visibility.

Fig 15 Little River Indian Casino, Corbin Design

Fig 16 Central Maine Medical Center, Sasaki Associates Color can be used to differentiate types of destination and urban districts, as long as the number of colors is kept to a minimum.

Fig 17 Paris wayfinding system, JC Decaux

names and two arrows). Also, logos and brand information count as a distinct sign element. Removing them almost automatically improves legibility while allowing more destination-oriented sign elements.

Color contrast Color contrast is among the simplest and most effective areas for improving legibility. Most research studies and regulations require that the foreground letters of a sign have a contrast of at least 60 percent with the background color of the sign. Percentage of color contrast is difficult to determine exactly, but the general method is to find the difference in light reflectance value between two colors. For example, white with a light reflectance value of 85 would have a 71-percent contrast with red with a light reflectance value of 14. (See Chapter 05: Legibility for users with disabilities for more detailed information.) If the contrast is less, the driver will have difficulty differentiating the type from the background.

Color as a wayfinding device A common design approach in urban wayfinding systems is the use of multiple colors to differentiate urban districts or types of destinations. For example, on hospital signs the emergency room is often represented by a red band on a sign separate from the hospital identification. While no definitive research on the subject has been carried out, it is important to realize that color is another sign element, equivalent to an arrow, message, or logo. This means that the same rules regarding efficiency in the number

of sign elements also apply to color. Most designers advise that no more than three, and preferably only two colors be used on a sign to differentiate locations or districts.

Arrows In Europe there has been great creativity in developing arrow designs for signs, including arrows that form the shape of signs (Paris), triangular arrows and chevrons (Italy), and fat lines with cutouts (UK). In North America signs have used Federal Highway arrows for some time. Ironically, this arrow form was found to be not highly legible in tests by the Pennsylvania Transportation Institute, with Meeker and Asssociates and Terminal Design, except when designed with a very long tail. Many urban sign designers today use the Montreal Expo arrow head. This arrow, designed for the 1967 Montreal Expo, has a long thin tail and a wide, narrow-line head, and has tested well for legibility.

The position and placement of arrows on signs This is another key area in which extensive testing has been carried out. Various studies have shown that the eye tends to follow the direction of the arrow at high speeds, indicating that a left arrow be placed to the left of the message on the sign and a right arrow to the right of the message. However, this becomes very difficult in urban situations; signs are often forced to compromise, with arrows placed below messages instead of immediately to the left or right. Another arrow placement issue that

Fig 18 American highway arrows.

Fig 19 Direction Philadelphia© directional sign, Sussman/Prejza & Company, Inc. This sign system uses a modified version of the Montreal Expo arrow.

Fig 20 Portland International Airport, Design Clarke and Neokraft Signs The position of arrows and hierarchy of destinations is crucial to successful sign design.

affects legibility is the hierarchy of arrows. A consistent rhythm of arrows is just as important for legibility as arrow placement. Most designers use the system recommended by John Follis in *Architectural Signing and Graphics* by which destinations that are straight ahead are placed at the top of a sign, followed by destinations on the left, and then destinations on the right. Once the driver understands this hierarchy, it is easier for them to read the signs.

The commercial environment

The world of commercial signs is one that is almost entirely outside the realm and authority of the designer and engineer. It is the result of thousands of different decisions made by thousands of different commercial interests, and governed by design codes. The metrics related to good commercial sign design are often not related to the individual sign, but to the rules governing the entire sign environment. The following four issues illustrate the balancing act between the esthetic needs of the community and the legibility needs of the individual sign for suburban commercial signs.

Sign clutter One of the biggest debates in cities and towns around the world has to do with sign clutter. How much does the visual pollution of many sign elements stand in the way of sign legibility. Years of minimal urban sign controls have resulted in signs containing too much information, too many elements, unreadable fonts, and being of inconsistent height. More recently, urban codes regulating signage have been enforced, but many pull in opposite directions, all but banning large signs, reducing clutter, and thus producing a more attractive environment, but also reducing any chance of road users actually seeing commercial signs. Ironically, many of these regulations are being created under the auspices of safety, even though smaller, less legible signs may actually create a more dangerous environment.

Jim Bolek of JRC Design believes that a well-designed street environment is almost exclusively governed by design codes, and that explicit instruction and enforcement is crucial to their success. He also comments that a good code must be a balancing act between reducing excess information and inconsistency on signs, but allowing for commercial signs to be readable and legible.

Foreground and background space "Large signs are easier to read," is often the mantra heard by designers, but this is only partly true. The amount of negative or background space around the type or logo is as important to readability as the size of the sign. Despite this, many municipalities have strict regulations banning large signs, thus forcing designers to squeeze a large amount of information onto a small sign. Sign legibility requires a compromise between municipalities and designers. Cities and towns need to provide and enforce codes that ensure an adequate sign area to allow for legible

18

19

20

Fig 21 Anaheim Disney World sign design standards, Communication Arts The reduction of sign clutter and organization of the streetscape allows signs and identification elements to be read more easily.

Fig 22 Nissan sign, Lippincott Mercer

Fig 23 Universal City Walk, Sussman/ Prejza & Company, Inc. Lighting brightness is closely aligned with color contrast in terms of sign visibility.

Fig 24 North Point Mall sign, Lorenc+Yoo Design A large background space greatly improves commercial sign legibility.

type, while designers and signmakers need to limit the amount of information and the number of elements on commercial signs to ensure readability without the need for enormous signs.

Height of a sign This is also an area where the desire of cities and towns has been in conflict with most research and legislation. Many cities and towns have set a maximum height of 7 feet (c. 2m) for commercial signs. This has resulted in very consistent streetscapes, but signs that are almost invisible to the motorist. Most research, and many government and disability guidelines, mandate that signs be at least 7 feet (c. 2m) off the ground to be visible to the motorist over distance. On the other side, many commercial signs are placed extremely high off the ground to be seen over roadway clutter. Other research conducted at the Pennsylvania Transportation Institute has shown that ground-mounted "monument-style" signs are blocked, more often than not, by leading vehicles. A good sign code creates a height range that allows for a balance between having a legible viewing height and a consistent viewing area.

Sign lighting and reflectance LED (light-emitting diode) and neon-lit signs have come to dominate streetscapes. Consequently, many towns have taken steps to tone down lighting, often by mandating a lower color contrast for lit signs. This contradicts the need for adequate color contrast for sign visibility, which applies as much to lit signs as to signs seen during daylight. As with most issues affecting commercial signs, reducing the clutter they create is usually the best way to prevent them from dominating a street, while still allowing the signs to be visible at night.

Remember, signs are not the only factor
When designing for the vehicular environment, good sign design is important, but it is not the only factor that affects motorist legibility. Issues such as the architecture of the buildings, and the surrounding landscape also play a crucial role. A designer should look closely at the entire environment and not just at the individual sign in order to meet the needs of motorists.

21

24

22

23

Developing Typographic Standards
for the National Park Service Donald T. Meeker, Meeker & Associates, Inc.

Beginning in 1992, our firm began developing new signage standards for the National Park Service (NPS). These standards were to be applicable to the 380+ facilities, including the big western national parks as well as battlefields, historic sites, and national monuments. The resulting program included the formal identification of a park or facility, motorist and pedestrian wayfinding, and information displays at key locations, from viewpoints and trailheads to campgrounds and parking areas. The goal was to create a seamless communications system for visitors. Although the standards we developed are quite specific, they can be adapted to the particular communications requirements of a park. Key to the design was the concept "go lightly on the land" so as not to overwhelm the site, but still provide the information required.

The selection of typefaces to provide a consistent visual "signature" for the system, and optimal legibility for each respective application, was also integral. Historically, since 1966, the NPS used Clarendon for road signs. Although Clarendon provided branding that was unique to the NPS when used on road signs, and had a stroke width-to-height ratio (1:5.3) that made it extremely readable, the heavy Egyptian slab serifs made each sign as much as 20-percent wider than other highway signs bearing the same legend. In addition, its use was limited to signage; NPS publications and exhibits used other typefaces, including Helvetica, Century Expanded, ITC Century, Times Roman, and Palatino, none of which would be appropriate for most sign applications.

To create a more uniform and seamless graphic system we recommended that the NPS adopt a consistent typographic system that could be used for all media. Integral to that would be a roman and a san-serif font. We teamed up with type designer James Montalbano of Terminal Design. In the selection process we realized we would need a roman typestyle that would be very legible in all graphic media, and that could be modified to give it enough weight for road sign applications (approximately 1:4.8 stroke width-to-height ratio). Note that most roman fonts have a stroke width-to-height ratio (1:7) that is one-third of the weight required, and adapting them to make them as heavy as is required severely reduces their legibility.

25

26

27

Hagerstown

Century Old Style

Hagerstown

Cheltenham

Hagerstown

Plantin

Hagerstown

Sabon

Fig 25 Existing NPS road sign with Clarendon Modified legend.

Fig 26 New identification sign for national parks using NPS Rawlinson Bold.

Fig 27 Preliminary display of recommended type families for selection of a new roman font for the NPS.

Fig 28 Initial field review of new NPS Roadway typeface designs with variations.

Fig 29 Comparison of original NPS Roadway (top), Clarendon (middle), and final NPS Rawlinson Road (bottom).

Fig 30 NPS Rawlinson Road (top) with NPS Rawlinson type family as designed for NPS publications and exhibits (below).

We initially suggested four roman fonts that included Cheltenham, Sabon, Century Oldstyle, and Plantin, and the san-serif font Syntax. The NPS selected Sabon, but was not excited about Syntax and later selected Frutiger, which made for an easier transition after 20-plus years with Helvetica. We realized that with all Sabon's elegance, it would not be ideal applied to other media, so recommended to the park service that we design a new typeface with the classical elegance of Sabon and the visual strength of Plantin. This would not be easy because these two fonts are based on two completely different periods of type design, but some form of integration would create a font with classical utility.

Key to this process was that Montalbano would develop the road sign version first and then adapt that design to the text family. This was based on the fact that it is easier to make a simple form more refined than to simplify a complex design. The other issue was that Clarendon was extremely legible and projected a well-developed identity to motorists despite its shortcomings for utility and adaptability to print and exhibit media. With the NPS investment in existing signs, we were advised that the proposed replacement typeface would need to test significantly better to justify the change.

For the road sign testing we teamed up with the Pennsylvania Transportation Institute (PTI). We began the field review by making sign panels containing the word "Everglades" with 5 inch (12.7mm) uppercase using the initial design, but with variations in weight, serif structure, and letterspace. These were reviewed with a team of human factors researchers, traffic engineers, optics engineers, and our NPS client, under both day and night conditions, and the most readable versions were selected for refinement.

The refined design of the initial font, named NPS Rawlinson Road was tested by PTI in a day/night study, with half the subjects being older drivers. The results showed the new font to be 2-percent better than Clarendon. Although better, this was not statistically significantly better. Based on these findings, we rebuilt the design with greater emphasis on the structure of the lowercase, and increased the proportion of the lowercase to the capital letter height, while reducing the overall letter width. The testing of the revised design resulted in an 11–12-percent improvement over the existing Clarendon. This was significant change and the new NPS Rawlinson Roadway font has now been incorporated into the NPS graphic standards. The research report was selected by peer review and published by the Transportation Research Board (TR Record 1862, 2004), an arm of the National Academy of Sciences.

The other side of this design process was the creation of the NPS Rawlinson type family for exhibit panels, signs (not highway) within a park, publications, and other media including the Internet. This is a four-weight type family in both regular and condensed weights, and with italic. It has now been incorporated into the NPS graphic standards for all media.

28

29

NPS Rawlinson Roadway (initial)

NPS Clarendon

NPS Rawlinson (Final)

30

Sign recommendations

Highway signs

→ Sign typography should balance the need for clear type while avoiding excess halation from reflective letters.

→ A combination of upper- and lowercase text greatly increases the legibility of words and allows more space on the sign for the message.

Urban signs

→ Sign type should increase in size relative to the speed in which cars are traveling.

→ Signs should have a color contrast of at least 60 percent.

→ There should be no more than three or four destination messages per vehicular sign.

→ Use only three different colors at most to differentiate destinations or districts on a sign.

Commercial signs

→ Sign codes should balance the esthetic and safety needs of the community with the needs for legible signs. Limiting the number of signs is preferable to reducing legibility.

→ Make sure that there is a lot of background space surrounding sign content, even if it involves simplification of the sign content.

→ Color contrast rules apply equally for illuminated signs and daylight signs.

Top five books and research sources

→ The Resource Guides of the United States Sign Council – This organization provides enormous numbers of research studies related to commercial signs including, lighting, color, and sign size.

→ Paul Arthur and Romedi Passini, *Wayfinding: People, Signs, and Architecture* – This book discusses many of the basic metrics for urban signs.

→ John Follis, *Architectural Signing and Graphics* – This book discusses many of the basic design issues related to vehicular sign legibility.

→ Ed Dore, *Highway Signs: Terror From the Road* – This critique of British and American highway signs discusses many of the design issues mentioned in this chapter.

→ H. Gene Hawkins, Jr. "Evolution of the MUCTD," *ITE Journal*, July–November 1992 – This series of articles discusses the development of road sign standards in the United States in the pre-and postwar periods, and includes information on testing data that resulted in many of the decisions made over the years.

Figs 1 and 2 Hospital identification signs,
Corbin Design with APCO Signs
Signs that meet the needs of the blind
can be almost invisible to the sighted.

05 Legibility for users with disabilities
Ken Ethridge AIA, RIBA

A designer involved in creating wayfinding systems for any interior environment *must* understand how to design for people with disabilities. The culture of the new millennium, as well as the laws of most developed countries, mandate that we think about the rights of our disabled citizens.

Designers must also think about wayfinding for the disabled because it is good design. Invariably, a well-designed space or sign system will meet the needs of the entire population, not just the needs of a special-interest group. Understanding the wayfinding needs of the disabled opens up a window on the needs of us all, including how a fully abled person navigates their environment. This is the foundation of "universal design," meaning that good design can meet the needs of all groups instead of satisfying only a few.

Unfortunately, laws are not written with this in mind; rather, they aim to satisfy the grievances or desires of one particular special-interest group. Combined, the various rules and codes dictating wayfinding design for the disabled often add up to a system that doesn't meet the needs of anyone. Designers, therefore, face a considerable challenge. They must design to meet the legal aspects of the design code while creating a satisfying system for everyone. That means that there can be no disabled design "specialist." It is a skill that all designers must master.

Fig 3 New York Subway System graphics,
Calori & Vanden-Eynden, based on
a template by Massimo Vignelli

Fig 4 New York City Hospitals, Hillier
Environmental Graphic Design
The visually impaired rely on large
letters with thin stroke widths, and high
color contrasts.

A short history

Until the twentieth century, the idea of the blind and visually impaired being able to navigate their environment was given no thought. The disabled stayed home or lived in special environments that could cater to their specific needs. Starting in 1929, with the establishment of the world's first seeing-eye dog school in Nashville, Tennessee, the blind began to gain the ability to navigate their environment, though interiors remained an enormous problem. There were hardly any signs available for the blind. Buildings also were not geared to the physically disabled, with multiple stairs and few ramps.

From the 1970s, a number of new technologies arose to satisfy the needs of the disabled. Sign designers began to create the first signs in Braille and raised letters that the blind could read. Researchers developed a better understanding of legibility issues related to color contrast and type size. Ramps began appearing as a regular feature in buildings. Many organizations focusing on rights for the disabled began to agitate for laws that would protect their right to navigate the world unassisted.

In the late 1980s, all this came together in the first national laws in the United States and the United Kingdom. Designers were slow to meet the challenge of these laws at first, but groundbreaking efforts to create

the first coherent and justifiable design standards were soon being made at the Lighthouse International Headquarters in New York City. Today an entire industry, as well as an academic and research base, has been built to meet the wayfinding needs of the disabled. Education efforts also began to pick up in the 1990s. Spearheaded by the Society for Environmental Graphic Design and groups such as NHS Estates in the UK, designers began to see how to best implement projects based on the new design codes.

Three groups and their wayfinding needs

The design code and the designers' work is geared toward three primary disability groups. These groups have distinct ways of navigating their environment and have special needs each one distinct from the other.

The blind The blind cannot see signs, interior changes, color, or type. What the blind can "see" are people and spaces through hearing and touch. The blind have a strong understanding of 3-D space and the position of their bodies in it. When walking, they expect information to be where their hands fall and where their feet and cane make contact. The blind can also receive directions by following the flow of people and asking questions. The functionally blind make up approximately 2–3 percent of the population.

The visually impaired The visually impaired can see, but with great difficulty, especially type and color. They focus on many directions at one time and are always trying to focus on type information because they have a hard time seeing anything immediately. People with visual disabilities are easily disoriented, especially by small type. People with visual disabilities make up at least 25 percent of the population. Among people older than 65, this figure can rise as high as 75 percent.

The physically disabled The physically disabled navigate their environment based on what services have been set up to meet their needs. Curb cuts in sidewalks, elevators, wider doors and bathrooms, and ramps are all physical additions to service the needs of this group. While this chapter does not focus specifically on the wayfinding requirements of this group, it is certainly built around the architectural design of the environment and whether improvements for the physically disabled are central to the design or a hidden background to the usual wayfinding process.

The regulation of wayfinding

Many designers would probably ignore designing wayfinding elements for the disabled if it were not required legally. The needs of so many different groups of the disabled makes designing for all of them difficult. The key issue for designers in balancing separation of sign information between people with visual disabilities and the blind is to meet the needs of both groups in one sign. This issue permeates nearly every aspect of the design codes, including those discussed below.

Location of sign information To the blind, signs are all about tactility, which means that the placement of Braille and symbols is specified in most sign codes. Type should be directly above Braille and at specific distances in most of these codes. This seriously restricts the location of information on signs, unless the same sign information is repeated in other locations. Many designers solve this issue by creating a "double sign," or a sign that contains both tactile and visual information, thereby duplicating information.

Position of signs The blind also need signs to be located in specific places. Since most sighted people see information more easily when it is overhead or away from the clutter of the immediate environment, most codes have had to divide "directional" signs (signs with information directing a user to a specific location), and "identity" signs (signs that identify a location). Directional signs only need to respond to the visually impaired, while identity signs need to respond to both groups. Ultimately, these codes restrict accessibility for the blind. This is being partially counteracted by design innovations that the codes recommend, but usually do not require.

Fig 8 Palmetto Expo Center, Lorenc+Yoo Design

Fig 9 American Airlines Arena sign, Gotschalk+Ash The blind expect tactile information to be in the same place and at the same height every time.

Fig 10 Color Calculator, ASI-Modulex There are a number of tools available for determining color contrast on signs.

Fig 11 Corporate sign, Roger Whitehouse Type for the blind can be small and invisible, while visual information should be much larger.

Color contrast and lighting Considerations regarding color contrast and lighting are not an issue for the blind, but they are the most crucial issues for people with visual disabilities due to age. As the eye ages it is less able to differentiate color. The reality is that most sign users need high-contrast signs as well as adequate lighting for them to be legible. Color contrast also provides another rationale for the separation of signs for the blind and signs for the visually impaired. Since a tactile sign does not need to be seen at all, by separating them, the tactile sign can be all but invisible.

Tactility of signs Tactility also separates the needs of the blind from those of the sighted. Since blind people read by touch, sign elements must consist of raised surfaces, or should be placed on a table-top or on a diagonal surface to enhance ease of reading. Signs for the sighted are better read vertically. Even shadows cast by tactile signs can confuse a visually impaired reader.

Typography Type fonts are one area in which the needs of the sighted and the blind are the most distinct. The blind need sans-serif fonts that are ½–1 inch (1.3–2.5cm) in size, and spaced far enough apart to allow for reading by touch. Lettering for the sighted usually needs to be as large as possible, and to have a wide variety of type fonts. The blind also find it easier to read letters that are all upper case, in contrast to the sighted, for whom upper- and lowercase is more legible.

Fig 12 White Paper, Roger Whitehouse;
Ken Ethridge AIA, RIBA; and Nora Olgyay
for the SEGD The Society for Environmental
Graphic Design and NHS Estates have
developed documentation to navigate the
regulatory process.

Fig 13 RaynesRail©, Coco Raynes
Associates

Fig 14 Floor marking at Charles De Gaulle
Airport, Coco Raynes Associates

Design codes around the world

These diverse issues have come to a head in a number of the codes being
written in countries around the world. All the codes have had to deal
creatively with the diverse needs of the blind and the visually impaired.

The American with Disabilities Act (ADA) The United States passed
the first codes that mandated signs for the blind. So far, it has by far the
most prescriptive codes, specifically mandating a tight range of fonts
styles, sizes, and widths, as well as the placement of Braille and signs
themselves. Recently the code has been advanced by recommending
the separation of sign information for the sighted and the blind.

The UK and Europe While Europe lags behind the United States in
specific enforced sign codes, a number of countries have endeavored
to create clear, consistent, yet flexible codes and have promoted them
through an educational process. The United Kingdom has gone farthest
in this area, with the introduction of new codes from the Disability
Rights Commission in the 1990s. The codes describe "reasonable
accommodations" and focus on a range of design solutions instead
of specific measures.

The developing world In most of the developing world, design for
people with disabilities has not yet entered the regulatory sphere.
Interestingly though, some of the most innovative work for the visually
impaired is coming from countries like Colombia, Brazil, Saudi Arabia,
and China. Perhaps ironically, the lack of design codes has allowed
a great deal of innovation. This has also been the case with the more
flexible European codes. The question of whether prescriptive design
codes curb innovation will be an area of debate for years to come as
the disabled gain more political leverage in a number of countries.

Wayfinding research and development innovation

Of course, all the discussion of sign codes tends to ignore one basic
fact: most blind people do not use Braille signs: most cannot read
Braille. Instead, they are accustomed to asking for directions. This has
been taken as a call to arms by many designers and people in the
business of developing technologies for the disabled. Three such
designers are profiled below.

Coco Raynes Coco Raynes, of Coco Raynes Associates, is one of the
leading international designers of signs and informational graphics for
the disabled. Some of her key projects include Paris' Charles De Gaulle
Airport and the National Museum in Colombia. Raynes has specialized
in using tactile and audio information as well as specially placed
wheelchair-accessible signs to tackle one of the thorniest issues in
wayfinding for the blind—that of creating specific wayfinding routes
for them to follow independently through a facility. Raynes' two key
innovations include:

→ **The RaynesRail©** This patented system consists of handrails with Braille information on the inside as well as multilingual audio information that can be activated by photosensors. The RaynesRail is innovative because it allows the blind to navigate through a facility without becoming disconnected from their environment. Other designers have used a form of the RaynesRail as long linear signs and other continuous information systems.

→ **Floor markings** Because a handrail keeps users attached to wall surfaces, Raynes has utilized floor markings for large facilities such as airports to give them more freedom. These slightly raised dots are mounted on the floor to further delineate the circulation path. The dots can be followed visually, or by foot, and make a sound if tapped with a cane.

Boyd Morrison Boyd Morrison, a designer with Gamble Design, has focused on extending the understanding of language for the blind and visually impaired. Acknowledging that very few blind people actually read Braille, Morrison develops special symbols that the blind can learn in order to navigate a facility. For health-care facilities with a long-term residential blind population, these unique systems can focus on tactile shapes as a teaching tool to help residents understand the feel of the shapes and use them to navigate.

→ **Symbol signs** These "place indicator" symbols—each uniquely differentiated by shape, color, and tactility—are designed to provide blind students and patients with new orientation strategy options while giving their teachers and caregivers potential new teaching tools to understand the meaning of shapes and forms.

Roger Whitehouse Roger Whitehouse, of Whitehouse & Company, has been a pioneer in both understanding the legal aspects of, and in designing for the disabled. Roger, Nora, and I wrote the ADA White Paper for the SEGD. This laid out the guidelines for American signs and best practices for utilizing them. Roger has also conducted extensive research on design for the blind on behalf of the Lighthouse International Headquarters (profiled in the case study on p 53). The two keys to Whitehouse's work have been:

→ **Ergonomics of the blind** This involves the recognition that a sign to be felt requires a very different sign type from a sign to be read. Whitehouse conducted extensive research in order to design a series of signs that could be more easily read by the blind.

→ **Tactile map** All three designers—Coco Raynes, Boyd Morrison, and Roger Whitehouse—have focused on the ability of the blind to read tactile maps and use them to understand the spatial configuration of a place.

15

16

New technologies

Other developers have used new technologies to assist in wayfinding for the blind through both audio and positioning devices. These technologies include:

Talking signs Talking signs are simply signs with an activating button or sensor that allows the signs to "talk," giving identification, directions, or other information. This technology is not new, having being used in the elevators of department stores as early as the 1960s, but today it is the basis for nearly every new technological development in this area. The two major benefits of talking signs are their ability to handle multilingual information and their ability to include directions. Lower prices and simpler maintenance issues will make this approach more common in the future.

GPS technology, infrared, and wireless Whatever type of technology is used, the idea that a handheld device can read information on a place is coming ever closer to reality. The main obstacle is not technology but content. Properly explaining directions will be crucial. Some advocates for the blind fear that this technology will so divorce the disabled from their environment that it could prove dangerous. Whatever does get selected, providing proper environmental cues will be just as important as the information placed on the handheld device.

In the end, new technology will closely follow design innovation to create an environment accessible to all. It is important to understand that good design for the disabled usually results in good design for everyone.

17

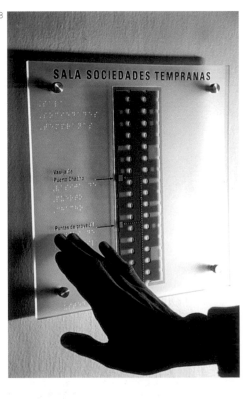

18

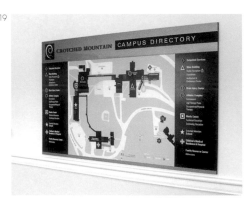

19

Lighthouse International Headquarters Whitehouse & Company

Lighthouse International headquarters in New York City is one of the only buildings in the United States specifically planned to integrate the needs of people of all ages who have a broad range of vision, hearing, and mobility impairments. A model of universal design and accessibility, this 170,000-square-foot (15,790m²) building is designed to satisfy, and in many cases exceed, the recommendations of the Americans with Disabilities Act.

The background to the project

The building is a "working laboratory" where many design features are tested for the first time. In creating the building, architects and designers were guided, every step of the way, with information from Lighthouse vision researchers and other staff experts. Lighthouse consumers provided their input regarding lighting, signage, color contrast, audible communications, safety and orientation, and mobility issues through extensive testing and research.

The difficulty of designing at the Lighthouse International headquarters was the diverse population who represent every step along the continuum of vision impairment, from partial sight to blindness, as well as people with other physical impairments, people who use wheelchairs, and people with full sight. Comfort and ease of use for Lighthouse employees was also a key consideration in designing the new structure. The resulting design had to fit the needs of this varied group without cluttering the space and impairing wayfinding.

Lighthouse International headquarters was an inspired collaboration between Mitchell/Giurgola Architects, lighting design firm H. M. Brandston & Partners, and environmental graphic design firm Whitehouse & Company. They developed the Lighthouse International headquarters through extensive tests by people with visual disabilities and other impairments.

The architects and the lighting designer began by developing a clear plan that eased wayfinding through the building. Some of the innovative features include:

→ **Easy-to-navigate lobby** The architects designed a functional entryway that is divided by a railing, separating people who enter

Figs 20 and 21 Lighthouse International Headquarters testing was carried out by Whitehouse & Company.

Fig 22 BrailleRail linear wayfinding sign.

Fig 23 Room identification sign. **Fig 24** Tactile map.

and leave the building. At the main reception desk, tactile and large-print maps of the public floors help consumers plan their routes within the building. The recessed waiting area in the lobby has space below the bench seating for guide dogs.

→ **Lots of light** Bright natural light from oversized windows and custom-designed, non-glare artificial light fixtures throughout the building produce a soft light that avoids dramatic changes in level or intensity.

→ **Contrasting colors** Since loss of the ability to perceive color contrast is one of the most common effects of vision impairment, strong contrasting colors—warm white walls with magenta door trims—are used throughout the building. Floor tiles, in shades of dark purple and mauve, point out elevators and safe travel paths, and color and texture contrast between walls and floor, on stair treads, and along the edges of desks also help maximize ease of use.

23

The wayfinding approach

Roger Whitehouse worked to support the innovative design features throughout the building with a sign system that could support people with varied disabilities. Whitehouse began with extensive research measuring how the blind read, including how they read test symbols and maps. Whitehouse coupled this research with observations on how the blind and people with physical handicaps navigate space.

24

The results of Whitehouse's research found their way into a number of design features in the wayfinding system. The first was the observation that the blind felt most comfortable reading Braille and tactile letters set at an angle. This led to the simple, but innovative angled Braille signs and maps that are positioned at a comfortable height for reading.

Another key research result that affected Whitehouse's design was that the blind feel much more comfortable following a continuous rail system that connects signs. The design approach that answered this development was a tactile element that connected each room identification sign. Additional information along the path directs users to the elevators.

The map design was another balancing act between the needs of the blind and those of the visually impaired. The map represents a full and complete raised floor plan that is mixed with Braille information, thereby providing a clear view both for the blind and the visually impaired.

Balancing the needs of the blind with the needs of the visually disabled is also key to the sign system. The Braille and raised letters for the blind are very low-key and unobtrusive, while the visual letters and symbols used are large, with a high color contrast. The typefaces involved also aided in wayfinding by using Whitehouse's Haptic typeface. This includes a distinct cross-section, large, open counterspaces, and the exaggeration of unique letterform characteristics, such as a slash through the zero to differentiate it from the letter "O" and an open-top numeral "4" to differentiate it from a capital "A."

One innovation that Whitehouse incorporated at the Lighthouse that is now being integrated into many buildings is the talking sign. These signs identify conference rooms, restrooms, and stairways out loud to users carrying special handheld receivers. The elevators feature a special enunciation system that identifies each floor and directs people toward the reception desks, where floor-specific tactile maps are located.

Lighthouse International Headquarters may have taken a leadership approach to wayfinding for the blind and visually impaired, but all the design innovations can be incorporated into any facility.

The language of wayfinding design for the disabled

→ **Talking signs** Signs that provide verbal information, identification, and directions

→ **Tactile map** A map with raised elements to give the blind an idea of place

→ **Angled sign** A sign placed at an angle to make it easier for the blind to read

→ **Floor markings** Raised elements in the floor that provide a trail for the visually impaired to follow

→ **Dual sign** A sign carrying both tactile and visual information, separately

→ **Grade one and two Braille** There are two types of Braille. Grade one distinctly separates each letter, while grade two uses Braille code to make word groups. Grade two is more popular for use on signs

→ **Rounded Braille** Braille that is rounded to make it easier to read

→ **Raised letters** Letters raised to be readable by the blind

→ **Color contrast** Distinct color separation between foreground type and background

→ **Sans-serif letters** Letters made without flairs and decorative flourishes to make it easier to read for the blind. Helvetica is the leading sans-serif typeface used

Wayfinding for the disabled design recommendations

→ Give provisions for the disabled as the highest priority in early building planning.

→ The blind and the visually disabled have different needs. It is important to design for both groups.

→ What works well for people with good vision will also work well for people with visual disabilities, and vice versa.

→ The blind look at wayfinding in three dimensions. Signs must be sensitive to the way the blind feel their way.

→ New technologies are not an end in themselves. Carefully integrate new technology, but do not rely on it overly for wayfinding.

→ Consistency is key to effective wayfinding for the blind. Make sure that all sign elements are at consistent heights and positions relative to doors and circulation areas.

→ The blind scan horizontally first and vertically second. Braille and raised elements should not be vertical.

→ Use floor changes and railings as much as signs to enhance wayfinding.

→ Color contrast and simple information is the key to strong visual information for people with visual disabilities.

→ Good lighting is every bit as important as large type and color contrast for legibility.

→ Codes and regulations do not always equate to good design.

06 Symbols and universal design

Lance Wyman and Craig Berger

The character and effectiveness of any wayfinding system are in large part a result of the language used to present identity, directional, and interpretive messages. The visual messages of a wayfinding system are usually 2-D and/or 3-D representative words and images. Words can be from one or more specific languages in a wide variety of typefaces. Image options range from elaborate, such as pictorial illustrations and photography, to simple, such as color-coding and symbols. Symbols can contribute simplicity, clarity, and personality to a wayfinding system.

There are two basic ways we have to communicate the objects, actions, and feelings in our lives: sounds (words), and images (symbols). Words are an effective way of communicating complicated, interrelated ideas where symbols fail. It is symbols, however, that communicate across the barriers created by different word languages. As obvious as that might sound, designers too often overlook symbols when planning and designing a wayfinding system. Symbols are actually the essential shorthand behind any environmental graphic design project. Arrows are symbols that have gained the status of universally understood wayfinding vocabulary. Letters and numbers are also symbols that can be used to represent places and spaces as images that range from literal photographs to completely abstracted images.

Fig 3 Atlanta Hartsfield International
Airport, Apple Design, Inc., based on
a template by Osgood Associates

Fig 4 Salt Lake City Olympic banners,
Look of the Games, Salt Lake City
Committee and Infinite Scale
International events have encouraged the
creation of a creative pictorial language
that can also serve to brand the event.

One of the most important things to understand before designing or utilizing symbols is the terminology involved in symbol design. Symbols have specific meanings, and are conveyed specifically. A symbol vocabulary is included at the end of this chapter to help you understand the recognized terminology.

A short history

Symbols have a history that predates the written word, and often form our first understanding of the ancient world. In antiquity, symbols were used extensively, with ancient Egypt and Babylon using pictograms to convey extensive written information. With the invention of written language, symbols began to serve a new role, as a way to bridge language barriers and assist a largely illiterate population. With the rise in literacy around the world, symbol design and use in signs declined.

After WWII, symbols began to make a major comeback because of increased globalization. A number of government organizations began to develop symbol standards, first seen in airports, train stations, and highway projects. The U.S. Department of Transportation (DOT) developed a symbols template for transportation in 1974; this is now the standard in airports around the world, and used on traffic signs, and in most transportation facilities.

With the Olympic Games and other international events, symbols also played an enormous role in communicating information to a variety of multilingual groups, and today, with multilingual legislation in every country, symbols are often used in institutions to break through the cacophony of languages.

Symbol use has also increased significantly with the development of the graphic computer and the Internet. Early experimental work at Xerox used visual symbols as part of the language needed to navigate a computer; the Apple Macintosh relied even further on icons. Today, these early forays into using symbolic language as a guide for users have become standards in computer wayfinding. Symbols help make wayfinding in both the virtual environment of the computer world and the real world of our built environments easier to understand and to navigate.

When symbols don't work

Every visual message of a wayfinding system has to communicate on its own, without the luxury of being explained by the planner or designer. Sometimes, however, symbol systems can fail to make a wayfinding system work effectively. Ask yourself the following questions.

Are there too many symbols? One of the most common mistakes designers make is to use too many symbols. For color coding, the rule

3
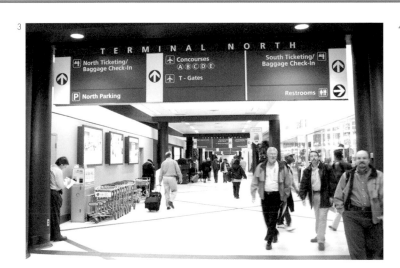

4

Fig 5 New York City subway standards, Calori & Vanden-Eynden Design Consultants, based on a template created by Massimo Vignelli A combination of letters, colors, and shapes can create its own language, especially for people who use the system every day.

Fig 6 Atlantic City bus station sign The creation of a standard set of international symbols for transportation has effectively created the first truly international pictogram language.

of thumb is to use no more than six colors (e.g., red, blue, yellow, green, orange, and purple); any more causes confusion. It is harder to recommend a maximum number of symbols; even one symbol is too many if it doesn't communicate well. On the other hand, hundreds of symbols can work effectively if they are well designed and used properly.

On road signs, the driver must read while in motion, and without slowing down. Here, the use of symbols should be limited to as few as possible—no more than three or four per sign. Sometimes road signs use words in combination with symbols, but symbols usually have a better chance of communicating to the larger audience— *if* everyone understands the meaning of the symbols.

Because subway lines are usually named or numbered and color-coded, it is possible to incorporate more symbols on subway maps to identify stations and uses. System maps and station signs are also available to help. The background shape of a symbol image can help the user interpret the message. When the user is standing still, more time can be allotted to understanding what is meant, so more symbols can be incorporated into a sign or other wayfinding component.

Are the symbols easy to remember? Whether incorporating many symbols or just a few, use familiar images: they are easier to

understand and to remember. Use symbols from an established system when possible; for example, the Department of Transportation (DOT) symbol signs (see John F. Kennedy Airport case study on p 65) can be used to represent generic services, activities, and regulations.

If the symbols are site-specific, such as identity symbols for districts, events, or special services, design or choose symbols that can be described in any language. A tree image, for example, can be described as "tree" in English, "arbol" in Spanish, and "ki" in Japanese—and has the same meaning in each language. Making sure there is a readily identifiable word for the symbol is important not only because it helps users remember the symbols, but also because they can describe them when giving directions verbally. If the symbols are arbitrary images, how will the user know which symbol refers to which district or place?

When navigating the urban environment, we often use architectural structures as landmarks. Thus, symbols that use architectural images can be used to effectively identify geographical districts or specific locations. Landscape elements, such as fountains, gardens, bridges, or monuments, also make good symbol images, as do symbols that represent functions, activities, history, and culture.

It is a good rule of thumb to use no more than one similar type of symbol image in a given wayfinding system. If it is necessary to use

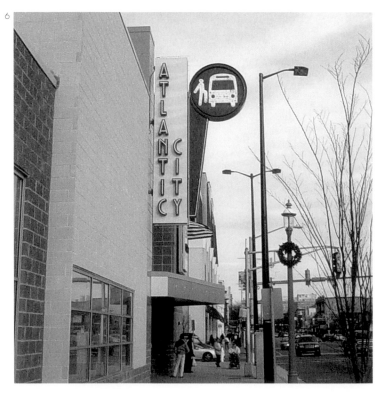

Fig 7 LA Walks map, Corbin Design with
Hunt Design

more than one architectural image, for example, make sure that you emphasize the differences between the building types or add details to make the symbols readily identifiable and easily distinguished.

Can the user read the symbols? When evaluating the legibility of a symbol, consider both how familiar the symbol is and how well it can be seen. Symbols tend to be highly familiar when they are commonly recognizable generic images, but there may be a learning curve in connecting the image with the intended message. Consider all possible inferences when selecting a symbol to avoid any confusion between the image and its intended meaning.

The visibility and legibility of a symbol depends on a number of factors, including form, size, viewing distance, lighting, color, and contrast. The criteria used in evaluating a symbol's visibility are very similar to those for evaluating the legibility of typography, but keep in mind that symbols are generally more complicated than simple letterforms, which are immediately recognizable and communicate their meaning without needing to be translated. When a symbol is reduced it can lose its clarity; details become blurred. Unless the shape is clearly distinguishable, one symbol can be confused with another. Highly legible symbols are simple and direct. Symbols that are too complicated to be recognizable or too simple to have meaning become decoration rather than communication.

Do the symbols say the right thing in the right way? As with words, symbols can express messages with many levels of meaning. They can identify, direct, and inform with clarity. As with names and written messages, it is important to craft symbol messages to get maximum value and effectiveness.

Symbols offer designers an opportunity to plan and implement a wayfinding system that visually expresses and supports its unique location, history, and culture. Planners can design or select symbols that make the wayfinding system more cohesive, more closely related to its history and environment, and unique. But in the end, the symbol must work easily for the user. A clever design is not clever if it does not communicate to the user.

Recommendations for symbol design

There are three schools of thought regarding symbol design and implementation on projects. While designers tend to fall into one of these three camps in their practice, most adapt their approach to specific projects.

Symbols as language One school of thought, proposed by a number of designers and researchers, is that symbols are a language that can be learned like any other language, through education and constant use. These designers have worked to develop sets of standard

7

symbols that are meant to be learned over a long period of time, through extensive design and testing by teams of designers, based on symbols recognized by years of tradition.

Symbols in this mold would need to follow a narrow standard of sizes, shapes, and colors as well as being used in a consistent way with standard heights and positions. The symbols themselves are often developed from extensive testing of user groups under a variety of conditions or from recognizing symbols that have been used extensively for a number of years. The symbols are usually not the primary design object in a scheme, but often share equal weight with text, arrow, and color information.

Symbols used as a language are integral on very large infrastructural standards like national highways, international airports, national parks, highway systems, and hospitals.

Symbols as a unique design language A number of designers have felt stifled by the regimentation of standard symbol shapes, sizes, and position. They feel that symbols can mix a universal vocabulary into unique design work, utilizing symbols that incorporate landmarks and other information unique to the facility. Their work does not reject the idea that universal symbols can exist, but that learning how to use them can be enhanced by modifying them to meet specific project needs.

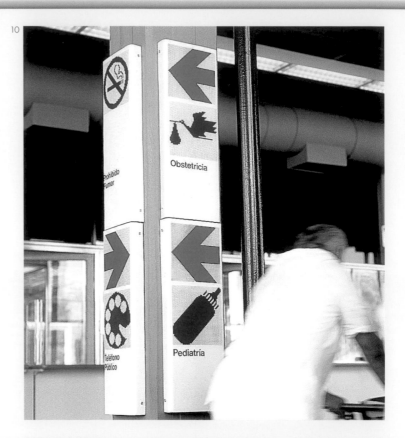

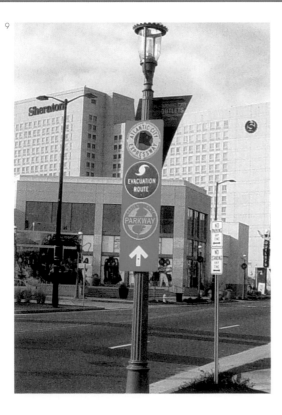

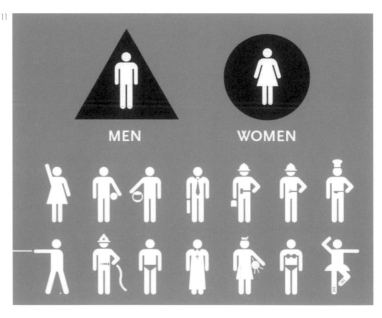

Fig 11 Children's Museum symbol vocabulary, Whitehouse & Company

Fig 12 Fashion Show Mall entry sign, Sussman/Prejza & Company, Inc.

Fig 13 Connecticut Children's Medical Center, Karlsberger Companies
Unique and creative symbols can be learned even by first-time users.

Fig 14 Xanadu Mall retail sign, Communication Arts

This approach also focuses on symbols as a dominant design motif, not as an additional communication support to text and other instructional information. The designers who adhere to this philosophy also use symbols as decorative details, adding size and color emphasis, forcing the user to fully interact with the system when using signs and print support.

When symbols are developed as part of a unique design language they can reflect geographic, cultural, or activity information. They can also be offshoots of standard symbols. In fact, the International Standards Organization (ISO) permits design to occur inside these standards, allowing for basic symbols to be stylized. The stylization of symbols occurs in a variety of projects, especially ones where theming is integral to wayfinding, like amusement parks, zoos, and museums.

Hybrid philosophy—a hierarchy of symbols

A third philosophy has been promoted by a number of designers. This philosophy acknowledges that there should be a symbols hierarchy based on the hierarchy of destinations in the facility. Crucial destinations are given a unique and creative symbol treatment, while smaller and standard destinations are emphasized less.

This philosophy also integrates other information like numbers, letters, and colors so that specific facility information can be integrated. The idea is that some symbols have attained the level of a design language and can be utilized with text in a formal way, while others need further emphasis and education to be effectively utilized. The philosophy also uses redundancy of information to get the point across, with symbols used at varying sizes on different signs for different purposes.

This approach is often adopted in airports, where arrivals and departures information is frequently given through the use of large symbols, while bathrooms and shopping facilities are given a much smaller symbol treatment. More important information is also increased in size and emphasis. Currently many health-care facilities use numbers and letters as a way to emphasize hierarchy, with symbols taking a secondary role.

Symbols research

There has been extensive research conducted in order to develop a system of symbols that work best in the environment. Wendy Olmstead, a symbols researcher, illustrates the three specific research criteria for symbol success as:

→ An increase in symbol understanding defined as the viewer's ability to perceive and understand the message of the symbol in isolation. The ISO has developed a system for gauging symbol understanding that is the standard today. This test involves ranking symbols according to the viewer's perception of what the symbol means.

Figs 15 and 16 Hablamos Juntos symbols
research project, JRC Design; Wendy
Olmstead, SEGD; and Phil Garvey

→ An increase in *recognition* for a group of symbols. This involves
looking at a range of symbols at the same time to see if the viewer
understands the underlying symbol system. Testing for recognition
often includes matching a series of symbols with a series of
destinations.

→ An increase in *detection* or salience of the symbols in the wayfinding
environment when additional issues like background, size, contrast,
lighting, color, and design are added. Testing for symbol success
in detection involves designing a symbol as part of a complete
wayfinding environment and testing user reactions when navigating
the system.

→ Recently, a project developed for Hablamos Juntos and sponsored
by the Robert Wood Johnson Foundation tested symbols designed
by a group led by JRC Design for use in the health-care environment.
Using the methods illustrated by Wendy Olmstead, the design group
will attempt to create a symbol language for use specifically in the
health-care environment.

15

16

Mexico City 1968 Olympic Games and the Mexico City Subway Lance Wyman Ltd.

The philosophy behind these projects was based on the design approach. The Olympic Games of ancient Greece were one of the first events for which symbols were used to represent activities, with a vocabulary of bodies performing different activities. With the first modern Olympic Games in 1896, the symbol language begun in ancient times was put to a new use: to convey information on the various Olympic sports to a multilingual, worldwide audience. An increasingly stylized universal symbol approach was developed for the Olympic symbols in successive Games.

The 1968 Mexico City Olympics significantly changed the design approach to the symbols by creating a series of graphic forms based on "glyphs" from Native American artwork. Instead of utilizing entire bodies, the symbols looked to identify activities through elements that would have universal recognition and forms that could be utilized in different ways. Boxing, in this case, could be represented by a glove instead of a boxer in motion, while a swimmer could be represented by a simple arm stoke instead of an entire swimming body.

The result of this design flexibility is a symbol system that could also be used as a decorative pattern, integrated into print programs, or used as part of a large-scale identity program.

The glyphic approach utilized for the Olympics was also put to work for the Mexico City Metro system, which was completed a year later. Instead of using human activities as the basis of the system, geographic and cultural references were used to define a sense of place for each train station. Because the Metro system would be in use for much longer than one event, the symbols were designed to make reference to specific urban places. The symbols were also configured to be the dominant design element over text and number information. Linear station maps of symbols created strong approaches for referencing symbol information, by showing all the symbols in context.

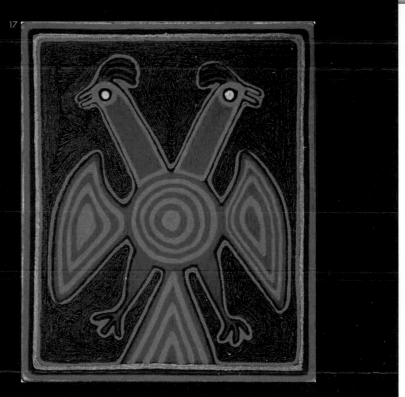

Fig 17 Native American glyphs used in a contemporary Huichol wool painting.

Fig 18 Olympic symbols based on glyphic images, Lance Wyman Ltd., with Beatrice Cole and students from the Ibero-Americana University

Fig 19 Mexico City Olympic sign, Lance Wyman Ltd. with Peter Murdoch

Figs 20 and 21 Mexico City Metro symbols, Lance Wyman Ltd. with Arturo Quiniones and Francisco Gallardo

Fig 22 Mexico City Metro sign, Lance Wyman Ltd.

John F. Kennedy Airport, Teminal 4

Chermayeff & Geismar, based on graphic standards by Bureau Mijksenaar

The philosophy behind this project was based on the design vocabulary approach. International airports have been among the most multilingual environments of all building types. The average international airport has people from 30 countries in it at any one time. In this environment, standard symbols, text, and color are important to convey visual information. Governmental organizations have been conscious of this issue for some time. Their attempts to develop standards culminated in the U.S. Department of Transportation (DOT) symbol standards, sponsored by the American Institute of Graphics Arts (AIGA), and designed by a team including Massimo Vignelli and Thomas Geismar, in 1974. Fifty symbols were created and tested. Over the years, these symbols were integrated into thousands of different transportation projects, from train and bus stations to highway projects.

In an attempt to develop a complete international airport standard, Bureau Mijksenaar in Amsterdam developed standards that integrated the DOT symbols as a vocabulary, along with color, type, and lighting standards. This system has been used in airports around the world, including Amsterdam, the Netherlands; Baltimore, Maryland; and Columbus, Ohio.

This system is currently being utilized at the New York Port Authorities Air System. The three airports of John F. Kennedy, Newark Liberty, and LaGuardia operate separately, as do all individual terminals. Over the years, this has resulted in a vast variety of signage styles and types, with inconsistent—sometimes even conflicting—information, all displayed in an already highly complex environment. The challenge was to develop one master system that could be applied to all airport terminals, roadways, and parking facilities, and that was sophisticated enough to direct passengers from all over the world within an environment of hundreds of possible destinations.

Instead of a system that relies completely on symbols to express information, the standards work on a number of levels and do not rely on any one element for wayfinding. Instead of having visitors rely overly on the symbols as a system, the standards are integrated with a green, yellow, and black color palette as well as text and arrow standards. The final configuration integrates the symbols palette as another language element along with text and color.

This systems approach has proven to be very popular. In testing by J. D. Power and Associates, airport users have reported easier airport navigation and comfort with the new wayfinding system.

23

24

Figs 23 and 24 A green, black, and yellow color palette was selected for the signage.

25

Fig 25 ING Direct Store, Gensler Sign systems can succeed using a hybrid of well-known standard symbols and unique symbols.

The language of symbol design

→ **Glyphic language** A symbol based on an ornamental design. Used extensively in language by Egyptions, Greeks, and Native American tribes

→ **Logos** Corporate brands and icons used as symbol information

→ **Symbol understanding** Being able to define a specific symbol

→ **Discrimination** Being able to differentiate symbols from each other

→ **Recognition** Being able to recognize a specific symbol among a group of symbols

→ **Detection** Being able to read a symbol as part of a sign or document

→ **Referent** The meaning of a symbol

→ **Symbol standardization** Attempt to create a specific symbol vocabulary that can be used in a variety of situations like transportation and health care

→ **Direct symbol** A symbol that roprosonts some aspect of what is being presented; for example, a picture of a snail representing slowness

→ **Indirect symbol** A symbol that stands for an object other than what it appears to be representing, for example, an elephant representing the Republican Party

→ **Universal symbol** A symbol that can be understood by almost all users around the world

→ **Unique symbol** A symbol meant to be used in only one specific project

→ **Pictogram** A symbol that uses the representation of a material object to convey meaning

→ **Abstract symbol** A symbol that at one time represented a picture, but that has been abstracted into symbolic indications over the years, for example, arrows

→ **Arbitrary symbol** A symbol that does not represent a specific object, for example, numbers, letters, musical notes, and mathematical signs

→ **Silhouetted pictorial** Symbol represented as a direct symbol in one color on a black background, needing no learning process to understand, for example, park symbols

→ **Diagrammed pictorial** Complex symbol that is not immediately understood, but takes time to learn, for example, a city's coat of arms

Symbol design recommendations

→ Do not design too many symbols for a project. Symbols are a language and too many characters make it more difficult to learn.

→ Use familiar images for symbols.

→ Use symbol standards and conventions wherever possible, but make sure to integrate them into the overall design of the project, including matching colors, shapes, and sizes.

→ Symbols should look similar enough to each other to look like they are from the same family, but not so similar that they cannot be differentiated from one another.

→ Keep symbols simple to ensure legibility in the environment.

→ Numbers and letters can be used as effective symbols. They can also be integrated with unique symbol languages.

→ Symbols are more effective with additional support from print, maps, and text.

→ Symbols can convey unique places and personalities, but their paramount goal is communication.

→ Unique symbols should be looked at in terms of design flexibility— how they can be integrated into patterns and other decorative elements.

Implementation and projects—internal

Fig 1 Seattle Public Library, Bruce Mau
Design Inc.

07 Transport systems
Ellen Taylor AIA

In transportation work, wayfinding is usually a four-letter word that starts with "s": sign. While signage may affect the design of any project, in transportation projects user-friendly signs are a critical component that often gets overlooked or is intentionally ignored by architects, planners, or transportation engineers. The people working on the project may think that a good design does not require signs, or feel that signs will visually clutter the quality of the design. However, if the design team does not address the signage issues in a building, someone else will, and the result will probably not reflect the vision for the building. This haphazard or belated approach to signage and wayfinding programs can result in an unattractive and ineffective addition to even the most beautifully designed structure. We have all seen messages scribbled on paper and taped to a window or door. The architect is not there everyday, but the station manager and janitors are. If you do not want others to make decisions that affect the appearance of the places you design, plan for signage, graphics, and information systems in advance.

Environmental graphics can address several aspects of wayfinding in the design and use of a building, but in transportation, environmental graphics has multiple roles. When properly designed, the graphics serve to inform without confusion. The graphics must do this while at the same time creating a consistency and balance in design. To function effectively, the graphics must neither overpower nor get lost in the other aspects of the fit-out. Travel can be stressful for many people, and the

Fig 2 Reading Station, Philadelphia, USA The railway stations of the late nineteenth century used very consistent architectural tools to define how people approached, purchased tickets, and went to their train.

Fig 3 TWA Terminal at John F. Kennedy Airport, Eero Saarinen Architects With the jet age, transportation buildings took on free-flowing, non-traditional forms.

Fig 4 Los Angeles Metropolitan Transportation Authority (MTA), Hunt Design Transportation graphics are becoming the glue that binds vast transit networks.

use of environmental graphics, along with good architectural design, can have a significant impact on creating a positive experience for travelers. Two areas that are especially critical in transportation projects are identity management and wayfinding through directional signage.

A short history

Identity and wayfinding have been critical issues since the birth of modern travel at the end of the nineteenth century, and the rise of modern rail networks. At that time, train stations were built so that the architectural design would inform people about where to find their trains with minimal additional support. The stations were all formally designed with a processional front door or head house backing into a large bay of trains. Ticketing and other features were placed in similar locations in every station. The train user knew the system well.

This architectural, ritualized approach to wayfinding began to break down in the early twentieth century. Instead of servicing a single company, train stations became integrated into vast urban networks containing regional trains, long-distance lines, and urban metro systems. Architecture began to play a secondary role to graphics in identifying where users were and how they could navigate the system. At the same time, the stations themselves began appearing as single and multiple buildings as well as aboveground and underground, further diluting the architectural hierarchy that made wayfinding self-evident.

In addition, modern air travel began to dictate the spread of large airports, each containing dozens of different airlines and terminals. No formal architectural hierarchy was developed for airport architecture, with the result that terminals began to take on unique features and layouts. This meant the traveler lost all natural understanding of their environment, which thus had to be supported with an alternate system carried by graphics and signs. Furthermore, the ownership and control of transportation systems were often spread among local and regional networks for train stations and airlines, and municipal authorities for airports.

Primary issues in transportation wayfinding

The wayfinding aspects of environmental graphic design cannot be underestimated, as many travelers are new or infrequent users of a transportation system, and often visitors to the area. Users rely on directional signage to help them through their journey. Effective wayfinding signage is truly an art form that requires a great deal of experience and skill in presenting information, and a real understanding of how information is digested. The five key areas for consideration are outlined below.

Acknowledgment Architects should have a basic understanding of how signage standards, design, and fabrication work to create an effective project. Without a basic understanding of these issues, there is potential

Figs 5–7 Amtrak sign system, Calori &
Vanden-Eynden Design Consultants
Design standards are crucial to the success
of modern transportation systems, by
providing a consistent template for color,
type, and form, and using it to extend the
system brand across a wide variety of
different locations and uses.

for dissatisfied clients, as well as frustrated and unhappy users. Most transportation providers have developed standards for wayfinding design. The standards in transportation projects identify types of signage and placement, as well as the graphic components, such as specific colors and fonts. Standards are critical because they represent the client's identity, as well as an approved approach to functionally relaying information. These standards can be a valuable part of the design process.

When acknowledged and incorporated early in the process, the identity and graphic standards can facilitate a stronger building design. It is therefore very important for the architect to ask for and receive any and all design standards that are in use or under development by any department within the transit organization. Of course, the signage system also needs to comply with local and national legal requirements, which may dictate fonts, contrast, and placement.

Hierarchy One of the most colorful quotes about transportation signage referenced New York's airports. The airports were referred to as "emotionally wrenching portals into the New York state of mind—the one that says, 'Sink or swim, baby'." Part of this reaction came from the inadequate signage system. A marketing survey conducted by the Port Authority of New York/New Jersey revealed that confusing airport signage ranked second to dirty restrooms in travelers' complaints.

What frequently happens in complex environments—whether a train station, airport, hospital, or city—is that over time, rather than replacing incorrect signage, new signs are added to the old ones. This results in a system that lacks any cohesive qualities for hierarchy.

At Kennedy Airport, for example, there was no directional signage to Manhattan. Signs for the Van Wyck Expressway were prevalent, but the first reference to Manhattan was at the Midtown Tunnel—not helpful wayfinding for first-time or occasional visitors trying to find their way to downtown New York. Furthermore, parking garages lacked information about which terminal the garage was serving, leaving you on your own to figure it out.

The hierarchy of a message system is important. An effective wayfinding system identifies the major elements first and follows up with specific details, such as building identification, entrances, ticketing, waiting, and boarding.

The New York Port Authority uses color-coding to provide additional levels in the hierarchy. Black letters on a yellow background (traditional warning colors) direct departing passengers; white letters on a green background (natural colors/highway signage) direct passengers leaving the airport; and yellow letters on a dark gray background direct passengers to waiting functions and amenities.

Fig 8 Newark International Airport, Apple Design Inc., based on a design template developed by Bureau Mijksenaar Because of the complexity of airports and railway stations, numbers, letters, and symbols become key methods for identifying terminals and services.

Fig 9 Miami International Airport, Carter Burgess Architects Designing a large number of different sign types to distribute consistent information instead of loading all information on a single sign is crucial to project success.

This new system allows users to focus only on signs that use the colors associated with their leg of travel and ignore other information, thereby reducing the amount of information that needs to be scanned and digested. The defined methodology can also help to reduce the number of signs needed and provide a streamlined design, resulting in far less clutter, more attractive building, and an environment that is far more easily navigated.

Quantity As we have seen, less can be more when it comes to directional and wayfinding signage. A glance at Union Station in Washington, D.C., highlights the potential pitfalls of providing too much information. Multiple signs with up to 12 messages each are placed at regular intervals along the main circulation spine of the rail portion of the station. Furthermore, the same information is at different locations on each sign and there is no coordination of directional arrows or hierarchy of information.

Creating a new plan at Union Station raised all of the difficult questions associated with designing and implementing wayfinding signs in an architecturally open facility, or one with multiple entrances, as are found in most transit environments. The solution required considering the user's perspective and focusing on the sequence of the journey from various entrances. The resulting wayfinding system highlights ticketing, waiting functions (including retail), and boarding location information; less

important and duplicate information was eliminated in order to reduce information overload. Text and pictograms are used to address the user's immediate needs. Each sign has a maximum of three messages and a "preview bar" that lists upcoming functions and amenities. As the traveler moves through the station, the new wayfinding system thus clearly provides the needed information in an organized and easily digested way.

Legibility Many architects want signage systems that become almost an invisible part of the building's architecture. This may be appropriate for certain building types, but in transportation, the key aspect of signage is legibility and visibility. The information that the travelers require must stand out and be easily recognizable. Signage that is consistent with the architecture may be attractive, but it may also be completely ineffective as communication. For example, the main train information board in Washington, D.C. was designed to become part of the central retail component in the grand entrance hall. The shape of the board matches the architecture, and the cherry stain of the wood creates a common tonality with the dark colors and lighted information systems on the information board. The result is low visibility: almost everyone entering the station misses the signage. This signboard looks wonderful and does a great job complementing the architecture, but it fails in meeting its main objective of providing information for the traveler.

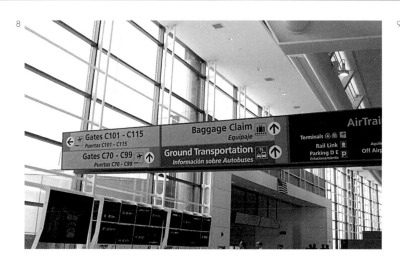

Fig 10 New Jersey Transit Station directional signage.

Fig 11 Union Station, Washington, D.C. High technology and beautiful detailing does not always equal visibility.

Supplemental components Supplemental components, such as advertising or retail signage and promotional signage, are integral aspects of a transportation facility. For an architect, the charge is to help the client identify standardized sizes and lighting levels. The value of a message can be greatly enhanced through the consistency of presentation. When the architect works to accommodate the information and communication functions, the resulting solution does not detract from the architecture, but does accommodate the needs of the travelers and others using the facility. Some of the requirements to accommodate information functions may include fixed poster frames, picture rails, or suspended hanging rails. Multiple sizes that are randomly mounted create a disorganized visual environment. When planned in a cohesive manner, however, the promotional materials become an integral part of the space.

Another issue that is difficult to identify in signage standards is lighting. In general, the ambient lighting of a public area is adequate for signage legibility, but retail stores often rely on eye-catching storefront displays. Be aware of surrounding conditions so that you can determine whether specific lighting is required to improve the legibility of a sign.

Rules of thumb in transportation wayfinding

The five primary issues are addressed more fully through ten rules of thumb to guide the design of the transportation wayfinding system.

→ Think about what the passenger needs to know at different points during their journey. People involved with transportation projects travel, but often forget what they need when they are faced with unfamiliar situations; it is always helpful to be "uneducated" in this regard. Service is improved by providing the right information in the right place at the right time. This is often briefly addressed in typical location plans of any standards manual.

→ Think about how people will behave. The location and orientation of information will influence where someone is comfortable standing, sitting, waiting, or queuing. Passenger flow diagrams should be developed between entrances, exits, and major functions to understand the critical paths of the facility. The shortest distance between two points is a line, and passengers will follow this rule, even when given a more formal path to follow. Information should be included at some of these locations, but should be eliminated at others to avoid bottlenecks and congestion.

→ Provide the right amount of information. Too much information on a sign creates confusion and results in an ignored information system. A well thought-out message schedule translates into positive perceptions for the operator and their respective customer service.

→ Use fonts consistently. Most operators will have a sign standard including a corporate font for wayfinding (most often sans serif for

Fig 12 Schedule board, 30th Street Station, Philadelphia, Pennsylvania
Travelers love familiarity and tradition. The old-fashioned schedule board can be replaced with electronic information, but the clicking caused by schedule changes comforts the visitor and draws attention to the object. In comparison to Union Station, this sign provides visibility by engaging the ear as well as the eye.

Fig 13 Grand Central Station retail sign, Two Twelve Design Associates

legibility). Strive to use only one font type in transportation facilities for clarity. If multiple users are present, a neutral typeface should be incorporated to avoid brand standard clashes, unless the providers can agree to use one standard or another.

→ Use appropriate materials and colors. Consider the contrast, the lighting, the architecture, and the viewing angles. A sign that blends into the architecture becomes useless, and materials such as clear glass become invisible in complex wayfinding environments. Additionally, when designing one terminal or station as part of a larger service route, it is important to recognize the signage as part of the operator's system, not just a design exercise for a stand-alone project. Consistency of materials and colors from station to station aids a traveler's understanding and comfort with the wayfinding system throughout their journey.

→ Use appropriate mounting solutions. Sometimes a sign band alone will not be visible in the context of the architectural layout. Overhead signs and signposts are often required for adequate visibility.

→ Make sure that the transportation functions can be found. Transportation facilities are often supplemented with retail functions that can easily confuse the environment due to lighting, color, displays, and activity levels. Try to establish standards for retail as part of the project to insure that the transportation information is still a focus of the facility.

→ Remove clutter. Older facilities become an archeological study of sign types. New facilities will begin to develop a multitude of signs over time. During any project, make sure the old and/or unused signs are removed as part of the demolition process, not just left as an unintentional supplement to a new program.

→ Understand post-occupancy issues. Cleaning, maintenance, replacement, and operations are significant issues. A beautiful sign system that is too hard to maintain will quickly be overcome by alternatives. Incorporating advanced technology, if the support structure does not exist, will create an operational nightmare of expensive and unused electronic components.

→ Lastly, help to educate the client and the whole design team about the role of wayfinding. Often this step is overlooked or added late in the process, resulting in ad-hoc systems of signage as the building is used over time. The best architectural solutions still need signs in transportation environments. Helping the team understand the implications of good and bad solutions can improve customer service and help to avert post-occupancy difficulties.

12

13

Typical components for transportation wayfinding programs

Many sign types are common to all transportation systems, while others may vary according to mode. The following types should be considered for a complete wayfinding package.

Logo or trailblazers Inexpensive trailblazer signs to put on major highways and access routes are important to help passengers find the facility, whether an airport or rail station.

Facility identification Monument signs are an effective way to identify facilities and often offer more flexibility in placement and entrance identification than identification mounted directly on the building. For urban transit and subway systems, this can be as simple as consistent entrance identification.

Parking location signs These signs identify locations to park, drop off departing passengers, and pick up arriving passengers.

Arrival and departure information signs Arrival and departure information includes a combination of static, schedule-based print material and real-time, electronic, variable message systems, whether CRT (cathode-ray tube), LED (light-emitting diode), LCD (liquid crystal display), plasma, or other technology. They may be used in ticketing areas, main concourses, at boarding gates, and on platforms, and will vary in size and detail of information, based upon the sequence in the journey.

Ticketing counter corporate backwall graphics The ticketing counter provides an opportunity (possibly the only one) for the service operator to incorporate their own brand and identity standards, especially in multiple-use facilities.

Ticketing counter availability Overhead or counter-mounted signs can indicate whether the position is open, closed, the next available agent, or a special service (i.e. first class, frequent user).

Freestanding stanchions Often used in ticketing and security queues, freestanding stanchions can direct passengers to the correct line, as well as provide information about the materials they will need for the process.

Directional signage Sign bands, overhead, wall-mounted, and floor-mounted signage should be used to provide directional information suitable to the travel sequence. Priorities of information need to be established to ensure that the correct information is offered at the correct time for the passenger's needs. The directional signage is most often a combination of text and pictograms. These signs often include service identification as well, such as telephones or rest rooms.

Retail signage Although often under the purview of another department, standards for retail operators (sign bands, flag mounts, and storefronts) should be developed to ensure compatibility with the other facility signs.

14

15
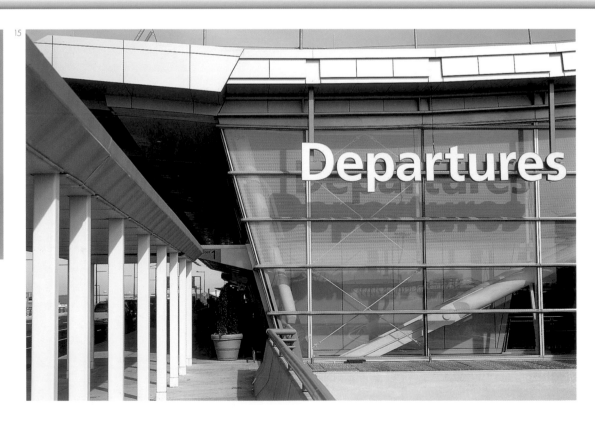

Fig 16 Los Angeles Metropolitan
Transportation Authority (MTA) station
identification sign, Hunt Design

Fig 17 Washington D.C. Metro map,
Lance Wyman Ltd. Metro system maps
must provide complex information in dark
and crowded places.

Advertising Third-party advertising contracts are often part of transportation facilities. Space needs to be provided for standard vertical and horizontal format adverts, which may be in both print and electronic formats. The effect of large, spectacular-style banners and immersion campaigns need to be considered, too. When space is designed to accommodate these functions (whether through frames, hanging picture rails, or other solutions), they can be better managed and controlled. Speak with the advertising provider to understand standard sizes used in the industry.

Maps Different modes will require different types of maps. Terminals, such as airports and large rail facilities, typically require a plan directory to highlight major functions, including ticketing, information, retail, rest rooms, waiting, and boarding. Route facilities, such as commuter rail stations and subways, should provide system maps to identify route stops and connection locations. System maps are often located with printed schedule information.

City/stop identifiers Rail systems, in particular, require identifiers for the station location visible to both the waiting passengers and the passengers arriving on the train. Directional arrows should be included to orient the passenger to major city locations or neighborhood destinations (to hospital, to university).

Temporary signage frames Frames for temporary signage should be included to announce policy changes, scheduled maintenance impacting service, and regularly placed marketing materials.

Permanent room signage Permanent room signage to meet all codes is required.

Regulatory signs Transportation facilities have corporate regulations and federal regulations that they need to convey, which require such signs as "secure area," "employees only," "danger," "caution," "no smoking," etc.

Signage design solutions

In general, three approaches can be used in transportation facility design projects.

Design-build approach A design-build scenario, in which one works directly with a fabricator, is often the riskiest approach, but it can be cost-effective and provide a timely way to complete small-scale projects. Design-build should be used only where the needs are clearly identified beforehand and the amount of information to be reviewed on a shop drawing is limited. A fabricator does not always keep in mind the interest of the client or the architect, so plan to spend extra time and attention reviewing drawings and proposals.

16

17

Fig 18 Denver Regional Transit System station, Carter Burgess Architects

Fig 19 San Mateo Transit Center, Gensler Studio 585 With the rise of aboveground light-rail systems and electronic ticketing, the architectural elements of railway stations have become fully integrated with wayfinding elements. The design team today requires a far greater collaboration between architects, environmental graphic designers, and fabricators.

Figs 20 and 21 Sign system, Lester B. Pearson International Airport, Toronto, Pentagram Design, Inc. Architecture integrated with graphics creates a complete system.

Architecturally prepared plans An architecturally generated plan, which can be accomplished in coordination with a service-provider's standards, can be an effective way of communicating message schedules and sign types, without the development of more detailed color layouts that portray the correct fonts and graphics. For smaller projects, it becomes easy for the client and bidders to review information and scope.

Environmental graphic designer systems Any project can benefit from the services of an environmental graphic designer or other specialist, but in smaller projects budget constraints may make this unrealistic. By understanding the issues and nuances associated with wayfinding and graphics, architects can strengthen their own practice through in-house expertise or by understanding the elements of a positive collaborative process that can take place between the client and the entire design team.

As an architect, I cannot stress enough the importance of identifying when additional layers of expertise are required for transportation projects. While well-prepared architects familiar with wayfinding principles may be able to handle small projects, an environmental graphics consultant is a must for any large-scale or high-profile project. A poorly designed transportation facility cannot be salvaged by graphics, nor can the best building survive the lack of adequate wayfinding. The best solutions embrace a balance, serving both the client and the users, elevating the awareness that good design can improve image, service, and, ultimately, the bottom line.

18

19

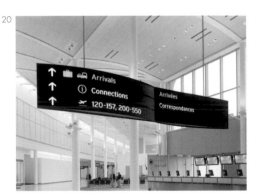

20

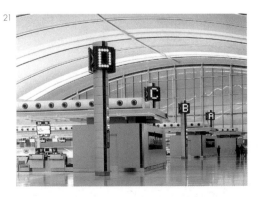

21

The Ottawa MacDonald-Cartier International Airport Gottschalk+Ash International

Air travel is considered one of the most stressful activities a person can undertake. Long waiting times and canceled or delayed flights are only too common. In the modern airport today, wayfinding success is determined first by proper planning, creating a progression and hierarchy of easy-to-navigate spaces, supported by a legible and clear sign and information system.

As the gateway to Canada's national capital, Ottawa airport's architectural design reflects the unique urban surrounding and thematically draws from a number of key iconic, image, cultural, and historic factors. Designed by Terry Heard Designers, the architectural result is the creation of humane spaces that reduce passenger stress by making it easier for visitors to find the way to their destination.

The architects began with the idea of the building being a large airplane hangar with exposed structural steel reminiscent of airport facilities from the early days of air travel. The airport services, including check-in, baggage handling, and terminals, are all separate design elements sitting in this large space. The placement and design of these elements create a rhythm that allows the airport user to see their progression through the airport, not through an alignment of spaces and forms, but through the configuration of objects in one central space. The building also has extensive window spaces, keeping the user in constant reference to where they are in the airport by the view outside. In certain spots, the airport is punctuated by tall atrium spaces marking central congregation spots.

The environmental graphic planning approach

Starting with such a clearly designed airport, Gottschalk+Ash established a wayfinding master plan strategy for both the interior and exterior of the airport that presented a clear vision and theme for the system. Working closely with the architects, this ensured its integration with the architectural design while establishing its own identity as an information system to enhance passenger wayfinding. The central master plan strategy informed and directed the design process for all subsequent development and product implementation for signage at the Ottawa Airport.

Research for Ottawa included a thorough analysis of inbound and outbound traffic flow including: departures and arrivals, parking, curbside zones, ticketing, baggage, service and retail locations, preclearance, customs, gates, ground transportation, and car rentals—in short, the critical elements of a comprehensive airport wayfinding program.

The planning process began with flow or route diagrams marking passenger paths that were prepared to determine decision points and destination while considering sight lines, viewing distances, and, with road signs, traffic speed and reaction time. Plans were developed, plotting the locations and schematic content for each sign. These plans were for the operational and design team to review the location,

22

23

Fig 22 The programming and architecture of the Ottawa airport has strived to present a clear, functional pedestrian image. The openness and transparency of the airport building was critical in providing immediate spatial understanding. It was universally recognized by management that orientation and wayfinding significantly affects passenger handling and contributes to creating a positive public image.

Fig 23 One of the more visually intriguing graphic applications is used for building identification at both landside and airside. The name "Ottawa" is mounted with large vinyl letters on glass panels. The letterforms are softened by using a dot pattern that slowly decreases in size the further the dots are removed from the letters. Through this sign, passengers and other airport visitors are introduced to the overall wayfinding theme of dots of light.

Fig 24 Flow diagram, marking the main passenger paths.

Fig 25 In the passenger hold rooms at the departure gates, large, wall-mounted, cut-out aluminum numbers identify each gate. Horizontally mounted rails underline these numbers and carry rows of LEDs to light the numbers with a "halo" from below.

25

content, and nomenclature, and established the order of magnitude for budgeting with project managers. One of the main ideas that came out of the research and design investigations was the use of patterns of light for wayfinding. Light was explored as a central theme and illustrated in the master plan, from the nature of light and its phenomena to its practical use in navigation, and the welcoming sight of runway beacons at the end of a journey. This idea is manifest within the airport, where points of light (LEDs embedded in posts and rails) are used to mark a path, such as that from the check-in counter to the departure gate, together with washes of light to define gate destinations. In the evening, the lighting is intended to have a calming effect, echoing the interior cabin lighting of an airplane that comes up as night descends. The theme of light also fits extremely well with the design of the airport. Using light as a wayfinding device would keep the open, airy, and flexible feel of the airport while still allowing the user to pinpoint the wayfinding elements in such large spaces.

The environmental graphic design approach

Based on the light theme and the extensive master plan, a series of design elements were created in collaboration with architects Terry Heard and Yow Consultants. The main wayfinding object was a unique sign post and panel system and lighting used throughout the terminal complex, including curbside information and regulatory signs, modified to support ceiling-mounted signs where required. The key element of the

24

post and panel system is its flexibility, with the ability to contain its own power source, lighting elements, electronic information screens, and other attachments. The sign system was also adapted to create specialty lighting fixtures, and integrate airport advertising displays and telephone tables. By allowing one basic object to fulfill all the wayfinding and identity roles in the facility, advertising and other sign elements were kept off the building wall and ceilings, keeping the dynamic form of the airport pristine and uncluttered. These objects also have the ability to be moved in the airport floor space, allowing the entire airport facility to be quickly reconfigured as needs change.

The type and symbol vocabulary also supported the flexibility of the post objects. Ottawa, like most international airports, is a multilingual facility, and supports the needs of the international traveler through standard pictograms and simple flag forms. Flags distinguish the principal destinations of travelers: domestic, international, and U.S. Gottschalk+Ash introduced large arrow icons in red or, for U.S. destinations, in red, white, and blue. These arrows indicate transborder, domestic, and international passenger routes and are installed along pathways to the specific destinations. The check-in staff at the counter only need to tell passengers, "Please follow the red arrow."

With so much information being placed on a single sign, the sign panels are based on a modular grid that differentiates primary from secondary information to keep information structured and uncluttered. The directional arrows are always placed inside a separate vertical color band while text information in English and French is placed on its own band separated from the universal symbols. This approach allows the bands of information to be configured in different ways based on the informational needs of the sign, while still allowing for one consistent sign module.

Like railway stations before them, airports are a visible expression of today's fast-paced and interconnected global society. The Ottawa airport offers an understated appearance, proportional in scale, filled with natural light, and elegant in the choice of materials and layout. It is a welcoming sight for the world traveler, supported by a wayfinding system that enhances the architectural integrity of the space while supporting traveler needs.

26

Fig 26 The sign support system—comprising post, arms, panels, and hardware—was engineered and tested to see that it was suitable for a variety of conditions. It carries power and lighting, and support for a variety of airport information devices, including Flight Information Display System (FIDS), plasma, and LED displays. The modularity of the system allows for ease of maintenance and response to the ongoing requirements of the airport. The small, 4 x 6in (10 x 15.25cm) footprint of the signpost helps the wayfinding system emphasize the open structure of the building. The ability to carry a variety of information reduces visual clutter and keeps signs off the actual building structure.

27

28

Fig 27 The bilingual signs distinguish English and French messages through the use of plain and italic type. Type sizes and sign panels are both based on a modular grid that differentiates primary from secondary information. The typography of the Ottawa airport signs establishes a distinct, contemporary identity. The chosen typeface for the wayfinding system is Thesis—The Mix, which was designed by Luc DeGroot between 1988 and 1994. It is a modern typeface with substantial range, clarity, and character.

Fig 28 Brevity and clarity are the guiding principles for airport communication. Whenever possible, standard international pictograms and symbols are used. Flags distinguish the principal destinations of travelers: domestic, international, and transborder.

Transport system design recommendations

Wayfinding and environmental graphics in transportation, like the architecture it supports, involves the ABCs of design: acknowledgment, brand, and customer service.

→ First, the importance of environmental graphics must be acknowledged. If the designer treats signage as an afterthought, the users will undoubtedly create their own system to address the wayfinding system's inevitable shortfalls. The result is often low-quality, inconsistent, and ineffective signage posted in too many, too few, or undesirable locations.

→ Brand is an important component for clients, owners, and operators. The wayfinding project team and clients need to understand and agree on the message that the system is sending about the corporate culture and vision. Even details such as the font used on signs can have an impact on the message that is sent.

→ Environmental graphics are an integral aspect of customer service. In transportation facilities, there are many transitions between a customer's points of contact. A successful graphics program continually reassures users that they are in the right place, headed to their desired destination. Ultimately, effective wayfinding contributes to a more successful building design for the end user.

08 Health-care facilities
Alan Jacobson

The word "hospitality" is defined as "the reception and caring of guests with kindness." Why then does a trip to a hospital so often feel like a crash course in survival?

Hospitals and medical centers are usually a maze of bricks and mortar that have been forced to expand over the years like a small city. Limited funds are stretched to treat a growing population with an ever-increasing menu of health concerns. Unlike a day at the shopping mall, the museum, or a hotel, a trip to the hospital can be filled with anxiety.

We don't think much about this until we enter the system. We experience health care when our body needs service. Some things we choose to tune up cosmetically. Sometimes we just check up. Happy times such as having babies tend to be the exception. Most of the time we have no choice at all; we are tossed into the world of health care when something is awry.

The health-care delivery system places focus on the quality of medical care and the direct pay-for-service experience such as testing, diagnosis, and treatment, but this represents only a brief portion of the actual visit.

Let's consider a typical outpatient visit to the hospital for an x-ray, doctor's appointment, or some preadmission testing. The actual time with the doctor or technician may require 15–30 minutes. While the

Figs 1 and 2 Grady Hospital, Atlanta, Georgia, in the late 1890s and today. The simple, rational designs of early neoclassical hospitals have been transformed through constant additions and renovations into complex, and difficult to navigate environments.

service rendered may take only a short time, the patient may be on the hospital campus for several hours. People often become lost and disoriented on their journey for health care.

A short history

In the past, disorientation in a hospital or clinic was not a problem. Hospital facilities consisted of one of two types: convalescent hospitals and university facilities. Short-term health needs were met by traveling doctors, while the larger facilities took on the form of residential or university buildings.

After WWII, the rise of the multidisciplinary teaching hospital changed these facilities dramatically. A hospital went from a very specialized building to one that needed to encapsulate an ever-expanding array of services, including inpatient and outpatient facilities, doctors' offices, research areas, specialties, and support functions. Most hospitals did not build new facilities to meet these needs, but merely expanded existing buildings, creating a cacophony of different architectural styles and layouts.

Another trend, starting in the 1960s and continuing today, was that hospitals began to consolidate into large "networks" of clinics, hospitals, doctors' offices, and research facilities. The devolution in a number of different facilities pushed these new networks to treat wayfinding and identity as part of their overall branding process, and every facility, no matter its size, began to be treated as part of an enormous interconnected organism. This direction put more responsibility on the designer, as did the need for multilingual facilities for increasingly multicultural communities.

The business of health care

Health care, like any other business, has two bottom lines. One is the customer satisfaction level from services offered. The second is the bottom line from revenues. Both bottom lines must be positive for any organization to grow, prosper, and create value.

The business of providing health care has swung like a pendulum over the last decade searching for ways to lower costs and improve the quality of services. The proliferation of health-care systems and networks regionalized and corporatized the business of health care. Most local hospitals and medical practices were bought, or consolidated, to realize economies of scale and increase marketing and branding power.

Much has come full circle with the realization that hospitals are part of the fabric of the local community. The national or regional corporate system can provide valuable services to the hospital such as financing, strategic and facility planning, and marketing and branding support,

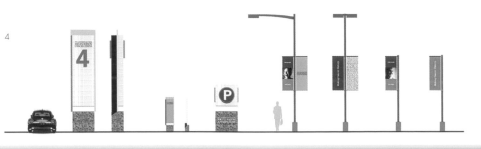

Fig 3 Exeter Hospital sign, Gamble Design
Hospitals are now becoming a business and incorporating multiple services into their overall design.

but the power of decision-making is still with the people who use the system and the doctors who refer them to the hospitals.

Health care is a fiercely competitive business and hospitals must earn their stripes with both patients and the doctors. The hospital facility and environment can provide a positive or negative experience for patients and doctors. Distinguishing a difference in this experience can therefore provide a competitive edge.

The medical center as a place

Medical centers grow from a single building into a complex maze of buildings over many years, responding to local population growth, advances in technology, and the need to refurbish the environment. Seldom are new medical centers built from scratch. More often, a new building is added, often changing the circulation and entrances to the campus and buildings.

The complexity of the medical center is unique. It is not an intuitive environment to navigate and those who are visiting the facility often carry some anxiety with them.

Many people scheduled for an outpatient visit will spend the better part of a day at the hospital. They may combine a doctor's visit with a procedure or test. It is important to understand that users may have multiple destinations to find in a single trip.

Investing in wayfinding

Why should a medical center or hospital invest in a wayfinding program? Wayfinding programs affect the patient and visitor experience, improve hospital staff productivity, and can improve patient referrals from doctors. While wayfinding is an environmental design discipline, it must provide a strategic benefit to the business of running a hospital in order to be perceived as having value.

Sign programs seem to be the obvious solution to helping people find their way in such complex facilities, but as we dig further into the realities of a typical patient visit, we find that signs are just one of the tools, along with verbal directions and graphic information, to solving wayfinding issues. Any design process needs to work hard in integrating these systems to develop a complete picture.

The process of health-care wayfinding

Developing a health-care wayfinding program often looks more like a planning and research project than a design project. Success is exemplified as much by backing up design decisions as the designs themselves. These steps work together to make a health-care wayfinding system successful.

Defining objectives and goals The design process should begin with a set of objectives, achieved through extensive interviews with a diverse

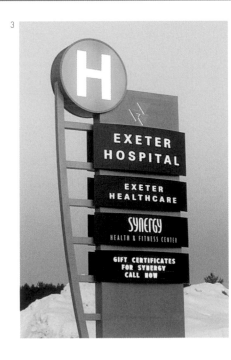

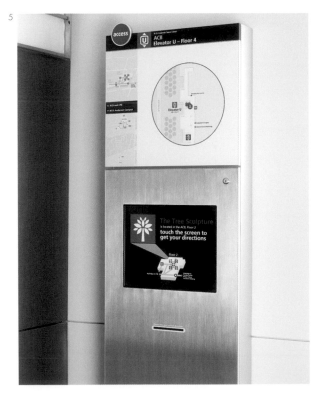

Fig 4 The University of Texas MD Anderson Cancer Center sign vocabulary, fd2s, inc. Sign vocabulary has grown to be the identity lynchpin of the modern medical center.

Fig 5 The University of Texas MD Anderson Access System, fd2s, inc. Electronic and print information is an important complement to sign systems.

Figs 6 and 7 New York City Health and Hospitals Corporation sign testing, Hillier Environmental Graphic Design

group from the facilities staff, including the nursing and support staff. All workers with a vested interest in the wayfinding process should be included to help support the objectives process.

User research User research involves the diverse group of visitors using the facility. User research generally takes on three forms: establishing basic wayfinding metrics; ensuring greater satisfaction for patients and visitors; and improving productivity for hospital staff.

→ Wayfinding metrics is the direction-finding research used to establish basic issues like sign lettering size, legibility, and planning. Wayfinding metrics can be researched on a project basis, but usually exist in academic documentation and research released by associations.

→ Satisfaction is measured in terms of the quality for good direction-giving to ensure that people trust the directions and remember them. The result is a feeling of calm and confidence for patients as they travel the corridors. Satisfaction research can be conducted through surveys of patients and a cross section of facility visitors.

→ Productivity is measured in terms of quality of direction-giving. While the direction-giving process is an opportunity for staff to connect with the community and provide a warm personal touch, it is possible to reduce the number of directions given and the amount of time spent on each encounter. Productivity research is usually done through staff interviews.

All research should also begin with a benchmark questionnaire, which establishes the effectiveness of the existing wayfinding system. This gives the design team a basis for judging improvements to the wayfinding system.

The master plan User research works in tandem with an observational site audit with the goal of creating a master plan. Master planning is the framework that architecture, interior design, sign planning, and graphic design are built from. This area is where the link between architects and environmental graphic designers works to ensure that all design decisions made are followed consistently throughout the entire planning and design process. Often, environmental graphic designers are brought in by the architect early in the new construction phase to help develop the master plan. In wayfinding programs in existing buildings or building additions, the situation is often the reverse with architects and planners supporting a new sign program being layered onto an existing facility. The best master plans are continuous, with the health-care facilities department updating it so often that it is integrated into the culture of the facilities staff.

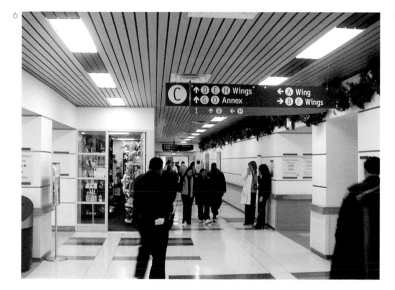

Fig 8 Lankenau Hospital, AGS Developing a simple hierarchy of destinations is crucial to creating a legible health-care system.

Fig 9 Kaiser Permanente sign numbering system, Kate Keating Associates, Inc.

Fig 10 Massachusetts General Hospital, Two Twelve Associates

Wayfinding analysis

With most health-care facilities being so reliant on verbal directions and signs, wayfinding analysis is often centered on sign and graphic issues over architectural decisions.

Directions hierarchy Creating a simplified decision hierarchy is the first crucial step. The decision hierarchy begins with the development of a complete set of directions to get to a destination, then progresses to a process of simplification built around decision points in the facility. Since health-care facilities are among the most complex building types, the simplification process is closely tied to the development of design elements.

Destination terminology Part of simplifying the directions process is developing a terminology based on the directional hierarchy. Destination terminology in health-care design often utilizes numbering, lettering, and symbol hierarchies to a great extent, along with destination names. The integration of the various identification methodologies is crucial to a workable system.

Universal design approaches Health-care facilities are used by a large number of people with handicaps, both visual and physical, and by people with a low proficiency in the national language. The wayfinding analysis must consider specializing wayfinding approaches for the disabled on a much higher level than most facilities, including much larger graphics and signs that can be seen by people at many levels, from waist height to overhead. For people with low language proficiency, number, letter, and symbol systems are often part of a plan that includes instructions in multiple languages.

Implementation plan Wayfinding systems are often designed to be installed in phases, so that some of the recommendations can be implemented quickly. The implementation plan identifies the most crucial wayfinding elements that need to be addressed quickly and how that can be integrated into the overall plan.

From the wayfinding analysis, a preliminary plan is developed, centered around a series of design decisions based on the master plan, research, and analysis. Budget and schedule information is also added into the underlying analysis.

Design development

Design development in health care is often based on the type of development occurring, and revolves around the ground rules established in the schematic development process. Marie Frith of Marie Frith Associates defines these design development approaches as: completely new system, system augmentation, and system support.

Completely new system When a health-care wayfinding program is being established from the ground up, the color, type, and numbering

Fig 11 Children's Hospital of Boston, Two Twelve Associates

system can be based on a set of design rules established from the research as well as input from the architect and other designers.

System augmentation When a new wayfinding program is added to a preexisting sign system, design development revolves around integrating new signs into the overall system while maintaining some unique features to the new system.

System support This involves improving on an existing wayfinding system through the addition of new elements while adding to and expanding on the existing system.

Testing

Testing design comes in two forms: testing prototypes at each stage of design development, and postinstallation evaluation. The prototype stage consists of making mock-ups of signs for installation in the facility. This is not to change the fundamental design approach, but to tweak details like lettering height, sign height, sign position, and sign density.

The final stage in the posttesting process is to perform user interviews to determine what works and what needs refinement in the final wayfinding system. This final, last-minute check validates the work done up to that point, and provides a guide for future work in the facility. This postinstallation analysis should be carried out yearly at some level after the system is complete. This will ensure that maintenance and any necessary development is carried out successfully and sympathetically.

Donor recognition

Often, major donors to the organization will be recognized through naming opportunities of buildings, public spaces, and various rooms. It is important to consider how this recognition will be incorporated into the wayfinding program and used as identifiers or landmarks.

11

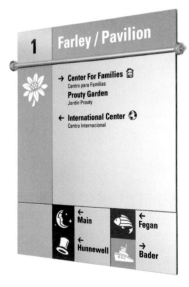

12

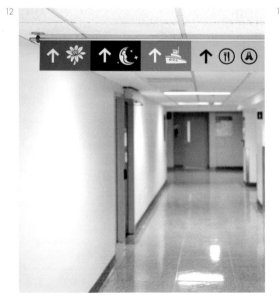

13

Fig 14 Christiana Health, Mitchell Associates In existing buildings, the wayfinding program often needs to be layered on top of the existing facility services.

Fig 15 Baylor School of Medicine donor wall, Wallach Glass Studio

Fig 16 The University of Texas, MD Andersen Cancer Center master plan, fd2s, inc. Successful guidelines take all the planning recommendations and design elements and translate them into a living set of instructions that guides future implementation of the project.

Development of design guidelines

Large health-care systems with multiple facilities often require design guidelines to support their strategy of standardization. While the wayfinding strategies may vary from facility to facility due to the differences in site conditions, architecture, and demographics, it is possible to standardize the components of the sign system and related wayfinding tools.

In this case, a cross section of the facilities must be surveyed to determine the common denominators and the unique attributes in order to design a kit of parts that can be used when designing a program at any of the hospitals within the health system.

A design guidelines document is more complex than a sign system document, in that it establishes planning, design, and utilization processes to be followed each time a program is to be implemented. The design guidelines manual provides a tool to communicate the branding goals and wayfinding initiatives to multiple facilities across the organization.

16

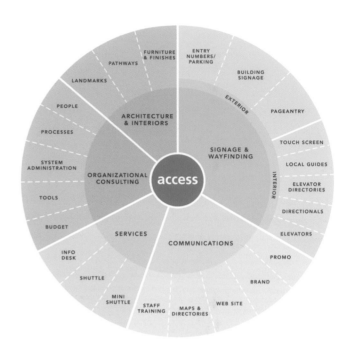

14

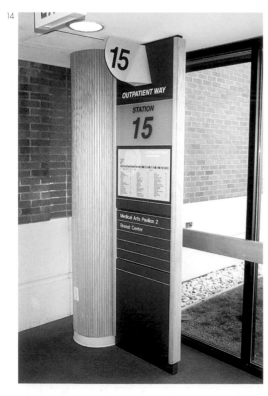

15

Lankenau Hospital, Philadelphia AGS

Lankenau Hospital, located in the leafy suburbs of Philadelphia, was developed during the postwar period as a health-care campus containing inpatient facilities, outpatient services, doctors' offices, and a range of support functions from cafeterias to parking decks. Over the years, the facility evolved chaotically to the point that users could not differentiate the specific areas of the facility that they needed to visit.

AGS's key goal was to develop a wayfinding system that would support the diverse group of visitors using the facility. To meet this goal, AGS developed a design approach based on research intended to satisfy two goals: greater satisfaction for patients and visitors; and increased productivity for hospital staff.

AGS used interviews among facility staff and patients, site audits, and visual observation to perform constant research and testing at each design stage.

Stage one: direction-giving

AGS started by interviewing 30 staff members and 50 visitors and outpatients on how often they were asked for directions and what directions were the most commonly given. Each staff member stated that they gave about four directions in the hallways each day. Based on 300 weekdays, it is estimated that 100 staff members give about 100,000 directions each year. There are about 2,000 people on staff at Lankenau Hospital. This figure does not include the many volunteers who also give directions.

Visitors were also interviewed and said that they asked about two directions on average each visit. There are approximately 2,000–3,000 outpatients who visit Lankenau Hospital each day, and over the course of the year 1,200,000 directions were given. All in all, that is a lot of direction-giving.

Interviews also identified that 75 percent of the people who visit the hospital were sure where they were going only 50 percent of the time. Only 15 percent of the time were people totally sure where they were going. People often were not sure how to find their destination or how to get back to their cars.

Design solution The interviews resulted in a master plan that split the hospital into zones based on function. The two primary zones were given the names "A" and "B." Zone A is primarily inpatient and Zone B is primarily outpatient, although some overlap exists. Each zone had its own specific parking facility, entrance, lobby, and destination. By creating this fundamental division of use, the facility was able to divide the widely differing wayfinding approaches between the two primary groups who use the facility.

17

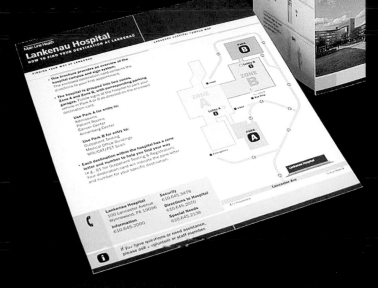

18

Fig 17 Destination maps use the same graphics and hierarchy as the directional signs in the hospital.

Fig 18 As part of the overall wayfinding system the hospital was split into two zones, A and B, based on function.

Fig 19 Donor recognition walls can be integrated into the identification system.

Stage two: Articulating the wayfinding sequence

It was discovered in the testing process that someone visiting the hospital for an outpatient service could experience up to 25 steps involving different types of design vocabulary. These steps included:

→ Set appointment with doctor or department
→ Prearrival package or letter received by patient
→ Travel to hospital campus
→ Arrival at campus
→ Follow signs to appropriate parking (if traveling by car)
→ Enter parking area or lot
→ Find parking space
→ Find elevator lobby
→ Travel to main lobby
→ Receive welcome and information
→ Follow information to hospital lobby
→ Present destination card to information desk
→ Get directions or refer to information kiosk

→ Follow signs to destination or to elevator and access other floor
→ Walk to first destination, identified by name or by number
→ Receive service or treatment
→ If second destination is required, receive directions from receptionist
→ Receive services or treatment
→ Get directions back to lobby/zone of original entry
→ Locate exit to parking facility
→ Walk to parking
→ Travel stairs or elevator to appropriate floor
→ Find car
→ Follow signs to parking exit
→ Follow signs to exit campus

Fig 20 Destination signs list both the alpha-numeric designation and the department name.

Fig 21 Directories installed at each elevator list the destinations that can be reached from them.

Interviews and observations concluded that the majority of people arrive by car, and that is the crucial key to beginning the wayfinding sequence. The hospital facility is spread out over a large distance, so it is very important for people to park in the garage closest to their destination. Many people did not know where their destination was in the facility or where to park, often creating a long walk for them once inside.

It is also interesting to note that the garage is often the first point of entry to the building and should therefore be treated as a main entrance.

Design solution The design solution was to focus on parking as the crucial beginning of the wayfinding sequence. Each parking garage was identified as Park A or Park B. Park A leads to Entrance, Lobby, and Zone A. Park B leads to Entrance, Lobby, and Zone B.

Exterior signs upon entry of the campus communicate which parking lot to use for primary destinations. Signs will help visitors park in the garage that leads them to the zone of the hospital in which their destination is located.

Patients are directed to go to specific parking lots when making an appointment. The focus on parking also extended to a recommendation for different valet parking areas for each zone. By breaking up the valet parking, visitors were further connected with the area of the facility they were in, even if disconnected from parking their car.

Stage three: Developing a destination terminology
Interviews identified that many outpatients stated the wrong name for their desired destination when asking for directions.

Some people were asking to be directed to Registration and were being directed to Outpatient Registration, but in many cases these people were scheduled to be registered at the Admissions department, which is located at the far end of the hospital from Outpatient Registration.

Another example of a problem with terminology is that there are three destinations in the hospital with "Cardiology" in the name. Many patients, when asking for cardiology, were not being directed to the place of their appointment.

Elevators also emerged as a key terminology problem. There were some incorrect assumptions that people had about the building, one of which was that all elevators led to all destinations on upper floors in the hospital. In fact, many elevators do not lead to all destinations. Directing people to the correct elevators became the next crucial step in the naming terminology process.

Design solution AGS designed a system whereby each primary destination at the hospital has an alpha-numeric designation along with the name of the department. People can ask for the department by name and/or number, for example A1 Admissions, or B1 Outpatient

20

21

Fig 22 Destination cards, giving specific directions for primary locations in the hospital, are mailed out to patients when they make an appointment.

Registration. It was also decided to use the elevators as a wayfinding device. Each of the elevator banks were named so people could be directed to them. Signs directed to the elevator banks to support the directions they were given. A directory was installed at each elevator with a list of destinations that could be reached from it.

Stage four: Using signs as tools for direction-giving

After extensive interviews and research, it was discovered that verbal directions were the primary way people found their way around the facility. Signs were being used as a support tool to help people find their way, but verbal directions were used first. People wanted to ask other people for help.

Design solution: verbal and print directions A process to give directions at Lankenau Hospital was designed around the three or four steps in each set of directions to a destination after a person has parked their car. The sign program becomes a tool to help with direction-giving, following this hierarchy closely. The design process began by developing the full wayfinding path for a user, including sign support.

Here is an example of a typical set of verbal directions:

To Mammography:
Upon arrival
1. Park in Lot B
Once in hospital
1. Follow signs to Lobby B
Follow signs to central elevators
Take central elevators to Floor Two
Follow signs to B15 Mammography

This outline was reduced to a set of simple verbal directions.

Directions to park
Follow signs to lobby
Follow signs to elevator and floor (optional)
Follow signs to destination

If the destination is on the same floor there will be as few as two steps in the process. In cases where someone parks in the wrong parking lot, they can be given directions to follow signs to the correct zone, then follow the original directions once they get to the correct zone.

Specific directions were written for all primary destinations in the hospital. These directions were printed on a destination card for each department and mailed to all outpatients once they had set an appointment.

22

Fig 23 All signage and printed material
follows the same hierarchy, and the same
system of zoning and identifying
destinations by name and number.

The destination card is mailed with a brochure that communicates the location of the parking lots and presents an overview of the sign system that they will see when they arrive. The destination number is printed bold.

Design solution: sign support The sign system was designed to support the instructions by creating a hierarchy of zones, elevators, and destinations by name and number. The signs themselves also express this hierarchy by breaking into a hierarchy of two different sign types: overhead signs and wall-mounted signs. Overhead signs contain overarching facility information, including facility zones and key destinations linked to that zone. Wall signs contain more specific information on the destinations.

A destination map containing all this information was made available to staff and visitors. It illustrates where all destinations are in the facility, in the same hierarchy as the graphic directions and directional signs.

Stage five: Training and communication among staff

Interviews with staff and volunteers of the hospital indicated the need for an extensive education program to understand the wayfinding system. Since they are part of the wayfinding program as direction-givers, they must be taught how the system works, how the facility is zoned, and how to give directions.

Design solution A series of training sessions were provided at each stage of the design process. The repetition of these presentations was important to the learning process and the feedback received was critical to the next step in the design process.

At the completion of the installation, a training CD was distributed to all employees and volunteers at the hospital to help them understand the new program and orient new employees. This CD will be updated as the wayfinding program is modified in the future.

The education program developed for the hospital was the final and crucial part of the documentation process to be encapsulated in the design guidelines. These guidelines will codify all the research and design solutions so that facilities managers will be able to continue the program long after the designers have left. These guidelines will also be revisited every year, thereby creating a living wayfinding program—one that can be continually improved as the facility is changed and expanded.

The language of health-care facility design

The wayfinding design vocabulary of health-care facilities fits the wide variety of complex patient needs. The successful facility balances a redundant complex of print, sign, and verbal information.

→ **Campus and building identity** Large-scale identification of a facility

→ **Exterior wayfinding sign** Outside directional signs in a campus setting

→ **Parking arrival signs** Signs that identify parking

→ **Help/information desk** A place where a visitor can receive personal and print assistance

→ **Orientation directory/map kiosk** A large directory placed in a prime location in the facility

→ **Print map and wayfinding brochure** A print map that augments the sign system

→ **Overhead and wall directional signs** Interior directional signs in a facility

→ **Elevator directories** Large directories at elevators that establish the location of all destinations on a floor

→ **Department identification** Identification of a specific discipline inside the building

→ **Room/office and personnel signs** Specific room identification signs

→ **Stairwell information signs** Identification of stairs and other circulation paths

→ **Regulatory signs/evacuation plans** Required maps and signs at each floor

→ **Accessibility route information** Maps at each floor defining a specific path for users with disabilities

→ **Donor recognition signs** Signs that contain donor information and are often closely integrated into the wayfinding system

→ **General information signs** Wallboards and other bulletin boards for temporary information

Health-care facility design recommendations

→ Know the facility and how it works; ask the people who work there.

→ Destination hierarchy is important: 80 percent of the people go to 20 percent of the places.

→ People ask for directions first. Design a program that helps people give directions.

→ Break the facility down into units and zones that serve to simplify wayfinding information.

→ Test everything in terms of improved productivity and user satisfaction.

→ Provide a number of levels of wayfinding information in the health-care facility based on the key ways the user approaches the facility.

→ Integrate donor recognition into the wayfinding and identity system for the hospital.

→ Provide orientation and training, and documentation to the staff to explain the concept behind the wayfinding system and its components.

→ Create tools to help staff order signs and other components.

→ Create a process to evaluate the program each year for continual improvement.

09 Corporate environments
Douglas Morris

The ever-changing corporate environment is a unique challenge for any environmental graphic designer. No two corporations, nor their goals and needs, are alike. While design history does not give us specific examples of wayfinding within this context, early attempts to define sign design within a corporate environment initially relied on graphic identity standards that extended to sign applications for identification and wayfinding information within a corporate headquarters facility.

Corporate identity in the 1960s

One primary example of this early thinking is evident in the corporate identity program developed for Westinghouse by Paul Rand and Eliot Noyes in the early 1960s. D. C. Burnham, President of Westinghouse, introduced the program's *Style Guide* thus. "As you know, Eliot Noyes is Consultant Director of Design at Westinghouse. Eliot brought in Paul Rand to work with us in the area of graphics. They have done some wonderful things for us. A typical example, and one of the first, was the redesign of the 'circle w.' ... Eliot has had a real influence on our logotype, our advertising, our graphics, our architecture, our packaging ... he is leading Westinghouse toward good design across the board."

Eliot Noyes stated "The purpose of the corporate design program we've been working on for several years now is to make the use of design effective wherever it turns up in the corporation. I am going to talk about practical aspects and applications of industrial design in

1

Fig 3 Phillip Morris identification totem,
Chermayeff & Geismar

situations which turn up from day to day in many parts of this company. I'm going to show you examples of graphics and architecture and product design. I think I can show you improvements that have occurred in these examples through the application of design."

This manual further illustrated building-mounted and freestanding letters, logotypes, and signs. In particular, it discussed the effective selection of a sign type that is appropriate to a style of architecture.

Corporate identity in the 1970s

Another primary benchmark is found in the work of Chermayeff & Geismar. With their work for Philip Morris, sign design became a primary extension of the company's corporate identity program. They broke the conventional boundaries of the past with their unconventional use of a word-mark in the built environment, and the creation of corporate landmarks. For their work at the Philip Morris Operations Center in Richmond, Virginia, Chermayeff & Geismar used geometric shapes as part of an "art program" that included large-scale exterior sculptures and large-scale interior aluminum screens. These screens, suspended along a central atrium, were used to identify main entrances as well as each of four circulation stairways. An individual color palette for each interior landmark also established a color-coded wayfinding element for building zones; the same color was also reinforced with the color scheme of the interior office furniture.

In their publication *Designing*, Ivan Chermayeff states "Fundamentally, graphic design is about presenting the printed word. So, in a sense, tinkering with typography is just returning to our [graphic design] roots—and giving those roots a playful twist." The same can be said of environmental graphic design in a corporate environment.

A similar approach to using corporate identity standards for sign applications is also evident in the early work of Hellmuth, Obata & Kassabaum. Another significant wayfinding project from the 1970s is the environmental graphic design program for Levi's Plaza in San Francisco, California, for Levi Strauss & Company. This understated sign program is a primary example of how graphic identity standards were extended to sign applications for identification and wayfinding information within a corporate headquarters facility.

The strongest brand recognition for Levi's was the brass fastener on their denim clothing line. Graphic designers Charles P. Reay and Greg Youngstrom capitalized on this immediate recognition of the button from the Levi Strauss & Company's corporate identity. The repeated use of a large-scale brass jeans button that was mechanically fastened to building identification and wayfinding signs gave this program an immediate connection with Levi's clients. The brass buttons were elegantly and simply juxtaposed against mirror-polished backgrounds that literally and figuratively reflected their corporate culture.

2

3

Graphic design for corporate culture

In a corporate environment, the primary responsibility of any environmental graphic designer is to allow employees and visitors to interact freely and easily within their headquarters facility, from entering the front door to reaching each and every possible destination, while simultaneously reflecting the corporate culture.

Immersion in the culture The main distinction between a corporate and any other wayfinding project is that the designer's immediate goal is to become totally immersed in the culture of their client. While this may initially appear to be a simple task, the corporate environment is difficult to penetrate and understand, since it is traditionally a multilayered, multifaceted, hierarchy-based organization. Furthermore, the environmental graphic designer needs to understand what forces (people, products, services, brands) control a company and what influences and experiences will affect their work. Will they be based on corporate policy or public perception? Will they reflect the company's architectural environment or contrast with it? These initial questions can only be answered through a thorough understanding of the client.

Research and interview process First, research the company using all resources available. It is important to review as much literature as possible from internal and external resources, including periodicals, trade magazines, annual reports, corporate literature, shareholder information, and graphic standards manuals.

With your research complete, the next step involves interviewing various client user groups. The facts discovered in your research phase need to be integrated in your interview process. The designer needs to understand what image the company actually projects, as opposed to what image they may want to project to their employees and to the various people who may visit their facility.

During a detailed interview process, questions relating to the company's employees, guests, and visitors need to be asked. Each of these user groups will experience the environment in different ways, and each will navigate their way through a space in a unique manner. For example, a first-time visitor may experience the space in the same way you did during your first walk-through. It is important to pay particular attention to your first on-site experience. Before you reviewed plans for the space, what did you notice? What did you see? What did you hear, or even what did you smell? Did you navigate the space easily or did you become disoriented or lost? You need to make a record of your visual experiences; this will be key in developing an optimum solution. An employee works in the same space every day and will not need to remember or rely on specific landmarks. However, a first-time visitor will need to remember this type of wayfinding information. Therefore, the

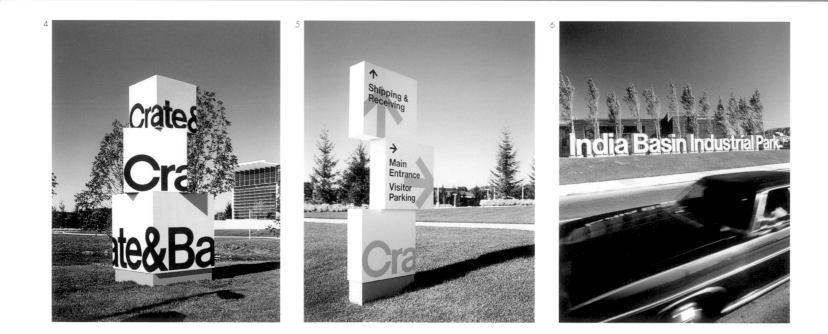

Figs 7 and 8 Monsanto incubator, Hellmuth, Obata + Kassabaum

Fig 9 Adobe Headquarters sculpture, Mauk Design This sculptural form uses the system of creating color using Adobe products as a way to illustrate the company's identity.

Fig 10 No. 9 Park Avenue, Chermayeff & Geismar

designer needs to create special areas that are of interest to the employee and become navigation tools simultaneously. Remember if you passed by a cafeteria or coffee bar, as your nose can also become part of your wayfinding experience.

The key to a successful wayfinding solution is the sequence of events and how that sequence incorporates the branding or identity of the company. As one approaches a corporate environment, one needs to take into account needs or special requirements or procedures for visitors. Do the visitor and employee use the same entrance? Are there similar or separate procedures for visitors and employees? Is there an employee's entrance or parking facility? Do most visitors usually arrive at a reception desk? If the visitor is announced, does the employee greet the visitor or does the visitor need to navigate to the employee's location? What information is the visitor given? Is the visitor given a map or only verbal instructions? The visitor may be given a room number or a landmark destination. For example "go to room 1203," or "take these elevators and see the receptionist on the 12th floor," or "walk past the coffee bar and then turn left." Designing all of this information, which includes nomenclature, information organization, sequencing, addressing, room numbering, and verbal/written/audio instructions, is part of the environmental graphic designer's consideration when developing a successful and functioning design solution for a corporate culture.

9

7

8

10

Fig 11 MCI Headquarters, Lorenc+Yoo
Design

Fig 12 Yahoo! Headquarters building
identification, Square Peg Design
Sometimes a corporate image is so strong
that it translates easily into three dimensions.

Time Warner Center Poulin + Morris Inc.

Time Warner Center is a 2,800,000 square foot (c. 260,100m²), mixed-use building project located at Columbus Circle, across from the southwest corner of Manhattan's Central Park. The Center is home to media giant Time Warner's corporate headquarters, accommodating 2,000 employees in nearly 1 million foot square (c. 92,900m²) of office and studio space, as well as live broadcast facilities for CNN, CNNfn, and other New York-based television programming. Time Warner shares the complex with the Mandarin Oriental Hotel, Jazz at Lincoln Center, luxury residential condominiums, upscale retail venues, restaurants, and commercial offices.

Time Warner selected Poulin + Morris to serve as the project's graphic design consultants. The scope of work included many diverse and unique components, but at its core was the programming, design, documentation, and implementation supervision of a comprehensive environmental graphic and wayfinding sign program. The program encompassed all building, floor, and reception area identification, office/workstation identification, conference identification, directional, informational, and regulatory signs relating to building, health, accessibility, fire, and ADA codes. Room numbering plans were developed to ensure an effective wayfinding system for employee workstation areas. Additionally, the three glass facades of the Prow, the building's most striking exterior architectural feature, were wrapped with large-scale glass letters that display the Time Warner and CNN logotypes in a continuous band.

Poulin + Morris was also responsible for the design of two wall murals installed on the executive suite levels. The murals identify each of Time Warner's major subsidiaries with their logotypes and media products, celebrating the diversity and breadth of the corporate holdings. A bold, large-scale CNN logotype anchors a third mural developed for the glass-enclosed CNN studio entrance corridor, which is visible from the street. Coordination of the CNN studio tour included the initial development of the name brand "inside CNN," as well as the design of all graphic components.

The corporate exhibit for Time Warner's main executive entrance consists of 10 individual vitrines recessed into the corridor wall, each containing a graphic vignette relaying the history of a particular media venture. Each "story," ranging from the Atlanta Braves baseball franchise to *The Sopranos* television sensation, commemorates a major media innovation or achievement.

In addition to the environmental graphic aspect of the project, Poulin + Morris was responsible for branding the Center's upscale cafeteria Park Café, including the design and implementation of the graphic identity throughout all printed materials, menu boards, and graphic sign elements.

Addressing/room numbering The most significant element of developing a wayfinding program for a corporate environment is

Fig 13 Main lobby identification.

Fig 14 Secondary lobby identification.

Fig 15 Prow identification/
electronic sculpture.

Fig 16 Brand mural.

Fig 17 Detail of brand mural.

Fig 18 Servery station identification.

developing a functioning room numbering program. For the most part, when plans are received from an architect, the room numbering plan has little or nothing to do with wayfinding needs. These plans are usually organized to be very convenient for finding rooms on a drawing plan, but actually have nothing to do with walking and navigating a space. When developing a functioning room numbering program, you need to imagine that you are actually walking through each and every interior space of the building and consider issues such as: what are you looking at; are there clear views across a floor, or will walls and tall workstations be blocking your view; is installed artwork distracting?

In planning for room numbering, the environmental graphic designer needs to consider several types of information. First, what is the organization of the building and how does it relate to critical room numbering: how many floors are there in the building, and how many rooms are on its most populated floor? The answers to these initial questions will tell the designer how many digits will be needed for room numbering. For example, if there are fewer than 99 rooms on a floor, room numbering can be based on a three-digit address; one digit for the floor and two digits for the room. If there are more than nine floors, room numbering needs to be four digits.

One common misconception is that users easily understand north, south, east, and west orientation as an effective wayfinding device in a building. This is largely incorrect. When people are in a building, orientation to compass navigation is rarely clear, instinctual, or intuitive. This is not to say that you cannot use north, south, east, and west orientation for a room numbering scheme, but you cannot expect a user to naturally understand that they are facing north, or in the north area of a building or clearly know how to walk to the south end of a building. If the designer uses compass direction for room numbering, directional signs along a wayfinding path need to clearly repeat the compass designation, or the use of this device will be unsuccessful.

Nomenclature As stated earlier, nomenclature is critical to a successful wayfinding sign program in a corporate environment. One typical question the designer needs to answer is what to name a ground floor. Should this be called ground level, ground floor, ground, street, street level, or floor one? Another consideration relates to levels below the ground floor. While the naming choices for ground level are to designate this as level one or level G, what should you name or number lower levels? We have found that when there are offices located on a lower level, employees do not like working in a space labeled as Basement or Cellar. A better choice may be to designate the level below ground as Level A, and levels below that could follow alphabetically. While it could be said that this still does not eliminate the designations of Basement and Cellar (B and C), the appearance of a descending alpha-designation inside an elevator makes B and C more palatable.

Future planning Another consideration is that an environmental graphic designer needs to have a thorough understanding regarding the future expansion plans for the company, as well as the intended circulation and function of a space—what are the plans for future construction of additional buildings, and what are the future plans for offices and workstations. Will large offices be split into several or will workstations be moved around and reorganized? What is the smallest common denominator of a workspace? In understanding the intended circulation of a space, information on how visitors enter a building will clarify how

they navigate to their destination. This primarily involves the circulation through stairs and elevators. What are the potential traffic patterns and major decision points in a space that would affect the amount of wayfinding required?

What's first? The room numbering plan shown in fig. 20 is from the Time Warner Headquarters in New York City. The objective for this aspect of the project was for visitors and employees to be able to find rooms and coworkers on enormous floor plans across 22 floors. For this it is important to think vertically through a space. Similar rooms adjacent to major landmarks should be similarly numbered. The base structure for this project was to keep the conference/meeting rooms near the elevators as the common denominator. These conference rooms never move, and while the adjacent large offices can be divided into smaller offices, and small offices can be combined into larger offices, they have been given the room number 100 on the south side of the elevators and 200 on the north side of the elevators. By using the lowest room number on the south of the building, the user will navigate in an order that comes as naturally as scanning lowest to highest, and in a clockwise direction.

Fig 19 Diagram of a room-numbering plan.

Fig 20 Office identification.

For Time Warner, the offices and furniture plans will always be evolving into new floor configurations based on two common office types. Type D is a large office and Type C is a small office. Further, one Type D office could be split to make two Type C offices. For this particular project, the grid of offices was even more complicated, with five different kinds of office configurations. When numbering these offices, the larger offices absorbed an extra room number that would not appear on any room sign unless the office was split in the future. This additional number, or "stop gap" in the address numbering may seem odd when looking at your numbering plan, but in reality it is a very smooth experience of physically walking the corridor.

Another aspect of developing a successful wayfinding solution for a company is in understanding the client's expectations regarding typical nomenclature requirements for the listing of personnel names, titles, affiliations, etc. on signs. Does this information need to be changeable? How often does this information change? One observation regarding the Time Warner corporate culture was that the people at the company were extremely friendly, personable, and warm. Employees take great pride in their job titles. Our solution includes a person's entire name and title on their office identification sign presented in a small scale, as well as a person's first name or nickname in a large scale. This solution reinforces the collaborative spirit inherent in the corporate culture at Time Warner where everyone, from administrative staff to senior management, are identified at their offices as Dave and Betty, rather than Mr. or Ms. Smith.

Landmarks One additional wayfinding technique that is particularly successful in a corporate environment is in the creation of landmarks, located at central gathering places, that highlight the corporate culture of a company. Two such examples in the Time Warner project were to rely on the rich media and diverse graphic or visual history to create special places within the corporate headquarters. During our initial research, we learned of the massive expanse of this company. Time Warner Inc. is the parent company of CNN, HBO, AOL, Cinemax, People, New Line Cinema, Sports Illustrated, The WB Network, Time Inc., Turner Classic Movies, DC Comics, Cartoon Network, Time Life, Hanna-Barbera, The Atlanta Braves, Mad TV, Mad Magazine, Moviefone, Mapquest, TNT, This Old House, Court TV, Looney Tunes, Popular Science, Netscape, and Warner Bros., among many others.

In reception areas and on the staff amenities floor, where the security office, nurse's office, and cafeteria are—the one place where everyone congregates during the day—we created giant murals comprising the many identities of the company. Working carefully with the Corporate Communications group, we developed a series of murals that celebrate their diverse graphic identities. This was done in a way that makes employees reexamine or revisit identities with which they are very familiar. These murals are comprised of cropped logotypes, symbols, and products. In the reception areas, where the general public arrives, we created murals that combine with integrated plasma screens for real-time media, closed caption news, and digital messaging. The main concept for the creation of the murals, which includes all the major brands of the company, was to express a metaphor of unity.

21

22

Fig 21 Inside CNN identification.
Fig 22 Reception lobby mural.

Corporate environment design recommendations

→ Become totally immersed in the corporate culture of the client.

→ Research the company using all resources available.

→ Conduct a detailed interview process.

→ Pay attention to and carefully document your first experience in the environment.

→ Understand the intended circulation and function of a space.

→ Develop a functioning room numbering program.

→ Nomenclature is critical to a successful wayfinding sign program in a corporate environment.

→ Have a thorough understanding regarding the future expansion plans for the company.

→ Work carefully with the Corporate Communications department of the company.

→ Ensure that all design elements highlight the corporate culture of a company.

Fig 1 International Spy Museum,
Gallagher & Associates

10 Museums and exhibitions

Gretchen Coss and Patrick Gallagher

The museum and exhibit world is changing and evolving with the onset of new technologies, increasing competition for the audience, and the need to remain fresh and relevant. Families and individuals want more for their money. Local patrons need a reason to return.

Museums are reinventing themselves in response. Many museum clients are striving for a fully integrated master plan that includes exhibits as well as revenue generators such as restaurants, retail environments, and desirable event spaces. Designers are working hand-in-hand with clients to select appropriate locations for these sites, themes, and concepts, business partners, incentives from city and state sources for funding, and economic development dollars.

Branding and image-building are becoming integral to the success of the museum. This brand extension correlates directly with the signage and environmental graphics. The graphics program can help to build excitement with temporary signage, Web-site graphics, and direct mail.

Museum venues are sparking revitalization of downtown corridors and are becoming destinations within mixed-use projects. In Washington, D.C., the International Spy Museum's positive influence on the local tourism and business community was recognized with the Downtown DC Business Improvement District's (DC BID) 2002 and 2003 Momentum Awards; the American Institute of Architects' 2002 Catalyst

Award; and *Washington Business Journal*'s 2003 Best Retail Deal. The museum complex has also earned several national marketing, public relations, and design awards.

The Spy Museum complex provides a new business model that is thriving during a time when tourism dollars are hard to come by. "Partnerships with organizations like the International Spy Museum serve as an engine for growth in the downtown area, helping us provide stability to developers and investors in the marketplace," said Richard Bradley, executive director of DC BID. "After opening to national acclaim, this blockbuster museum continues to help transform the downtown area into the new heart of DC."

The influence of tourism

Tourism is an enormous industry, and funding for projects has been on the rise. Historic sites are major tourism draws, and they can have a tremendous impact on the economic health of cities and towns. The client team can include a host of stakeholders including the State, related foundations, counties that surround the attraction, and governmental agencies such as the National Park Service. The design team plays an active role in the negotiation of agendas brought to the project by diverse client groups. Consensus-building is part of a successful implementation plan. Without buy-in, the best design concepts can fall by the wayside.

Collaboration

Collaboration among the disciplines has become the norm, not the anomaly. Synergy between team members is critical to the design process and to the project's overall success. No longer do the building and architecture dictate the museum experience and design. Clients understand that the placement of experience components, visitor flow, pulsing and sequencing, and overlaps with marketing and branding are inextricably connected. This means that the design team must have the key players in place from the onset, including the wayfinding consultant.

Technology

Technology is becoming an integral part of most museum exhibitions. It can convey an immense amount of information. But staying abreast of the newest and the most appropriate, user-friendly, cost-effective, and updatable systems is a challenge. Also, it is important to analyze the effectiveness of multimedia in the overall exhibit and wayfinding system. Because technology can be a sizeable line item, it is critical for the wayfinding consultant to be a part of the process at an early stage, when budgets are being set and parameters for design established.

Fig 5 View of the rotunda at the
National Museum of Natural History.

Figs 6–9 Louvre, Carbone Smolan Agency
Integrating a brand into architecture, signs,
print, and maps creates a complete
wayfinding program.

Key Design Issues

Museums and exhibits come in different shapes and sizes:

→ large, collections-based institutions whose focus is research,
 like those of the Smithsonian Institution;
→ visitor centers and historic sites that include living museums, walking
 trails, and outdoor experiences, such as Gettysburg Military Park and
 Historic Jamestown Settlement; and
→ experience-based museums and exhibits, like the International
 Spy Museum.

Wayfinding is *not* just about signs. It is about navigating through
complex spaces and integrating all forms of visual communication.
Besides signs, wayfinding components can include sculptures,
landmarks or icons, special lighting effects, architectural structures,
materials and wall colors, technology, and video walls. These
components should be integrated with the drawing sets and project
budget at a very early stage. Large, landmarking icons such as the
elephant in the National Museum of Natural History (see fig 5) cannot
be moved or inserted at a later stage.

The wayfinding team can help identify issues with visitor flow, entry/exit
points, and crossovers on the path of travel. Once the architecture is set
and venues such as theaters, exhibits, and lecture halls placed, it is not
possible to change those decisions. Electrical and power requirements
must be included when the structure is being built and the power is
being pulled to the appropriate locations. They are too costly to add
after the fact. In a museum or exhibition environment, wayfinding should:

→ enhance the experience
→ extend the brand
→ mesh with the architecture, exhibit finishes, and graphic palette
→ utilize appropriate communication tools for each message
→ give information
→ be flexible
→ elicit an intended behavior

Branding and the visitor experience

A museum's brand is the sum of all the experiences that visitors have
with that institution. Seeing the logo, receiving an invitation to an
opening, talking with docents, and walking into an exhibit all help
define the institution's brand. Even difficulty navigating through
a space and finding the parking area contribute to public perception
of the institution.

A successful program is integrated on all levels so that each
communication tool reinforces the brand and creates the intended visitor
experience. These tools can include:

Fig 10 Integrating branding, signage, and architecture.

Fig 11 Getty Museum, Getty Museum Exhibition Design Department Museums have among the most diverse audiences; their signs must meet the needs of a variety of age groups, the disabled, and people representing special programs.

→ advertising (magazines, visitor centers, airports)
→ printed materials (direct mail, newsletters, handouts)
→ the Web site
→ billboards
→ enhancements to physical space (interior and exterior)
→ film
→ operational issues
→ wayfinding and interpretive signage

It is critical to create connections between the various venues within a museum experience. This adds meaning and helps visitors make informed decisions. Connections can be made through print, signage, host interaction, and website integration. An introductory film can reinforce the overall story and link the various venues.

Wayfinding and navigation also help create comfortable, engaging spaces. And if visitors feel comfortable in an environment, they spend more time there. The ease of traveling from one venue to the next—coupled with efficient queues and friendly, knowledgeable greeters and security personnel—greatly enhances the experience and fosters positive feelings that are conveyed to others. The wayfinding system should be carefully designed to match the institution's brand and interior ambience. Considerations should be made concerning appropriateness of materials, colors, graphics, and messages so that balance is achieved.

Signage can demand more attention than it deserves; however, it has also been proven that too little emphasis on the directional and esthetic elements can leave them ineffective.

Clear messaging and signage for the audience When, where, and how visitors receive messages and information is critical. The goal is to create a thoughtful system that orients visitors to appropriate entrances and destinations throughout the building. Messaging must take into account varied users including school groups, dignitaries, special program attendees, general visitors, disabled visitors, and staff.

Flexibility Flexibility is key to the ongoing success of a museum or exhibit. The wayfinding system must remain changeable, portable, and responsive to visitors' time constraints. Donor recognition programs change, major renovations occur, and new wings are added to existing projects. New donors must be recognized, and the program must remain flexible yet contextual within the space.

Host/greeter interaction Personal interaction with greeters and docents is an additional wayfinding and visitor experience tool, especially in spaces that are difficult to navigate. Here, wayfinding issues, coupled with multiple choices for the visitor, make it imperative that human contact be an integral part of the system. Greeters are ambassadors for the institution. Their demeanor directly affects the visitor experience.

10

11

Problem-solving In museums, there are often many choices for the visitor, and wayfinding can be difficult. The wayfinding system must deal with levels of information both outside and inside the building. Our first charge is to analyze issues affecting the site: circulation and wayfinding issues, language barriers, and/or architectural complexities. We also establish the character of the space—e.g., whether it is a historic space or a themed environment. The appropriate system of components can then be designed to address the project's unique challenges. These may include:

→ establishing graphics standards and message hierarchies to set the stage for present and future enhancements
→ staging and sequencing; peak and low times; natural visitor flows, etc.
→ dealing with changeable information
→ multiple venues within the space
→ donor recognition and ongoing campaigns
→ interrelationship of inside and outside—e.g., walking tours, interpretive signage for key areas
→ security issues
→ varied hours of operation; evening programs

The museum wayfinding process

Designing successful wayfinding programs in museum and exhibition environments involves unique challenges. Wayfinding must be thought of as part of the entire museum experience so that it is integral to the building and to the museum master plan.

Building the team—the collaborative process Museum and exhibition wayfinding systems are most successful when there is a seamless collaboration beginning very early in the museum design process. This includes coordination with the client, architect, and exhibit design team, and with graphics, operations, volunteers, docents, and security specialists. If a client team has not already been established, form one. Clients are a valuable source of information on the nuances of their institutions. Ask the right questions, and you will gain valuable insight. Then, use your skills to translate and expand on that insight.

Initial research phase Typically, a design team undertakes a research and analysis process at the onset of the project. Aspects of this initial phase include:

→ studying existing plans
→ conducting on-premise observation
→ coordinating photo and video documentation
→ reading and analyzing visitor studies
→ creating a series of recommendations and concepts for the client

12 13

Programming and analysis Programming in this type of environment is largely dependent on the visitor flows as they relate to the various venues and experiences within a museum. In galleries, museums, and performing arts centers there can be multiple venues and choices for the visitor. Is the visitor intended to follow a specific, sequenced path of travel? Or are there choices?

Visitor circulation may be a random process, or it may be based upon a deliberate system of movement. The design of the wayfinding system includes paths of travel for the audience groups which may include local patrons, tourists, school groups, and special event visitors.

Weighing all of these factors during the programming and analysis phase will help to determine sign placement and message hierarchies. It is imperative for the design team to have a clear understanding of the audience and the sequencing for the user groups in order to prioritize the messages for each visitor. The sign hierarchy must provide the appropriate information at the key decision-making points, and it must establish an integrated series of messages that are clear, consistent, and easily recognizable.

The museum experience can be extended to outside spaces. Many historic sites include trails and interpretive walking tours that correspond with the wayfinding and graphics program. Projects such as the Gettysburg Military Park/Visitor Center and the Historic Jamestown Settlement are examples of experiences that span both interior and exterior spaces.

System design

There are important design parameters to keep in mind when designing a museum wayfinding system: the need to manage changing information and the need to manage placement of information to avoid visual clutter, information overload, and/or confusion.

The environmental graphic designer should also become aware of the natural flow of the building architecture and queuing lines in order to anticipate the need for signage, the most appropriate and succinct messaging, and the proper locations for signs.

Changing information Within museums and exhibitions, dealing with changeable information and the multitude of messages are major challenges. Design details are incorporated based upon the frequency of change and the ease of changeability. A sign that will remain for a longer duration of time can be made of more permanent materials, while information such as event or ticket pricing can be displayed through changeable systems including electronic signs, changeable inserts, and/or banners.

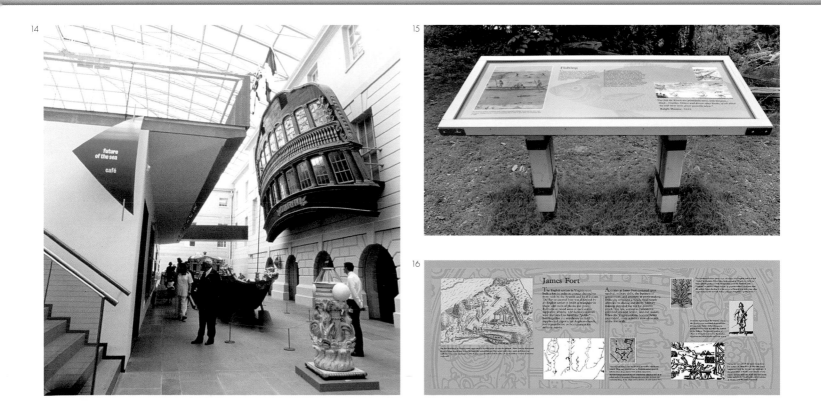

Fig 17 Gettysburg National Military Park and Visitor's Center, Gallagher & Associates Wayfinding programs can be part of a park, integrating interior spaces with exterior trails.

Fig 18 Nexus Contemporary Art Center, Lorenc+Yoo Design

Fig 19 Houston Museum of Fine Arts Audrey Jones Beck Building, Vignelli Associates Art museum identity graphics change often. The permanent wayfinding system must be exceedingly simple to fit the needs of the changing exhibits.

Fig 20 American Folk Art Museum, Pentagram Design, Inc. Donor recognition can play a crucial role in the museum wayfinding system if well integrated into the overall design of the complex.

Donor recognition signage is a major component of the flexible museum signage program. The design of the donor recognition program must be updatable and expandable, yet it must have a look of permanence. The ongoing capital campaigns, special programs, and development efforts leading to future donations will be added over the years.

Avoiding visual clutter and information overload

Information overload can happen very quickly in a crowded museum environment. The competition for the visitor's attention is heightened by the sights and sounds in this type of space. It is important to anticipate how the signs will look once they are placed within the context of the exhibit. Message hierarchies should give visitors enough information—but not so much that it becomes visual clutter. Extensive prototyping and experimentation is helpful, as well as clear, consistent design guidelines.

Set graphic standards

These guidelines set the stage for present and future enhancements and are crucial to maintaining the design intent through the years. Typical sign categories include:

→ identification
→ ticketing
→ directional
→ informational
→ donor recognition
→ retail
→ promotional/event-related
→ base building
→ regulatory
→ parking
→ interpretive panels

We have provided several case studies to illustrate successful programs in both collections-based institutions and experience-based museums.

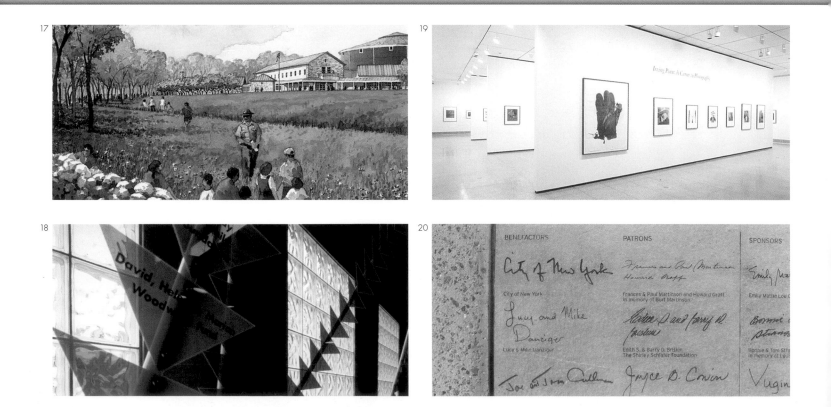

17

19

18

20

National Museum of Natural History, Washington, D.C.

The Smithsonian's National Museum of Natural History is a good example of a situation where signs were created to respond to the building's architecture and historic nature while not overwhelming the building.

The museum, which opened in 1910, was designed in the elaborate style of beaux-art architecture. In 1999, the design team developed a graphics system to promote three new attractions—an IMAX theater, retail shops, and new café—and to highlight the renovated Rotunda as the core of the visitor experience. The comprehensive program includes directional kiosks and graphics, exhibit hall identification, an LED system, and changeable public program signs.

The museum galleries and amenities are accessed by a circular public corridor. The design team responded to this unique architecture by devising a system that incorporates protruding signs with perpendicular logo/identity elements. Due to the historic nature of the building and the strict conservation rules, the overhead signs were designed to install in a pressure-fit method to avoid penetration of the surfaces.

A key premise to the system is that landmarks can serve as effective wayfinding tools. The elephant in the rotunda acts as a primary landmark for the wayfinding system. Other museum logos/icons relating to galleries or landmarks lead the visitor throughout the building. Printed maps were also keyed to the icons that figure prominently on the panels and directionals.

In an historic museum site like the National Museum of Natural History, it is important to take design cues from the architecture and carefully place wayfinding and identity elements. In contrast, the design of museums such as the International Spy Museum, discussed on p116, can take a much more immersive thematic approach.

Signage standards by Douglas|Gallagher Inc.

21
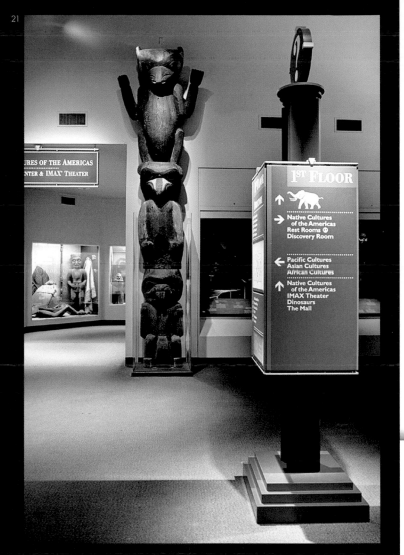

22
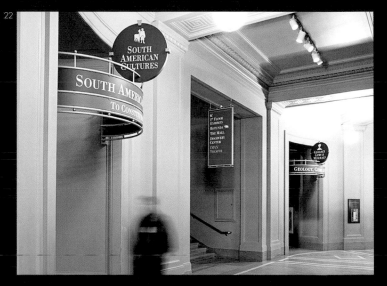

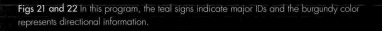
Figs 21 and 22 In this program, the teal signs indicate major IDs and the burgundy color represents directional information.

The International Spy Museum, Washington, D.C. Gallagher & Associates

The five-building International Spy Museum, which opened in 2002, is imaginatively designed to immerse the visitor in the world of the professional spy. Gallagher & Associates designed this unique museum's comprehensive environmental graphics and wayfinding program as well as master planning the entire facility and developing all exhibit galleries. The museum competes for visitors with more than 100 museums in the greater D.C. metropolitan area, most offering free admission. Its engaging interactive exhibits, the rich atmosphere provided by state-of-the-art immersive environments, and the compelling personal stories of real spies have made it a must-see destination.

The multiple structures and historic nature of the buildings created a challenge for the graphic design team. To unify the original buildings, Gallagher developed a special exterior color palette and graphic vocabulary. Retail-level signage echoes signs on the original facades. A central marquee, similar to an earlier one in this location, defines the main entrance to the museum complex. There are separate entrances from the street to the museum itself as well as to the shop, two restaurants, and special events facilities.

Gallagher & Associates devised the initial concept and master plan for the program and environmental graphic design. Then teams of designers—architects, graphic designers, metal workers, exhibit specialists, filmmakers, and lighting experts—expanded this concept with different approaches to the spy theme. "The process was incredibly collaborative," says Patrick Gallagher. "A project like this is the result of the quality of the collaboration and the quality of the client, who played a strong role in decision-making."

This project is an example of successful collaboration with the environmental graphics team. The extension of the brand is seamless. The placement, size, impact, and amount of information on each sign component meshes with the exhibit and architecture. The dynamic end product is due, in large part, to the integration of the environmental graphics team throughout the process.

The 68,000-square-foot (c. 6,320m^2) complex is organized on two levels around a central circulation spine. In order to control the crowds of more than 800,000 visitors per year, museum staff lead small clusters of visitors, or "pulsed" groups, into the galleries at timed intervals. Visitors are led sequentially through the various galleries and never retrace their steps. Instead of creating a homogeneous environment, Gallagher combined new and historic spaces tailored to the buildings' unique architecture.

Materials such as concrete, steel, glass, and cool neon create an atmosphere of mystery and set the stage for the museum experience. Espionage tools, historic documents, and hands-on exhibits fill the galleries. Gobo lights sprinkle espionage messages over the lobby surfaces, and projections of viewfinder crosshairs activate the space. The comprehensive signage system weaves the espionage theme throughout the informational and wayfinding program, while guiding the visitor through the multiple galleries.

Once visitors exit the final gallery, they enter a 5,000-square-foot (c. 465m^2) museum store. There is no need for directional signage to lead visitors to the retail space, as the architecture and exhibit flow do so automatically. Within the retail store, the brand image of the Spy Museum is displayed prominently, and the visitor remains immersed in the spy world.

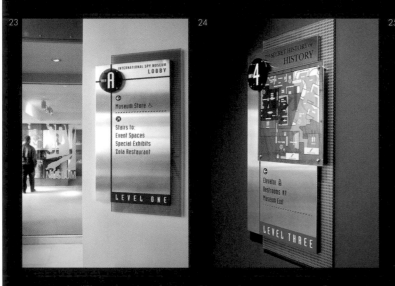

Figs 23 and 24 These location finders illustrate the creative use of architectural materials in the signage.

Fig 25 The restroom signs replace "traditional" male/female icons with spy images.

Museum and exhibition design recommendations

→ **Make messaging clear** When, where, and how visitors receive messages and information is critical. Clearly define the choices and various venues so that visitors understand them immediately. Establish an integrated series of messages that are easily and quickly stated. Prioritize; place the major destinations at the top of the hierarchy.

→ **Know your audience** Identify the intended path of travel for visitor groups. This can include a series of clearly defined pathways to specific destinations for different user groups—e.g., scheduled groups, disabled visitors, families with strollers, etc. Prioritize the appropriate entries and exits for each audience, and direct visitors with a series of messages delivered in digestible amounts.

→ **Form follows function** Establish message hierarchy and sign placement first, then sign sizes, forms, and materials based upon the function of each wayfinding element. To avoid visual clutter and minimize multiple distractions, consider whether each component should be static or dynamic, or if it should even be a sign. It could be a landmark, a fountain, or a lighting effect.

→ **Anticipate change** Flexible systems include a mechanism for staff to change daily, weekly, and/or monthly information. Without this, the dreaded taped signs will appear. Plans should consider both immediate and future needs. In many museums, designers provide a graphic standards manual that can be implemented over time as funds become available and renovation plans materialize.

→ **Consider maintenance** Wayfinding systems must be easily maintained. Otherwise "Band-Aids" will appear. Once systems are in place, clients are inundated with weekly—sometimes daily— requests for signage updates and/or revisions. Inevitably, part of the system needs to be modified. Devise a system that will enable the client to use in-house staff, in conjunction with a reliable fabricator, so that the process is as painless as possible and the integrity of the original design intent is retained.

→ **Extend the brand** The museum's brand is the sum of all experiences. The combination of seeing the logo, receiving an invitation to an opening, talking with docents, and walking into an exhibit helps define the institution's brand. Even problems such as navigating through the space and defining appropriate parking areas contribute to the public perception of the institution.

→ **Collaborate** Mesh with exhibit and architectural palettes, and respect the character of the institution. Seamless integration necessitates compromises on all sides. Consider the whole museum environment as you design an appropriate solution in context with its surroundings.

→ **Plan for implementation** The design team should have checkpoints throughout the process to ensure the design has a chance for final implementation. These checks include budgetary responsibility and value engineering prior to submission of final construction drawings.

Implementation and projects—External

Fig 1 A monument along the Via Appia outside Rome. Rome used landmarks like obelisks, monuments, and markers to define their rational urban areas.

Fig 2 The boulevard leading to the Vatican, created by Mussolini, cut through the medieval fabric of the city to connect the Vatican to Rome. This was an antecedent to formal street signage.

11 Urban systems
Craig Berger and Jon Bosio

Walking down the streets of an increasing number of cities and towns around the world, you can see a large variety of gateways, vehicular signs, and small, multicolored pedestrian maps and signs along with banners and information kiosks. The signs on local street systems are an extension of interstate and state road systems, but use completely different colors, hardware, and typefaces.

Since the hallmark development of the Philadelphia wayfinding system in 1990 and the Baltimore system in 1996, both by Sussman/Prejza, a number of other cities (including Newark, New Jersey; Washington, D.C.; and Lancaster, Pennsylvania, in the U.S.; and Bristol in the U.K.) have created their own unique wayfinding systems. As cities and towns compete for tourists, hundreds of sign systems serving large cities and multitown heritage regions could be created.

A short history
Urban sign systems for pedestrians have been around for thousands of years. Ancient Roman towns started to define streets by a specific name and number around 2,000 years ago, and also began to create a structure of stone highway markers and street signs around this time. The Romans were extremely rational. For the most part, their cities were gridded for military reasons, so a system of street signs and landmarks was all that was needed for wayfinding.

Fig 3 Philadelphia Visitors' Center exhibit, Gallagher Associates Visitors' centers are getting bigger and more sophisticated as they move toward providing the base of urban orientation.

With the collapse of the Roman Empire, the resultant medieval empires developed small, informal urban environments comprehensible only to lifelong residents. The advent of pilgrimage churches—the first tourist landmarks—brought about the need to develop true wayfinding systems. This resulted in two devices: processional paths cut through the city and connected by landmarks, begun in Rome in the 1500s; and rudimentary wayfinding signs incorporated into buildings to connect the primary religious sites, begun in Venice c. 1000 and still in use today.

These systems were pedestrian based. The car was ignored until after WWII. Urban vehicular sign systems were nonexistent or relegated to simple stone-and-steel highway markers. In the United States, after the war, the Federal Highway Administration created the Manual for Uniform Traffic Control Devices to apply to interstate signs, state road signs, and urban wayfinding signs. This was quickly followed by the U.K. and mainland European countries. The major flaw in these systems is that they did not represent the unique qualities of their particular urban environment. The standards set up followed a one-size-fits-all approach; they tried to encapsulate an entire nation or group of nations in one graphic system.

The 1968 Olympics in Mexico City began to break cities out of the mold of rudimentary wayfinding signs to include logos, graphics, color, and type in the creation of a system that relates to the city in which it is located. This was a temporary system, but its effect on urban designers was great. Urban wayfinding began to be incorporated into all urban events, including subsequent Olympic Games and World Fairs. When, in the early 1980s, Disney World developed a wayfinding system for its connected theme parks it was only a matter of time before cities began to apply the lessons of the "event" to the permanent city.

The tourist economy

In the 1990s it became clear that cities were truly shaping themselves into hubs for tourism and conventions, and that urban wayfinding would be crucial to making these work. Beginning with the design of advanced Visitors' Centers and maps, and extending to that of signs and graphics, the idea of making a city easy to navigate for visitors became incorporated into many economic development budgets. Later, banners and streetscape enhancements were added to create a complete urban kit of parts.

During this time a unique set of standards for urban signs was developed, covering wayfinding signs related to features inherent in all cities. Urban wayfinding signs must:

→ be attractive
→ be oriented to both residents, and visitors new to the city

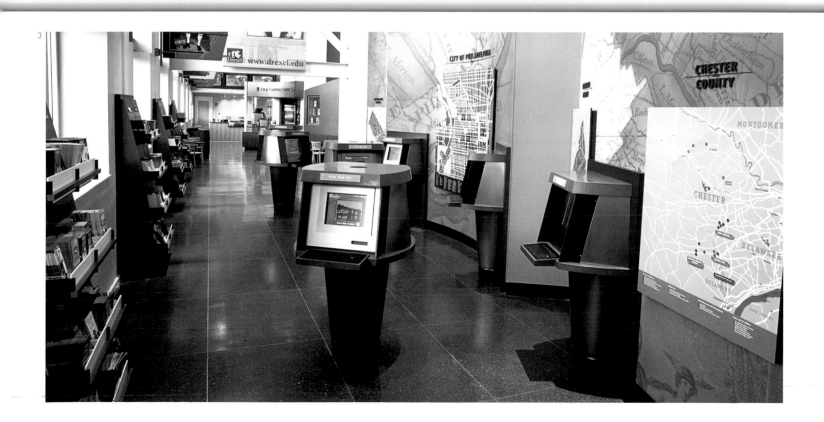

3

Fig 4 Tainjin Haihe River wayfinding system, Calori & Vanden-Eynden

Fig 5 City of Brea gateway, Hunt Design
In order to meet the high standards set by many modern cities, urban signs can be highly sophisticated.

Fig 6 Lower Merion sign system, Cloud Gehshan Associates

4

Wayfinding Signage Family

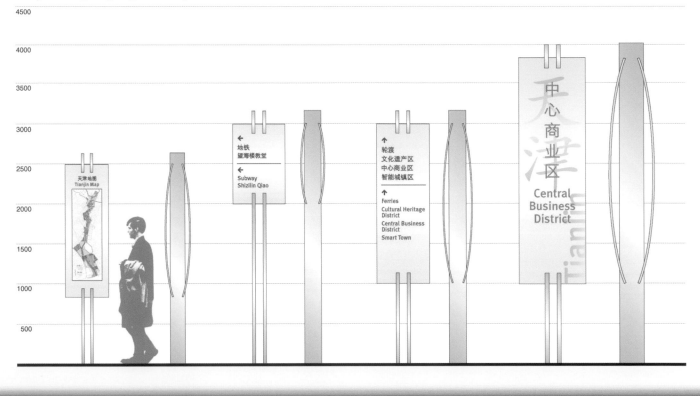

5

6

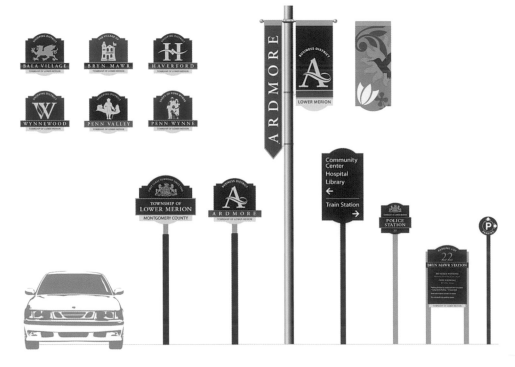

Fig 7 Norristown sign system, Seiler + Drury Architecture and Kent Design The design vocabulary established for Norristown urban center.

Fig 8 Wilmington sign system, Mitchell Associates Establishing a design vocabulary, the relationship of signs to one another, and their intent to satisfy wayfinding needs is a crucial first step in project development.

→ consist of a vocabulary of parts that each serve a specific role
→ be part of the overall city identity
→ provide direction to smaller destinations
→ provide direction over very small distances at low speeds
→ provide direction at a number of levels, for drivers, pedestrians, and transit users
→ compete with street, regulatory, and storefront signs for the attention of the motorist and the pedestrian

The key areas of urban wayfinding

In the development of dozens of wayfinding systems during the 1990s, a number of processes and guidelines for creating and managing urban systems have emerged. The 9-step process outlined below, combining all the elements in one, is how wayfinding projects are developed in cities. While this chapter focuses predominantly on signs for wayfinding, this process can be applied to all urban elements.

Mission statement Urban wayfinding signs form part of the process of city image-building and should be defined in those terms. The Mission Statement should contain program goals, vocabulary that will be used in the program (maps, banners, gateways, interstate trailblazers), the stakeholders involved, and the system management.

The stakeholder group Urban wayfinding systems must be developed by a stakeholder group representing all the entities that will be involved in making the system possible. Most large cities, including Washington, D.C., developed their systems with government (both Federal and State where they exist) and local input, including even the smallest local institutions. The stakeholder group should be two-level, with a small working group of critical institutions actively overseeing development of the system, and a larger constituency receiving project information. The stakeholder group should also help manage the regulatory process. Department of transportation engineers can be very easy or very difficult to work with, depending on the location. Having a complete stakeholder process not only ensures that the project approval process is in place, it also develops the limitations to such a system.

Criteria The average urban cultural destination has fewer than 20,000 visitors per year. In a city, most do not have on-site parking, but share large-scale parking facilities. Destination criteria must be adapted to these smaller institutions and the parking and transportation needs of the city. All the signs and design elements employed should reflect the destination criteria. For example, a system oriented to directing visitors to parking first should have an extensive parking garage and lot identity system in place. A transit-based visitor system, as operates in most European cities, should have a kiosk or map located near most major station stops.

7 8

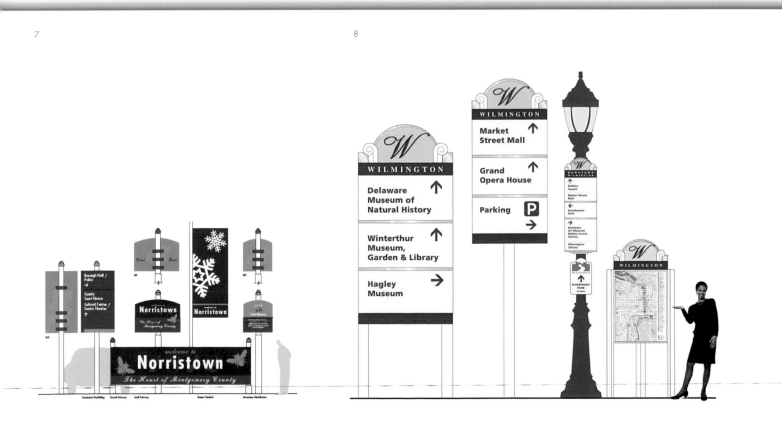

10

Fig 9 Plaza Arena parking lot, Bureau Mijksenaar It is important to understand who signs are for before establishing destinations.

Fig 10 Indianapolis City sign system, Corbin A well-designed sign balances color, type, and message to create an extremely readable system.

Fig 11 Houston sign system, Gensler Large, clear type is crucial for readability at vehicular speeds.

Designing urban wayfinding systems

Urban wayfinding signs require a marriage between the practicality of reading a message at vehicular speeds and the importance of creating an attractive design for the pedestrian environment. To meet these goals, the design for vehicular wayfinding signs must follow some basic rules:

Color Almost any color can work well with wayfinding signs, but the foreground and background must contrast to ensure readability. Color contrast should be at least 60 percent between typeface and background to satisfy the needs of people with color blindness or limited vision. It is a good idea, even on pedestrian signs, to limit the number of different colors on one sign to no more than three or four, in order to keep the design clean and simple.

Typeface Letters should be at least 3 inches (76mm) and preferably 3–4 inches (76–10.2mm) in height. Letter styles should be simple, with narrow stroke widths, few flourishes, and a wide kerning (spaces between letters) relative to the height of the letters. These standards are designed to meet the needs of older drivers who tend to have problems differentiating lettering at vehicular speeds. Typefaces like Helvetica, Clearview, and Garamond are commonly used. Letters should be applied using a reflective material—vinyl is the most common—to allow for alterations to the sign message should the need arise.

Symbols and logos Internationally recognized symbols are best, for example the Parking P or the Hospital H. If unique symbols are developed, only three should be used at most: this will allow the driver to gain some familiarity. Logos should be kept small and should not dominate the messages on the sign. Logos representing districts or subdistricts can be used, but always with a text message.

Destination messages To ensure readability, never include more than three to four vehicular messages on one sign.

Pedestrian signs While typefaces, colors, logos, and number of messages can be much more extensive in pedestrian systems, simplicity is still important, at the very least to cut through the clutter of the urban environment.

Banners and gateways Keep in mind that at the urban scale, graphics are much less legible. Dimensionality and illumination enhance graphics identity and legibility.

Fabrication

Wayfinding signs are street furniture and have a similar impact on the pedestrian environment as wastepaper baskets and trash receptacles. Although they are created for the benefit of motorists, these signs must be pleasant to the eye from all sides, and safe for the pedestrian. There are a number of issues that must be kept in mind.

9

11

Fig 12 Camden Parking trailblazer directional sign, Hillier Environmental Graphic Design Clear, simple symbols can create tight, readable signs.

Fig 13 Washington, D.C. pedestrian sign, Calori & Vanden-Eynden A pedestrian sign can contain much more information than a vehicular sign, but similar rules apply to both, in terms of consistency and simplicity of information.

Fig 14 Back of Camden directional sign, Hillier Environmental Graphic Design An urban sign is a piece of street furniture that interacts with pedestrians—the appearance of the back is as important as that of the front.

Fig 15 Washington, D.C. sign footer, Calori & Vanden-Eynden For safety reasons, footers should be able to break away in an accident, but they should still be attractive.

Panel height This must meet any local legal requirements—vehicular signs must be at least 7 feet (2.2m) off the ground to satisfy the Americans with Disabilities Act. Panel heights should also be high enough off the ground to deter vandalism.

Width Width is restricted by the need to keep the sign support out of the pedestrian path, and also to maintain an urban scale. The width is generally 40 inches (1m) or less.

Horizontal clearance The sign panel should be at least 12 inches (30cm) from the street curb to prevent damage from vehicles maneuvering into or out of a parking space.

Connections All brackets and connections should be hidden under covers and tamper proof screws.

Footers Pedestrian signs and kiosks should have a footer around them for the blind to spot with a stick.

Maintenance There are a number of new technologies being researched in cities, including talking signs and electronic kiosks. All these systems can enhance the wayfinding environment, but maintenance is an issue. Signs are generally in place for at least 10 years, so any system installed should be able to withstand technological and stylistic as well as physical forces.

Installation

The installation of wayfinding signs is very difficult in urban situations. Given their size, they can be very dangerous to pedestrians and drivers unless installed correctly.

New poles or existing poles Large vehicular signs are commonly placed on new poles for a variety of reasons, including the need for exact placement and to ensure separation from the street curb. Smaller trailblazers (consisting only of a destination logo and directional arrow, and commonly used to direct back to interstate highways) can be placed on existing poles.

Foundations Similar to interstate highway signs, breakaway footers should be used. These footers should have less give than interstate sign footers. A flying sign or light pole would be much more dangerous to the pedestrian than a bent sign to the motorist. Exposed elements on footers should also be protected to avoid them becoming hazards that pedestrians could trip over.

Underground conflicts Every utility imaginable is found under city streets, from subways to telecommunications cabling. Installation must involve the standard city processes for utility calls as well as a system of approval by the department for public works.

12 13 14

15

Fig 16 "Edge Cities" diagram, developed
by Joel Garreau These "maps" illustrate
the new vocabulary used to describe the
growth of modern cities.

Fig 17 Brandywine sign system, Mitchell
Associates When a system covers
a large linear area, large graphics,
simple directional information, and
distance information become crucial.

Fig 18 Chicago street sign, Two Twelve
Associates Street signs with district names
are a simple, but effective approach to
linking far-flung districts through design,
along with landscaping and lighting.

Sign planning

Unlike highways, urban streets are complex and cluttered. Sign routes must take advantage of the urban elements that define a city. The planner Kevin Lynch established a basic vocabulary of urban elements in his book *The Image of the City*. This urban vocabulary of paths, nodes, landmarks, edges, and districts provides the basis of establishing urban sign planning. The common method for developing urban sign routes is the "peeling the onion approach," i.e., using a hierarchy of urban elements to direct the motorist to their destination without using an excessive number of sign messages.

→ Edge of the city: Direct to large districts (Downtown)
→ District edge: Direct to smaller subdistricts, major boulevards, major landmarks, and parks
→ Inside the subdistrict: Direct to larger destinations and parking
→ At the pedestrian level: Direct to all destinations

The "peeling the onion" approach reflects the way traditional cities developed before 1950. Other wayfinding approaches, employed in the early 2000s, have reflected the changes in our cities. The journalist Joel Garreau, writer of *Edge Cities*, has developed terminology to cover these three areas.

Main street Many cities and regions, especially cities built since 1950, have taken on the form of a continuous main street. Wayfinding

elements on these corridors are much simpler and rely more on banners for identity, with distance information on signs.

Pig and the python Traditional downtowns have begun to sprout main street corridors leading out of the city. Berlin and Chicago have transit systems and major roads extending far out of the downtown area. Wayfinding systems with this approach must take on a hybrid role, being compact in the downtown, and exploding in size outside the corridor. Many cities use improved street lighting and landscaping, in coordination with signs, to extend corridors outside of downtown.

Uptown/Downtown Planned, traditional cities like Paris, France, and new cities like Phoenix, Arizona, U.S., were designed with multiple downtowns linked by main streets. Wayfinding systems in this environment follow the "peel the onion" approach and use simple signs and gateways to connect one downtown with the other.

Placement of signs

Signs must be placed to avoid urban clutter while allowing the motorist enough time to make decisions. A few rules of thumb apply.

Vehicular sign placement Because the distance between intersections is generally very short, 300–500 feet (90–150m), there is rarely more than two signs on any street segment. Vehicular signs should always be further than 75 feet (23m) from an intersection to give

Peeling the Onion Main Street Pig in a Poke Uptown/Downtown

Fig 19 Amsterdam Woods forestry signs, Bureau Mijksenaar Pedestrian signs can be much smaller than vehicular signs, be more delicate, and provide much more information.

Fig 20 Reducing sign clutter increases the visibility and readability of signs, but clutter also leads to a more vibrant environment. Observation, balance, and active streetscape management is just as important as design.

Fig 21 New Orleans sign system, Douglas Group Planning ahead for more space or easily dismantled signs aids future sign expansion and changes.

the motorist decision-making time, and to avoid conflicts with traffic signals and signs at the corner. Spacing between signs should be at least 30 feet (9m).

Vehicular signs and pedestrian signs Vehicular signs should never conflict with pedestrian directional signs. There is more flexibility in the location of pedestrian signs: the pedestrian environment contains freedom of movement as it can utilize one-way streets in both directions, as well as parks and pathways that have restricted or no access for cars, while the vehicular environment is tightly bound by rules. Pedestrian signs should never be placed in locations where a motorist might misinterpret them.

Banners, streetscape, and identity elements Because these elements are often in close proximity, a clear plan must be put in place to ensure that they do not conflict. Since most of the placement will be governed by different designers and groups, a complete communication system is important to ensure that there is not too much clutter.

Maintenance and management system

Before a single sign is put in the ground, a system for maintenance and management must be put in place to sustain the program in the long-term. Any such system must contain not only a plan for sustaining existing signs, but also a process for adding and deleting destinations, and a process for expanding the system.

Maintenance and replacement A short-term graffiti- and sticker-removal system should be matched with a long-term cleaning program. Every year, 3–5 percent of elements in the average wayfinding system are damaged or destroyed. In order to continue with a realistic maintenance program, it is important to create a replacement budget that reflects urban damage and destruction.

Changes to the system In most large cities, existing destinations move and new ones are added, and this happens, on average, once per year. In 2004, in Philadelphia, one new destination was added (the Kimmel Center for the Performing Arts) and one was moved (the Visitor Center for Independence National Historical Park). A well-managed database of signs and maps (a Geographic Information System) is needed to keep track of all of these changes.

Expansion A plan for expansion into adjoining areas must also be put in place. Most wayfinding systems evolve over time. A rule book for a city's wayfinding system should contain the information needed for continual development in new parts of the city. The plan must include a continuing funding source.

19

20

21

City of Miami Beach Hillier Environmental Graphic Design

Follow the fashionistas and you'll find Miami Beach's white, sandy shores and round-the-clock South Beach dance clubs, but you may miss the art museums, botanical garden, and galleries. Tourism is big business in Miami Beach—the new signage program will help you find your way should you be lucky enough to visit. The City of Miami Beach system is the perfect example of a complete process for developing an urban wayfinding system, including vehicular, pedestrian, parking, gateway, and banner signs. It also illustrates the time it takes to manage the regulatory hurdles and stakeholder decision-making process that make these systems a success.

Initially, the project had a number of obstacles to overcome. Two previous wayfinding projects did not get support from the County and State transportation authorities and were scrapped. This new project, led by Joyce Meyers of the Department of Planning, with support from Craig Berger of the Society for Environmental Graphic Design (SEGD), worked on getting approvals of design with all the stakeholder groups. This process took over 18 months.

After the design firm Hillier, led by John Bosio and Glen Swantak, was hired, they included research in their initial planning process, observing all existing signs and destinations, all the major routes leading into and out of the city, and all its tourism goals.

Hillier's wayfinding analysis was built around the fabric of the city, which is comprised of three zones—North, Mid-, and of course South Beach. The analysis organizes the city street patterns and districts into an understandable information heirarchy of paths, nodes, and points of arrival. Signs direct to the three zones, and then to major destinations such as the art deco National Historic District, the Miami Beach Convention Center, Ocean Drive, Lincoln Road, parking, museums, and shopping districts.

The designers also developed destination criteria for these areas based on the findings of their research. They sent drivers to parking garages and lots throughout the city first, and then directed them to their

Fig 22 Miami Beach has unique urban wayfinding issues including harsh weather; diverse pedestrian and vehicular alley, road, and bridge conditions; large beach parks bordering urban areas; and vastly differing neighborhoods.

destinations as pedestrians. The analysis also covered the gateways leading into the cities and major neighborhoods, and the need for identity along the major boulevards. In addition, the consultant team worked with Florida Department of Transportation (FDOT) and Miami Dade County to develop a set of technical criteria that was in the spirit of the Manual on Uniform Traffic Control Devices (MUTCD) and acceptable to the approving agencies.

The design process started with the team leading a brainstorming session with the local community. This "identity workshop" invited stakeholders to comment on a series of visual elements, including color, typefaces, sign programs from other cities, graphic patterns, materials, and imagery. From this consensus-building exercise, three schematic design options were developed and presented to city officials and the stakeholder group.

The result was that Miami Beach and its influence on style became the primary focus of the final sign design. The design presents simple sign components, shaped into unique forms, that establish a stylish esthetic appropriate to the city and its image. The polished, ellipse-shaped post provides a modern elegance to the spine of the sign structure. The sign face is simple, meeting FDOT criteria, but at the back of the sign, the panel shape and brackets take on curved forms that turn a seemingly straightforward sign into a distinctive element on the street, helping it to integrate into an environment that has an overwhelming architectural context and visual presence.

The design also establishes a brand that extends beyond the directional sign program. Starting on the MacArthur causeway, which links Miami Beach to the mainland, a large Miami Beach gateway brands the city for highway travelers and for visitors arriving on cruise ships in the Port of Miami. The brand identity will also be utilized on maps, Web sites, city communications, and as a marketing tool in advertising, merchandise, and other promotional materials.

With approval of the design, Hillier is developing a series of design guidelines and documents for the specific routes the signs will take, and for their locations. Alongside a cleaning and replacement program, the physical structures of the signs will also be developed to withstand the harsh ultraviolet and hurricane conditions of the South Florida climate. With all these elements in place, the final sign system is ready to be installed, after a testing and phase-in process, over a period of a few years. During this time the colors, type, and graphics used will be integrated into the overall system.

24

Figs 23 and 24 Miami Beach Gateway during the day and at night.

25

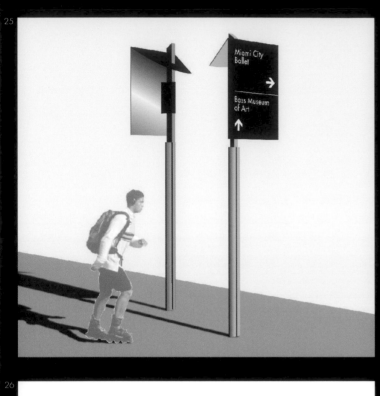

26

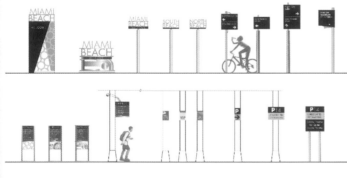

Fig 25 Miami Beach sign elements Both the front and back of signs should be esthetically pleasing. The Miami Beach signs were designed to suit the particular character of this city.

Fig 26 Miami Beach family of signs Established by authors Kevin Lynch and Joel Garreau, these urban development concepts work as a good planning vocabulary for the development of urban wayfinding programs.

The language of urban systems design

→ **Visitors' center** This area, located inside a building, in its own building, or in a kiosk in a hotel or at a destination, contains information that orients the visitor

→ **Guide map** This map generally contains three important elements:

1 a map showing major destinations, routes, roads, towns, districts, and landmarks;

2 pictures of the wayfinding sign elements used; and

3 a list of the major destinations included on the map, with a basic description of each, including hours of operation and prices, and interpretive information for historic landmarks.

→ **Banner** Decorative, generally cloth sign used to identify elements of particular interest in town and district areas

→ **Logo trailblazer** Inexpensive trail sign used to indentify major heritage corridor routes, including bike and river trails

→ **Gateway** A physical structure that separates two districts or falls inside a district. These gateways can be signs, landmarks, or other like elements

→ **Parkways and boulevards** Wider streets that connect major urban destinations

→ **Landmarks** Buildings and public art that orient people in a city

→ **District design codes** Specific design codes that ensure a unique identity in a specific district

→ **Streetscape elements** Lighting, trees, planters, and paving that not only enhance a street, but also identify a corridor

→ **Interstate logo or directional sign** A sign directing to interstate exits, with no more than three of the most important destinations; it must follow the regulatory sign design rules

→ **Vehicular directional sign** A sign oriented for vehicular destinations

→ **Pedestrian directional sign** A sign oriented for pedestrian destinations

→ **Destination arrival sign** A sign marking a destination visible from a car

→ **Destination arrival sign with information** A sign marking a destination that includes interpretive information

→ **General information sign** A sign exhibiting general historical information not linked to a specific destination, as part of a history trail

→ **Landmark arrival sign with information** A sign marking historic landmarks that do not have public access

→ **Parking arrival sign** A sign that identifies parking locations

→ **Street sign** A sign containing street and district information

→ **Regulatory sign** A sign containing traffic and parking regulations information

Urban system design recommendations

→ Make sure you carry out a thorough analysis of the specific urban condition, including project goals; vehicular, pedestrian, and transit routes; destination criteria; and urban stakeholders.

→ Make sure a regulatory approval system is in place before you develop a design.

→ Use multiple design elements to develop more complex systems instead of relying on one element.

→ Make sure all the design elements complement each other.

→ Make sure you limit the amount of information per sign to ensure visibility and comprehensibility.

→ Use colors and type that enhance legibility.

→ Make sure signs are attractive to pedestrians, even if they are oriented only for motorists.

→ Develop route planning on models based on the history and development of the city.

→ Build signs to withstand the test of time physically, stylistically, and technologically.

→ Establish a maintenance and management system before any signs are put in place.

12 Heritage areas and parks
Jerome Cloud

Founded in the late nineteenth century with the creation of Yellowstone National Park in 1872, the USA's National Park Service (NPS) now protects more than 83 million acres (33,590,000 hectares) of tidal estuaries, monuments, parks, forests, seashores, harbor islands, historic buildings, villages, and towns, with more than 400 million visitors each year.

The NPS, and similar organizations around the world, helps people enhance the quality of their lives by providing them with opportunities to care for the places that give their lives meaning. The national heritage phenomenon, which grew out of the NPS, is one such opportunity. A National Heritage area is a place designated by a governing body where natural, cultural, historic, and recreational resources combine to form a cohesive, nationally distinctive landscape arising from patterns of human activity shaped by geography.

National Heritage areas are landscapes on the same scale as national parks, with one critical distinction: people live and work in these places. They comprise powerful stories about family, race, and nation that span the full continuum of history. Residents are aware that they inhabit areas of great historic and scenic beauty. They are also aware that they are the stakeholders and stewards of the areas' necessary restoration and renewal.

Fig 1 National Park Service sign system.

In addition, both federally designated heritage areas and smaller state and locally designated areas have started to use similar models to protect a variety of other historic areas and landscapes in the USA and abroad. The process, products, and related considerations described here are drawn from several National Heritage models and should prove applicable to many smaller heritage sites as well.

In the USA, in order to receive official designation from the federal government, heritage areas are required to develop a management plan. A plan can take many years to develop, and it identifies how the area and its partners can work together to fulfill a common vision. The plan contains short- and long-term actions, such as developing an interpretive plan, opening visitor centers, restoring historic buildings and sites, and defining a network of car and bicycle tours and recreational hiking trails. In addition, effective communications and outreach need to be developed, and cooperative agreements should be established with the NPS as well as other important agencies and organizations.

A successful heritage program is the result of good planning and an inclusive stakeholder process. With projects that involve many partners and contributors, articulating primary objectives and timelines at the outset is essential. It is also important to have buy-in and long-term commitments of support from all members. A collaborative and consensus-building atmosphere facilitates the resolution of diverse points of view. The result is the formation of new understandings and working relationships between committee members, and solutions that are enduring and strongly supported.

The communications plan

Through the development of a heritage area, a community can learn to conserve, develop, and interpret historic, recreational, and natural resources for everyone's benefit. In addition, the community should be raising awareness of their unique significance both inside and outside of their immediate area.

The Ohio & Erie Canal Association, after going through a three-year process to create a management plan, took the next step with the creation of a communications plan. They understood that communicating effectively, investing limited resources wisely, and coordinating all forms of outreach were all critical to their mission. With the help of consultants Cloud Gehshan Associates, Dommert Phillips, and Davidson Peterson Associates, they developed a communications plan that included specific and unified recommendations in the areas of brand identity, wayfinding and signage, interpretation, and marketing and positioning. The thoughtful combination of these elements and the process involved to create that plan form the basis of this abbreviated survey.

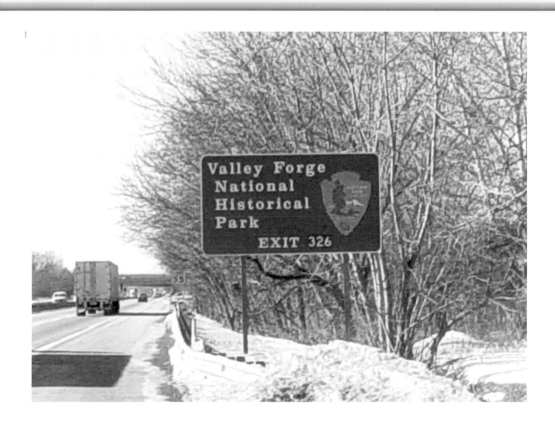

1

Fig 2 Delaware and Lehigh identity,
Cloud Gehshan Associates

Fig 3 Blackstone Heritage Area identity,
Selbert Perkins

Fig 4 Golden Gate National Historic Area
logo, Michael Schwab

Branding is about substance Both intellectual and physical assets are drivers of value in the heritage environment. In a virtual marketplace, where people can't kick the tire to test for quality before they make the decision to visit, a vivid and coherent brand message should present substance that people can understand, embrace, and share with others. It should help people make emotional connections with the deeper underlying stories and ideas as well as the rich physical man-made and natural landscapes.

What's in a name? Establishing the right name for a heritage area makes up at least 50 percent of the identity equation. An area's name will be spoken and written, and used in all kinds of media, print, advertising, and promotional materials. It will be applied to signage, banners, street furniture, and clothing as well as retail items. An area's name is also its portal to the Internet, through which both a national and international audience can access a range of information about the area's past and present. The name, therefore, must be agreed upon before embarking on identity development.

Identity as nucleus Identity is the heart and soul of the brand experience and the design should grow out of the area's rich history, while simultaneously serving as a beacon for opportunity and growth. The design of logo/logotype should be simple and memorable, communicating something essential about the area.

Defining the messages: interpretive planning

Heritage areas comprise neighboring sites linked by a diverse range of resources and experiences as well as a shared legacy and history. In the U.S., the emphasis on interpretation springs from the purpose for which Congress established National Heritage Areas, that is, "to preserve and interpret for the educational and inspirational benefit, of present and future generations, the unique and significant contributions to our national heritage." The goal of the interpretive plan is to create an exciting and cohesive interpretive experience. To accomplish this goal, it is important to articulate a framework for presenting the area's rich history and stories, demonstrate how individual sites can connect to these themes, and define a range of presentation tools.

Creating an interpretive plan is a collaborative effort. Key to the value of the plan are the contributions of community members and experts from local civic, cultural, and educational institutions. These constituent groups should be engaged in developing the themes for the interpretive system as well as providing background material and content for the plan itself.

To achieve an overarching theme, the interpretive process should begin with the development of a core story. In choosing this, the committee must be selective; not every story can be told. The interpretive specialist must lead the team to consider which theme has the richest resonance,

Fig 5 Motor Cities Heritage Area,
Selbert Perkins

Fig 6 Topics Diagram for Ohio & Erie National Heritage Canalway, Dommert Phillips This diagram illustrates the topics that are embedded in the Canalway core story. Along the perimeter of the diagram, represented as stars, are the different heritage, recreational, and nature "sites" that visitors are physically coming to as they experience the canalway. They "enter" the story of the canal from these portals. The topics of each particular site connect to other topics and eventually to the Ohio & Erie Canal.

appropriate content, and imagery to support it. Secondary themes should connect and build on the core story. Storytelling, unusual anecdotes, first-person accounts or references to local lore can be used to amplify and enrich the primary story.

Goals for a thoughtful interpretive process include the following:

→ Create a partnership panel to act as a steering committee.
→ Retain an experienced interpretive consultant to guide the process.
→ Define the visitor/audience and what they can expect from their visit.
→ Forge connections between the inherent meaning of themes and the audience.
→ Build a cohesive set of signage and presentation tools for use throughout the area.
→ Define the partner benefits of participation in the plan.
→ Outline implementation opportunities.

Defining the experience: wayfinding and signage

People are natural pathfinders. Provide them with simple, clear, and consistent information to assist them in their journey and they will perceive the place as enlightened and truly welcoming. For this goal to be realized, a comprehensive and integrated signage plan should be developed that will provide guidelines for gateways, auto-pathfinders, vehicular direction, destination identification, visitor information, historic markers, interpretation, hiking, cycling trail signs, and regulatory signs.

Individual sites in a heritage area can choose to use or opt out of an identity and signage system. Therefore, the many benefits associated with becoming part of a heritage program as opposed to existing as a stand-alone site need to be explained and promoted by the partners.

Going public: marketing and positioning

The marketing plan should guide the organization and its partners in developing a consistent marketing approach. It should also provide the framework for integrated communications materials and media programs.

The plan begins with an assessment of current market conditions by defining the strengths, weaknesses, and opportunities associated with the region. It should then develop a positioning statement that captures the essence of the visitor experience. The positioning statement can also reflect the core interpretive theme or story. This statement and the strategy that supports it will provide marketing and tourism professionals with some of the tools they need to increase visitation to the area. To ensure a consistent message, all communications should be based on this positioning statement.

The marketing plan also defines target markets and marketing opportunities. The target market starts with the core communities and ripples outward in consecutive increments, potentially building toward a national or even international audience.

4

GOLDEN GATE NATIONAL PARKS CONSERVANCY

6

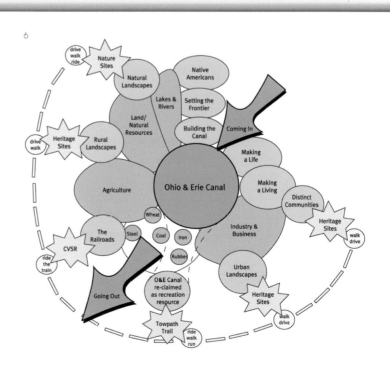

Figs 7 and 8 Ohio & Erie Canalway
sign system, Cloud Gehshan Design
The interpretive message map translates
into a specific sign vocabulary.

Fig 9 Ohio & Erie Canalway sign system,
Cloud Gehshan Design Sample Journey 2
– Route 30 to Electronic Education Center.

9

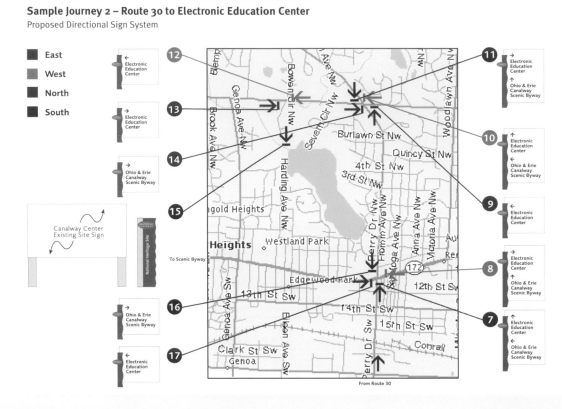

Sample Journey 2 – Route 30 to Electronic Education Center
Proposed Directional Sign System

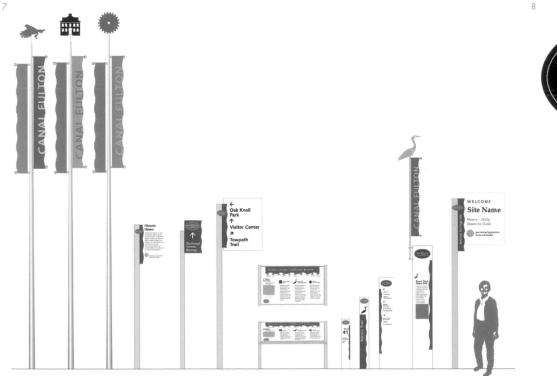

7

8

Figs 10–12 Golden Gate National Park, coordinated by Goodby, Silverstein and Partners People who receive the same message five times in the same medium are less influenced than people who receive similar messages in five different media. For instance, one is less likely to be influenced by seeing the same message in a newspaper five times than if one sees a newspaper ad, Internet banner, and sign, and hears a radio commercial and a word-of-mouth endorsement. An excellent example of cross-referenced messaging is the Golden Gate National Parks Association's (GGNPA) campaign.

Developing the wayfinding and signage program

Wayfinding is the science of navigation. It involves identifying the important messages and determining how they are best communicated. It assists people on their journey to and from a destination. The wayfinding experience can begin with a phone conversation, a Web site, or a vehicular sign.

Key to the visitors' experience is their level of comfort about where they are, where they're going, and what they're supposed to learn along the way. Signage plays an important role in raising public awareness about an area or region and establishes a sense of visual continuity. In general, a strong, but understated look is recommended, balancing clarity, effectiveness, and form with appropriate identity.

Pre-visit information When planning a trip to a heritage site, a visitor's first point of contact might occur via the Internet, telephone call, print brochure, advertisement, or email. To ensure that the visitor's initial experience is welcoming, helpful, and clear, it is important to coordinate the content in as many of these pathways as possible. Several things are helpful when coordinating the visitor experience:

→ Create information packets that contain salient information about the area and its resources.
→ Include maps and standardized directions to centrally located information centers or logical starting points.
→ Consider Internet and email as parallel channels for disseminating information.
→ Make sure that maps (both printed and online), directions, and related content are consistent and clear.
→ Train staff and volunteers to be helpful ambassadors.

Audit and survey Existing sign products located throughout the area usually combine a mixture of good and functional signs along with confusing and poorly located ones. In some areas, signs may provide identification, guidance, and direction, while in others signs may not even exist. Not only does this limit the esthetic impact and the identity function of the system, it has a negative effect on wayfinding.

It is important to begin the process of defining a signage system by first photographing and cataloging existing signs and conditions to determine a baseline from which improvements or perhaps an altogether new signage system will develop.

Location planning: GIS/GPS tools Removing dysfunctional signs is just as important as adding new ones. An inventory of existing sign products is a good way to begin to develop a tracking and management system for new sign products. Just as the signage and information systems necessary for successful wayfinding in heritage areas need to be continuous and consistent across all municipalities and counties, there also needs to be a plan for coordinating their content, location, repair, and replacement.

10

11

12

Fig 13 Delaware & Lehigh National
Heritage Area directional sign,
Cloud Gehshan Design

Fig 14 Lenape Indian interpretive banner,
Cloud Gehshan Design

Fig 15 Blackstone Heritage Area sign,
Selbert Perkins Design

→ A Geographic Information System (GIS) is a computer-based system for managing geo-referenced data. Geo-referenced data can provide two fundamental capabilities: recording the dimension, class, and condition of a particular object or sign; and recording the spatial location of the object or sign.

→ A Global Positioning System (GPS) is a tool for determining the exact position of an object or sign in the landscape. GPS is a highly accurate satellite-based positioning system now widely used in commerce and industry.

The introduction of GIS/GPS tools unquestionably improves long-term management, analysis, and mapping of sign systems. In addition, maps generated from a GIS system make useful tools for community leaders to better visualize auto-tour routes, festival and performance event routes, tourist center locations, trail heads, bicycle trails, and other amenities. By using a GPS, signs can be coordinated more easily with other planned improvements such as street trees, light poles, bus stops, traffic signals, and benches. Communication with signage contractors is improved when they are provided with details of sign type, message, and exact location. The client can then check the coordinates of installed signs against the database to ensure that the location and specifications have been properly met.

Government guidelines In the U.S., many states have already developed, or are in the process of developing, a tourist orientation signage program. State guidelines often describe a network of directional signs designed for use within the individual state's highway right-of-way, and are not permitted for use on interstate highways. Their key function is to guide travelers from major highway off-ramps to civic, cultural, recreational, and entertainment venues.

Each state defines these systems a little differently, but many view them in terms of signing areas or regions. However, wayfinding signage networks can cross municipalities, counties, and sometimes even states. To avoid navigational chaos, consistency of design and message across your network is essential. It is also imperative to engage state transportation representatives early in the process to better understand their standards before beginning the design of a sign system.

Frequent vs. one-time visitors One way to determine what kinds of vehicular signs are necessary for a destination is to evaluate and define the kind of visitors the site will get. For high subscription venues (such as theaters or concert halls) where most people visit more than once, the need for wayfinding signage is reduced. In contrast, museums, historic sites, and exhibits tend to attract many visitors only once or infrequently and therefore require more comprehensive wayfinding systems.

13

14

15

Figs 16 and 17 Tainjin Haihe River
wayfinding system, Calori & Vanden-
Eynden A family of signs must contain
consistent type, color, and shape standards.

Another type of destination is one that provides attractions for frequent, infrequent, or one-time visitors. Destinations of this kind include parks, trails, bicycle paths, and other recreational facilities. Often these sites rely largely on the support of one-time or infrequent visitors from outside of the immediate region. The best approach in such cases is to offer a more comprehensive wayfinding system to help all visitors arrive at and enjoy these sites.

Sample journeys Whether it involves directional, identification, or interpretive signage, a wayfinding system should grow out of a user scenario approach, which imagines a series of typical users and their needs. To better define a user scenario for motorists, for example, you should plot their destinations and critical decision points. Of course, the actual trajectories of visitors, residents, and workers can vary widely, but by imagining a few of the most common sequences of movement, it is possible to develop a directional system that will serve many people efficiently and conveniently.

Site identification signs and confidence markers There exists a wide range of freestanding and wall-mounted entrance signs throughout heritage areas. These signs belong to the individual sites and range in material, scale, and function. It is not typically the intention of the heritage signage programs to impose modifications on these signs but whenever possible to provide the site with a tool kit for associating the site with the heritage area.

This process can involve a complete remake of an existing sign to conform to the heritage standards, or it can take the form of a confidence marker. A confidence marker is a form of identification that can either be applied to an existing sign, or be a freestanding marker. In all cases, the name/identity for the heritage area would be used as an endorsement or underbrand.

Kiosks and trailheads The kiosk or trailhead is an introduction to the site or trail system. It provides identity and supplies interpretive and orientation information. The kiosk's design should be the first introduction to the graphic language used throughout the sign system. The design of this element should be adaptable to both urban and rural locations and have the flexibility and adaptability of a Swiss army knife.

Pedestrian wayfinding The pedestrian wayfinding system guides people from the entry point to a given destination. The experience starts with the kiosk and is shortly followed by a series of pedestrian trailblazers. These signs carry trail directional information, maps, regulations, restroom and telephone symbols, caution and safety messages, and trail difficulty symbols.

Banners and flags Banner and flag programs hold significant interest for stakeholders and the communities they represent. Defining a system for their design, programming, maintenance, and removal is desirable. Banners and flags can provide a welcome presence and strong visual

16

17

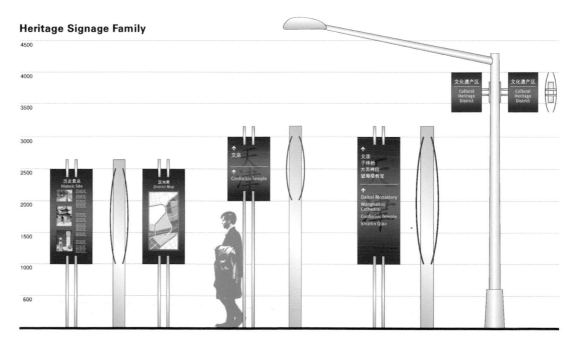

Fig 18 Discover DC Heritage Trail kiosk, Calori & Vanden-Eynden

Figs 19 and 20 Richmond Canalwalk viewing frames and scopes, Ralph Appelbaum Associates, Inc.

Fig 21 Amsterdam Woods forestry signs, Bureau Mijksenaar

impact at a relatively low cost. They can be deployed in groups or individually as identification markers. Using festive banner groupings can help create a sense of arrival.

Regulatory signs Design parking and other regulatory signage to work at several levels, starting with simple directional cues for drivers and ending with directional signs for pedestrians as appropriate. Include parking space identification along with rules, regulations, and hours of operation as appropriate for individual sites.

Interpretive signs, markers, and plaques An integral step in the development of the interpretive plan is the selection of appropriate interpretive tools. These tools need to be versatile in size and medium to provide opportunities for interpretive stories of different content and length. Whether static or electronic, these elements need to be right for the context, and to support and enhance the message.

Design process and system guidelines

The wayfinding and signage planning stage should result in a catalog of recommended sign types with functional descriptions and preliminary cost estimates. These elements are executed in schematic form and can be placed into photographs of typical locations with indications for color, message, and scale. This schematic document should also contain a set of goals and objectives that are mutually agreed upon, but flexible, to become the springboard for the design of the system.

The design process The design process should be a thoughtful, rigorous search for the most appropriate and visually exciting ideas; a signature "kit of parts" that can become the basis for the system. Use a sketch and modeling process to study form, hardware, use of logo/logotype, typography, color, scale, and site location. Functional aspects should be investigated simultaneously and can greatly inform the design including: wayfinding strategy, nomenclature, information hierarchy, legislation considerations, changeability, placement, sequence, modularity, materials, lettering technologies, fabrication methods, maintenance, and cost.

System guidelines For any system to succeed, it is essential to have a guidelines manual. These guidelines describe and specify the elements that have been developed for the system. The table of contents can include everything from how to use the manual to chapters on proper use of the logo/logotype, typefonts, color, promotional materials, signage drawings and details, interpretive tools, print and promotional materials, maps, and complete performance specifications.

Other heritage experiences

Some other heritage experiences are discussed in the sections below.

Heritage plazas Plazas and public spaces are important centers or nodes for people to meet, congregate in and pass through. These

18

19

20

21

Fig 22 Discover Philadelphia interpretive kiosk, Cloud Gehshan Design Associates

Fig 23 Strands of History exhibition wall at the California State University Chancellor's Administration Building, BJ Krivanek Art + Design

Fig 24 Boston Freedom Trail interpretive kiosk, conceived by William Schofield

Fig 25 Biddy Mason interpretive wall, Sheila De Bretteville

Fig 26 Interpretive bus shelter, Cloud Gehshan Design Associates

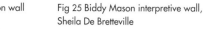

surfaces present an exciting opportunity to tell a story, incise important historic milestones, or present an historic map of the region.

Heritage trails Historic walking tours are a prominent feature of most heritage experiences. Linking contemporary and historic sites through self-guided tools such as guidebooks, annotated maps, interactive videos, and interpretive kiosks can help visitors preview different tours and plan their experience accordingly.

Heritage artwork Murals have long been a medium for telling stories and elevating people, places, and events in a painterly and powerful way. Existing building surfaces have been the favored canvas on which most public murals have been displayed. Sculpture, mosaics, and other forms of 3-D expression can support heritage stories, animate and activate public spaces, and create interactive objects for children to explore.

Heritage walls A heritage wall can be a fluid and serpentine wall tracing the edge of a canal that has long since disappeared, or an existing vertical surface in a public plaza. It can form the backdrop for embedded artifacts and text, or it can support graphic panels. Constructed from permanent materials, it can also function as a protective guardrail or help to define pedestrian walkways.

Fig 27 Blackstone Heritage Area system guidelines, Selbert Perkins

Fig 28 Portland Harbor Walk, Mayer Reed

Fig 29 Desert Lives Trail, Thinking Caps

Fig 30 Brooklyn Bridge centennial plaques, Keith Goddard

Fig 31 Welcome Park at Independence National Historic Park, Venturi, Scott Brown & Associates

Fig 32 New York Heritage Trails, Chermayeff & Geismar

Fig 33 Boston Freedom Trail, conceived by William Schofield

Schuylkill River Greenway Association Cloud Gehshan Associates

In December 2003, the Schuylkill River Greenway Association (SRGA) retained Cloud Gehshan Associates and Standing Stone Inc. (security consultants) to establish an emergency management sign system for the Schuylkill River trail system. The study consisted of site observation, surveys, and interviews with stakeholders and emergency service providers within five counties.

Since the first 60 minutes after an accident are the most critical to saving lives, the best tool you can offer is the ability to find and treat an injured person quickly. Our first goal was to develop a location system for land- and water- based travelers to effectively communicate their location to emergency service personnel. Signs also warned of restrictions: for example, if fire trucks or emergency vehicles were incapable of traversing a certain area of the trail, that information needed to be conveyed. A second goal was to increase the ease with which river water trail users could identify their location by reinforcing the locations of man-made and geographical features.

Principles for the location indicator system

To develop an effective system, it is crucial to understand how emergency personnel operate as well as how people react in crisis situations. It must narrow the search area as accurately as possible. It is also necessary to study existing numbering systems (trail and river mile markers, etc.) to determine whether they can be used as part of an effective location indicator system. The following principles were used in creating this system:

→ The location indicator system should be reduced to the simplest identifier and applied consistently in land and water environments.
→ Location indicator numbers along the corridor should be unique, in the same manner as a street address.
→ The system should provide for locations along canals or river tributaries.
→ Emergency locator indicators should coordinate road access, foot trail access, and important river points.

The location indicator number The numbers established for the SRGA use the River Mile System. This system is recognized and published by the Delaware River Basin Commission and is effective because it is a nonchanging continuous system. The single numbering system allows unique addresses to be assigned and coordinated along and across the river and its tributaries in a logical and consistent manner.

When the emergency operator keys in the location indicator number, access roads, boat launches, local geographic information, and corresponding trail points on both sides of the river quickly come up. This information can then be relayed to the appropriate response team. The database (GIS) will provide the county, township, park, and appropriate response teams with the most accurate location information.

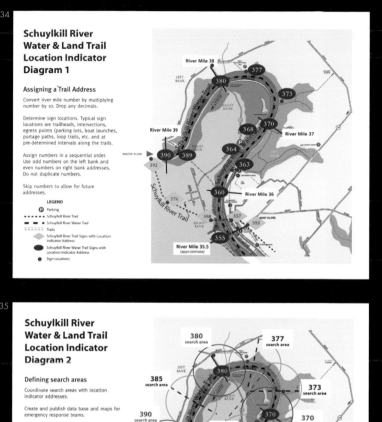

Fig 34 The address number is the river mile number multiplied by 10. Decimal points are not used and the water trail and land trail addresses are differentiated through geometric shapes and colors.

Fig 35 An alpha modifier distinguishes the Schuylkill River land and water trail tributary addresses from the main Schuylkill River land and water trail addresses.

The Wissahickon Valley Park Cloud Gehshan Associates

The Wissahickon Valley is a spectacular forested gorge that is a much-treasured part of Philadelphia's Fairmount Park, a system of neighborhood parks that comprises one-tenth of the land in the city. "Forbidden Drive," so named since it was closed to vehicular traffic in the early 1900s, is a peaceful, tree-lined pathway frequented by runners, walkers, cyclists, equestrians, and cross-country skiers. A strong sense of community ownership in the area created special challenges for the team.

Despite the generally agreed-upon need for new signage, there was much concern that the signs not result in "visual pollution." By listening to stakeholders, a sign system was created that complements the natural surroundings and reduces the overall number of signs. Low-profile signs do not obstruct the natural vistas and views. The low-profile signs are accessible but not intrusive—visible for those who need them, but not intended to dominate.

Relatively few users of the Wissahickon Valley knew its history or importance. From its first use as a route for Indian migration, through European settlement and the American Revolution, the Wissahickon Creek was also host to more than 50 mills during the height of the Industrial Revolution.

According to Dommert Phillips, Cloud Gehshan's interpretive consultant on the project, knowledge about a park's resources, ecology, and history is a key to promoting stewardship for the environment.

Inspirational messages, such as writing, poetry, or quotes from famous people who have a close association with the area became powerful tools for creating an emotional connection with the park.

Things to be considered:

→ Anticipated audiences/special characteristics/reading level
→ Audience knowledge about the area/common myths or misconceptions
→ Take-home messages
→ Defining the voice to deliver the content
→ Characteristics of the writing style
→ Single perspective vs. multiple perspectives on a portrayed topic
→ Content to be timeless vs. representative of current attitudes and opinions

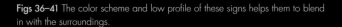

Figs 36–41 The color scheme and low profile of these signs helps them to blend in with the surroundings.

Heritage areas and parks design recommendations

→ Adopt a user-based approach. Designing with this approach:

→ creates a welcoming experience and connects people to the important stories and events;

→ establishes a visual identity that is expressive and appropriate to place;

→ recognizes that wayfinding is more than signs: it integrates signs, gateways, landmarks, views, and pathways into a legible system that works by day and night;

→ supports all types of users, considers who they are, how they are arriving, and the purpose of their trip;

→ recognizes a multimodal environment with bicycles, cars, pedestrians, transit, and taxis;

→ emphasizes the 20 percent of users who will have wayfinding or orientation problems;

→ enhances safety and the perception of safety;

→ coordinates with maps (printed and Internet) and verbal directions;

→ culminates in design guidelines describing proper use and specification; and

→ establishes a framework for contracting, maintenance, and replacement.

Fig 1 Tangeman Center at the University of Cincinnati Prewar campuses held to traditional campus-planning ideals, with the symmetry of neoclassical design.

Fig 2 Helsinki Technical University, Alvaar Aalto

Fig 3 Illinois Institute of Technology campus, Ludwig Mies van der Rohe The modern campus buildings broke from all tradition, including symmetry and neoclassical order.

13 Universities and campuses
Kelly Kolar

Everyone has an image of the prototypical university in their mind; leafy pedestrian walkways linking symmetrical classical buildings with large front porticos. This *was* the predominant model for universities until WWII, and their wayfinding needs, as a result, were minimal. Few campuses had more than 5,000 students and every building was connected by line of sight. Beyond the engraved facade there was little need for further wayfinding assistance.

A short history

Two changes exploded traditional ideas about campus wayfinding. The first was the rapid expansion of universities starting in the 1950s. Campuses matured to become mini-cities with multiple libraries, performance spaces, classrooms, dormitories, and retail spaces. The second transition was the rise of the modern architecture movement, a precedent set by Alvar Aalto's Helsinki Technical University and Ludwig Mies van der Rohe's Illinois Institute of Technology Campus. Modern university buildings began to have multiple entrances and asymmetrical layouts. Campuses lost their basic navigation structure, thus creating the need for signs, maps, and other informative kiosks.

In the 1960s, universities began to tie themselves more strongly to the cities and towns in which they were located. This established a trend of creating urban districts in which streetscape design elements, graphics, and signs closely matched the surrounding urban environment. Systems

Figs 4 and 5 Uptown signage systems, Schenker, Probst & Barensfeld/Chuck Byrne Design A collaboration of designers affiliated with the university created an academic study to establish the new district identity, with the university as the focal point.

Fig 6 Sign experience diagram.

such as the "Uptown" system, built in Cincinnati in 1984, blurred the lines between campus and city. This vehicular city signage plan brought together cultural institutions, hospitals, and landmarks to create a cohesive wayfinding system.

Issues in campus wayfinding today

Today, universities are living, breathing, and ever-expanding institutions. They are complicated environments with high traffic and accessibility issues. Connection is critical as a typical visitor transitions from major highways onto major arterial city streets to local roads, and eventually to campus gateways. From there, parking facilities and a pedestrian wayfinding system direct visitors to multiple destinations. The case study on p 151 is a good example of a comprehensive system.

A "sign experience" diagram illustrates a better understanding of access to modern universities in relation to the urban streetscape. A sign system in this environment must support the full gamut of user situations, from infrequent visits by out-of-towners, to large groups attending a sporting event, to prospective students visiting the campus for the first time. These factors create the need for a navigation system with a clear hierarchy of messages that is integrated into the campus and community environment.

Advanced technology now plays a major role in successful wayfinding systems. The Johns Hopkins University, for example, makes use of one-

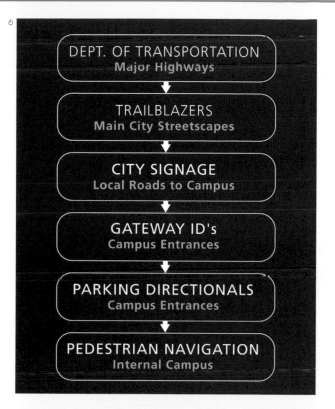

6

DEPT. OF TRANSPORTATION
Major Highways

TRAILBLAZERS
Main City Streetscapes

CITY SIGNAGE
Local Roads to Campus

GATEWAY ID's
Campus Entrances

PARKING DIRECTIONALS
Campus Entrances

PEDESTRIAN NAVIGATION
Internal Campus

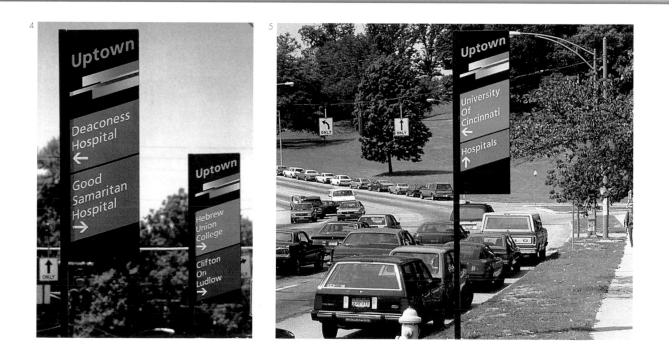

Fig 7 Johns Hopkins University electronic kiosk, Cloud Gehshan Associates

Fig 8 and 9 People, product, brand, and place analysis diagrams.

Figs 10 and 11 University of Maryland Medical Center, Cloud Gehshan Associates

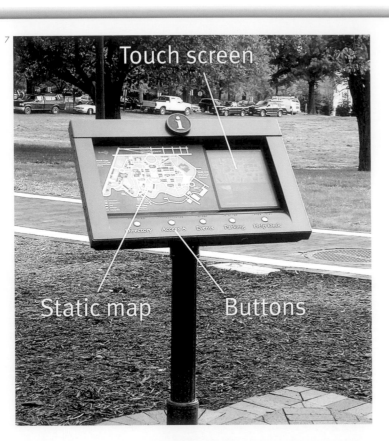

7

stop wayfinding centers by establishing a network of 12 computerized kiosks. Called "i-Sites," these kiosks combine cutting-edge technology with customized structures and software. Although hi-tech, the low-profile units are designed to fit into a campus where the traditional architecture and park-like grounds are prevalent. In the near future, as technology becomes more affordable and accessible, it will support the ongoing communication needs of the event-filled university setting. One may see "public information systems" linked all over campuses to celebrate and communicate major events and student life activities.

The integration of a university sign system within the city fabric and campus environment results in a memorable visitor experience. This conjunction can capture the institution's unique sense of place and offer a branding opportunity.

Four ways to understanding the user

It is important to gain a complete understanding of the people, product, brand, and place through analysis. Analysis diagrams illustrate the cultural makeup of an organization and its interrelated parts. Wayfinding and environmental graphics provide an opportunity to bring to life the connection of brand and place.

8

9

10

11

Figs 12–14 University of Cincinnati Main Street District, Hargreaves Associates/Glaserworks, Kolar Design/Shortt Design The Main Street District represents a new trend of modern campus wayfinding and identity programs with wayfinding signs directing to a mix of retail, academic, theater, and recreational areas. All the buildings were tied together with a streetscape program containing the best aspects of city and university pedestrian life, including large-scale public art, sculpture, and graphics.

People—the university community The makeup of the university community is a unique and diverse combination of users. This can include the leadership, faculty, employees, alumni, and residents of the surrounding community who support the institution, as well as the current and prospective student body attending the institution. Wayfinding systems focus on the first-time or infrequent visitor because they are the least familiar with the campus setting. Supporting documents include:

→ Student population demographics
→ Visitor and parking services
→ Student life and campus events

Product—higher education The university's mission and dedication to the importance of higher education plays a paramount role in understanding *who* they are and *where* they are going as an institution. Its philosophy, characteristics and academic offerings could be reflected visually in wayfinding applications. For example, the University of Maryland Medical Center artfully uses the form of the gene helix to illustrate the mission of the organization (see figs 10 and 11). Supporting documents include:

→ Mission statement
→ Current initiatives

Brand—the university image The historical and contemporary image of the university is often reflected in branding guidelines and marketing materials. Many institutions maintain a seal or crest on signage because it will outlast the evolving branding efforts of the university and is usually related to the campus setting. Many are also revisiting the role of signage in relation to the branding efforts. A wayfinding system can be a 3-D extension of this public image and in many situations is the first touch-point for the visitor. Supporting documents include:

→ Campus graphic standards or brand guidelines
→ Marketing or business plans

Place—the campus setting The physical size and geographical locations of the university (single or multicampus) should be evaluated along with its urban planning and unique landscape. It is valuable to gain an understanding of the current master plan of the university and review future building opportunities. It is possible to create a seamlessly integrated vehicular and pedestrian experience that defines the roadways, parking, and pedestrian paths that lead you to individual destinations or unique districts on campus. For example, the University of California, Los Angeles' Main Street district defines a new "heart" and "student-life district" within the campus. District identity and wayfinding are integrated into the built environment through the use of information and map kiosks, landmark sculptures, and banners.

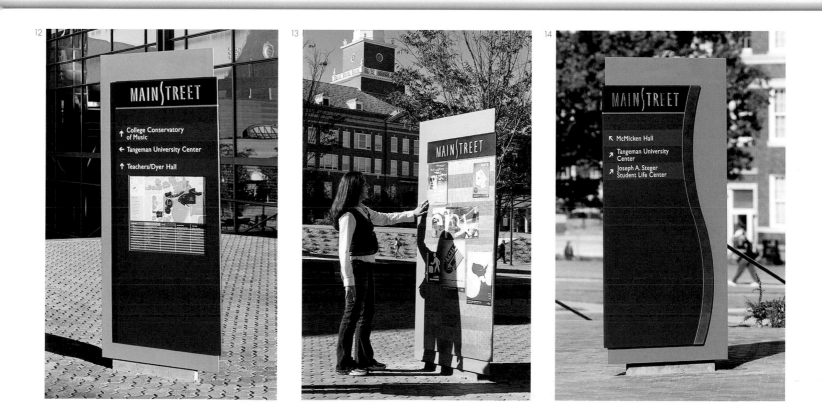

Figs 15 and 16 University of Cincinnati
Food-court and book-store sculptures,
Hargreaves Associates/Glaserworks,
Kolar Design/Shortt Design Stylized
iconographic sculptures reflect the
Main Street character, and function
as landmarks.

Fig 17 University of Cincinnati Main Street
District, Hargreaves Associates/
Glaserworks, Kolar Design/Shortt Design
Metal banners emphasize district identity
and the "S" pathway that meanders
through campus.

16

![Tangeman University building with glass facade and sculpture]

Supporting documents include:

→ Campus plan or master plan
→ Building facility and maintenance plan
→ Fire and safety plan
→ ADA guidelines and routes

Wayfinding systems primarily function to connect the place with the
brand, contributing to the unique sense of place. An excellent
wayfinding sign system is one that blends the needs of the user with
the built environment and can play a role in contributing to the overall
esthetic and impression of the university.

An understanding of these key issues is a holistic approach to a
wayfinding design plan that takes into account *who* the university is,
where it is going, *what* its user needs are, and *how* it implements its
master plan. The sign system goes beyond completing a wayfinding
need—it can contribute to the culture of a university and its unique
sense of place.

17

University of California, Los Angeles campus sign guidelines Biesek Design

At the University of California, Los Angeles (UCLA), with nearly 500 acres (c. 202 hectares) of campus to contend with, wayfinding is approached as a work in progress. For this program, Biesek Design developed signage guidelines and implemented a master plan that includes:

→ Campus sign standards
→ Roadway sign system
→ Parking sign standards
→ Pedestrian wayfinding
→ Architectural signage
→ Americans with Disabilities Act (ADA) and life safety signs
→ Donor recognition

The Biesek team began developing campus wayfinding standards for UCLA in 1993. Working with campus architects, facility managers, and the Chancellor's Office on Accessibility, the firm began an audit to evaluate the varied mix of the signage and the architectural vernacular in key parts of the campus in order to get a feel for its tradition, and to look ahead to future needs. This included vehicular and pedestrian wayfinding, sign nomenclature, sign code compliance, life safety and accessibility issues. The audit enabled the team to identify specific issues, develop parameters for future projects, and build consensus among stakeholders. From this initial effort, a collaborative process began to emerge—among campus planners, architects, project managers, and the campus sign shop—focusing on a broad range of issues from immediate needs (upgrading specific buildings), to long-term plans (signage master planning).

Biesek Design utilized a discipline similar to that of architecture (i.e., planning, design, and construction methodology). The process incorporated suggestions from administrators, facility operations, fire and police representatives, and special-interest groups. Enough flexibility was built into the program to allow interior signage to complement the architecture. Implementing the sign program was a large undertaking that required a commitment of time, funding, and a sincere desire to create a sense of order and wellbeing through wayfinding elements. At UCLA, the Biesek team incorporated four powerful tools to help augment the campus identity:

→ UCLA campus sign guidelines
→ UCLA signage color scheme
→ UCLA campus typeface
→ UCLA campus maps and nomenclature

In 10 years, more than 25,000 signs were fabricated and installed in campus buildings, which included both new architecture and renovations. UCLA has been diligent in requiring that all new signs use the campus typeface, and this has paid off superbly. The campus feels and looks like a mecca of higher education with its classic architecture and modern buildings unified by brushed bronze lettering of identical typeface, size, and finish.

Roadway sign system

Initial awareness of the campus and the medical center begins with the roadway signage on the freeway and along arterial streets. Working with local transportation authorities, designers planned and implemented off-premise signage for the campus, including hospital directional signs that helped people find their way to emergency services. Gateway entrances and roadway signs provide an opportunity to introduce the wayfinding system. Standards were created for roadway signage, campus maps, and neighborhood maps. Pedestrian trailblazer information helps to smooth the first-time visitor's transition from vehicular to pedestrian activities.

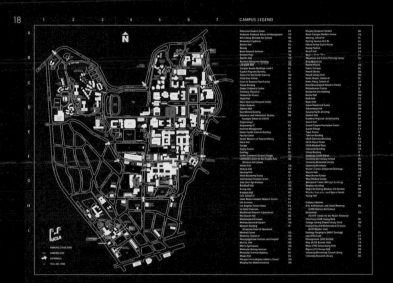

Fig 18 Campus map.

Parking sign system

Tens of thousands of cars fill more than a dozen of UCLA's major parking structures. Many of these structures are multistory; some are subterranean, which creates special wayfinding challenges.

In response to these wayfinding—and car-finding—challenges, Biesek devised new standards for identifying parking facilities, color-coding for floor-level orientation, neighborhood maps (as you leave the parking zones), and a specialized row-numbering system for subterranean mega-parking zones.

Pedestrian wayfinding

The scale of the UCLA campus—it has more than eight major entrance points—can overwhelm first-time visitors. The campus has information kiosks at every main entrance, staffed by knowledgable personnel who provide maps and information. For a campus with 44,000 vehicle visits per day, this human dimension is invaluable.

To enhance pedestrian activities, standards were created for street signs, campus maps, vicinity maps (specific to campus quadrants and neighborhoods), trailblazer signs, and destination identification of buildings and public venues.

Architectural signage

Many campus buildings were originally constructed around 1930, when craftsmanship was unparalleled. Newer architecture includes signature buildings by architects like Venturi, Scott Brown (Gonda Research Center); Cesar Pelli, Perkins, and Will (research buildings); and Pei Cobb Freed (Anderson Complex), as well as historical reconstruction upgrades by Barton Phelps (Royce Hall) and Moore Rubel Yudell (Kaufman Dance Building). To unify these various elements and eras, as guided by campus architects Charles Oakley, Sarah Jensen, and Marc Fisher, a wayfinding strategy that uses signage to cohere and complement the variety of architectural styles was produced.

These new sign standards promote the use of venerable materials like bronze and carved stone, which will last for centuries, and porcelain enamel, aluminum, and acrylic signs, which will last for decades.

Disabled access/safety signs

A prime directive of wayfinding—comfortable and successful access—is a concept that the Biesek team actively promotes. At UCLA, the tactile signs, their size, placement, and typography, more than met legal and safety requirements. They are designed to benefit a broad audience in the spirit of "universal design," which is an inclusive program that communicates to everyone.

The design team is intimately familiar with sign codes and compliance issues relating to life safety, fire and earthquake safety, evacuation and exit standards, and campus security.

Donor recognition

Donor recognition, properly executed, can add an elegant finishing touch to an architectural environment and reward generosity with a formal "thank you" in graphic form. At UCLA, letters have been carved into buildings and plazas, bronze plaques set into granite benches, and wall niches built into entrance lobbies, with architectural down lighting to accent the graphics.

Recognition graphics honor the indelible contributions of students, alumni, and benevolent donors. Biesek Design approaches donor recognition as an opportunity to merge architecture with graphics in a harmonious manner. Creating gracious solutions that appropriately—and sensitively—recognize the level of giving is a hallmark of their design.

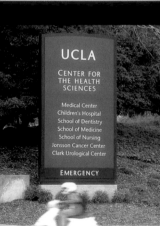

University of Pennsylvania, Philadelphia

Calori & Vanden-Eynden with the Department of Facilities and Real Estate Services, Office of the University Architect, and The Olin Partnership

The multiphased, multiyear University of Pennsylvania wayfinding project involved the design and programming of a dynamic new signage system for the 270-acre (c. 110 hectare) urban campus of the University of Pennsylvania. Directional signs, identification plaques, building identification pylons, map kiosks, message boards, regulatory sign posts, monumental campus ID signs, and access symbol signs comprise the overall wayfinding system. Clean, simple, and inexpensive, the entire program had maintenance and replacement concerns as top priorities.

Established by Benjamin Franklin in the mid-1700s, the University of Pennsylvania was the first university established in the United States and is one of the prestigious Ivy League universities.

The project is completed through Phase 1—the main central campus. Phase 2—the balance of the campus—will be completed by the in-house staff of the Department of Facilities and Real Estate Services. The entire project was under the direction of the Office of the University Architect.

Calori & Vanden-Eynden (C&VE) started on the project in 1999. Shortly thereafer the project underwent a hiatus until 2001. An initial prototype installation, consisting of one blade sign, two plaque signs, and one small monument sign, was installed in the spring of 2003. The Phase 1 installation took place during a six-month period ending in July of 2004. Two people held the position of University Architect during our work, and further compounding the lengthy decision-making process, the entire facilities department office moved during the course of the project. The signage program was an initiative of the President of the university. After starting and stopping over a four-year period, the project team came under pressure to complete the Phase 1 installation before the existing President resigned in late 2004.

Building on existing designs
The cut-through crest used on the signs was adapted from one of the contemporary versions in use on campus. Our intention was to veer away from the highly stylized crest developed by Chermayeff & Geismar Associates (CGA) and return to a slightly more traditional look, while projecting an up-to-date public image. CGA designed a very successful sign program for the campus in the mid-1970s. It stayed in situ until C&VE replaced it in 2004. The CGA system consisted of a series of blades and plaques, similar to, but smaller than those designed by C&VE. Like any system that survives for 30 years, it had begun to break down and look a bit dated.

C&VE initial concepts did not resemble the final design. The CGA system was well liked and had the positive qualities of being simple and easy to maintain, which the university powers wanted to retain. C&VE's final design adopted the best qualities of the CGA system and updated the look with larger sizes, ADA-compliant typography, fresh materials (no coatings), and a cut-through U Penn crest. Whereas the

25

Fig 25 Pylon directional blade sign.

26

Fig 26 Pylon destination sign

CGA system used an abstraction of the crest, C&VE embraced the entire crest. Key to the process was the introduction of additional information on the blade and plaque signs. C&VE recommended that building addresses be added to the signs. The addresses facilitated FedEx and courier deliveries—services not nearly as common during the mid-1970s—and life safety services also benefited from them.

Process of implementation

The program included the removal of all existing CGA signs and the remnants of several other systems, including the colonial-style signs.

The position of the crest on blade signs, and its orientation to sidewalks and pathways was an issue. As the signs' layout is asymmetrical, C&VE recommended that, where possible, the blade signs always be positioned with the crest adjacent to the pathway. For example, facing a walkway with a north–south axis, a sign on the east side would have the crest on the left side. A sign on the west would have the crest on the right. Obviously, this was not possible in all cases, but it served as a guide.

The system uses aluminum sheet with a nondirectional finish. It has no coatings applied to the surface so graffiti and stickers can be cleaned using solvents without damaging the sign surface. The crest is water-jet cut and painted. Typography is applied to vinyl using high-bond adhesives and set using a heating/baking process. The signs are set in concrete footings or mortar, and plaques are pin-mounted to wall surfaces and set with mortar. The project was fabricated by Architectural Graphics, Inc. (AGI) and installed by a local contractor familiar with the working conditions and union requirements of the Pennsylvania campus.

The working process and collaborations

There were numerous working meetings and presentations to various levels of the university administration, including several to the design review committee, the Provost, and ultimately the University President. C&VE also worked closely with The Olin Partnership (the campus master plan landscape architects) during the design period.

"No Ivy" was a statement often made during the design period. Although the University of Pennsylvania is considered one of the Ivy League schools, and it has a traditional Ivy Day event, ivy has been removed from most of the buildings on campus since it causes damage to the stone and brickwork. Ivy now grows only in planter beds. Ivy, therefore, had taken on a less-than-favorable image.

C&VE did not produce a standards manual. The Department of Facilities and Real Estate Services has in-house capabilities. The new materials were incorporated into existing documentation developed, produced, and maintained by in-house staff.

27 28

Fig 27 Typical building id plaque with building name, address, architect, and dedication date.

Fig 28 Typical plaque sign including tenant information.

University and campus design recommendations

→ **The charge/initiative** A president can charge an individual or department with the creation of a sign system or master plan. The plan will establish procedures, policies, and esthetics of the system.

→ **The committee** Once charged with the task, a committee of stakeholders will be formed to facilitate and guide the process. This may include writing an RFP (request for proposal) and selecting a consultant. A committee may include members from the university community such as architects, landscape architects, designers, planning, facility management/maintenance, faculty, user groups, and marketing.

→ **Design criteria** The committee and the consultant will develop the goals and design criteria of the project based upon needs of the university. This may include an audit, analysis, planning, and recommendations phase.

→ **Design** Once selected, the design consultant or in-house environmental graphic designer will create a visual language and appropriate design system through the phases of schematic design, design development, and construction documentation. The designer will guide the committee and build consensus of recommendations to be approved by the president and cabinet of the institution.

→ **Fabrication** Implementing the system in a phased approach or campus wide will be dependant upon budgets, time frames, and schedule. A public award bid process or an in-house manufacturing/maintenance department are both viable options for fabrication.

→ **Installation** Standards for installation are necessary for locations, orientation, methods, and height. The installation is coordinated with building construction schedules and may need to have a temporary system as the campus development is phased.

→ **Maintenance** The university should have equipment and staffing to maintain the consistency and quality of the design. Institutions are able to add required maintenance equipment to the bid process in order to properly maintain the set standard.

→ **Standards manual and guidelines** Typically, a designer creates a manual that visually defines the design vocabulary, sign types, and related documents so that any professional can work within the system to implement the standards successfully. The manual also defines the process and approval guidelines for additional sign requests.

→ **Training and education** Ongoing training and education of firms working with standard manuals will ensure the optimization and accuracy of the system. This includes the review personnel at the university that may be implementing building projects.

→ **Annual review** The committee of stakeholders should review the standards annually and evaluate the changing needs of the academic environment. They can make recommendations for further study or inclusion of sign types to better the needs of the users on campus.

14 Sports facilities
Charleen Catt Lyon

The protagonist in W.P. Kinsella's 1982 book *Shoeless Joe* (and the hit movie *Field of Dreams*) was compelled by inner forces to build a ballpark in his Iowa cornfield. He was driven to create a venue that would eventually draw thousands of people, all looking for the same thing—something authentic. Kinsella understood the ethos of sports fans everywhere. Attending a sporting event, no matter if it's a Little League game or the World Series, is real-time drama. Nobody knows how it will end. That's what keeps the fans coming.

A short history
Professional sports venues have been dramatically transformed over the last 40 years. Ballparks, stadiums, and arenas have evolved from simple amphitheaters for watching sporting events to become multifaceted hospitality facilities. They are being built in combination with convention centers, downtown revitalization projects, and shopping centers. They are seen as a central component of economic development because of their ability to generate foot traffic. In the U.S. during the early 1990s, as cities started to realize the economic benefits of having a resident major league sports team, they either built new stadia to keep their teams in town, or in the hope of luring a team to their city. A generation earlier, in the 1970s, many cities built new sports stadia that could host both baseball and football. These stadia could be converted from baseball to football with a few field changes.

Fig 2 Soldier Field stadium renovation, Wood and Zapata with Lohan Caprille Goettsch

Fig 3 The oldest stadium in the US still in active use, Fenway Park, in Boston, was built in 1912.

Fig 4 Camden Yards Ballpark, built in Baltimore in 1992, is reflective of stadia of the past.

It was especially easy when you didn't have real grass to worry about. Most stadia of that era used artificial turf or "astro-turf," a name coined when it was first employed in the Astrodome in Houston, Texas. Though the 1970s-era stadia were efficient and predictable, they did not offer the best sightlines for watching either sport. By the early 1990s, architects were beginning to think about more sophisticated issues like enhancing the fan experience and generating more revenue for team owners. Concurrently, the media was becoming a more important "partner" in the production of sporting events. They required better sightlines and better press rooms and communications infrastructure. Increasingly, sports venues have become sports-specific, necessitating at least two stadia in many cities.

The situation today

Today's professional sports venues offer a range of different settings (and price points) for watching the game. Club seats and suites are among the new innovations in stadium seating and bring in the most revenue. Often there are special seating decks, which offer exclusive access and may be sponsored by a corporate partner. Another recent innovation in stadium design is that handicap seating is now available throughout the venue. Lawsuits won by disabilities advocates in the 1990s have profoundly changed the design and geometry of seating bowls. A handful of earlier-generation ballparks, which escaped the 1970s and 1990s building booms, have now become cherished venues. Fenway Park in Boston and Wrigley Field in Chicago are now regarded as historic landmarks. Though facilities managers have struggled with how to upgrade these historic venues with the necessary amenities, such as adequate toilets and concession stands, their fans would lay down in front of the bulldozers if their existence were threatened. In fact, these treasured ballparks have provided a template for the latest generation of ballparks, which strive to cash in on nostalgia. The new sports venues, no matter how historic or modern they appear, offer fans amenities that their grandparents never dreamed of. Restaurants, sports bars, banquet rooms, food courts, party plazas, game arcades, and team stores create a new retail dynamic within them. Another recent innovation in sports architecture is the integration of a sports venue into a mixed-use complex. Arenas in particular may be integrated with other developments to capitalize on the flow of people. Philips Arena was built adjacent to the media giant CNN headquarters in Atlanta, Georgia. The synergy of CNN's headquarters, including its food court, museum, and store combined with the arena, creates a more exciting 24/7 atmosphere. Many newer arenas are being built alongside convention centers. Sports venues have become an important measure of status to cities around the world. They are part of the culture and, if trends continue, that will only become stronger as time goes by.

Figs 5 and 6 Khalifa Stadium, Dohar,
Qatar, Minale Bryce Design Strategy
The entire design vocabulary of the
stadium graphics was designed to take the
user from the far parking lot into the facility.

Why wayfinding design is important

The evolution of sports venues from simple assembly halls into more complex multifaceted buildings has contributed to the need for a stronger emphasis on wayfinding design. Our job as environmental graphic designers working in sports venues is to integrate the pragmatic issues of wayfinding, safety, and security with the emotional connections sports fans feel for their team. It is a thrilling endeavor to tackle such monumental spaces and develop a plan that will guide thousands of people while also entertaining them. There are a number of issues specifically connected to wayfinding design for sports facilities, as outlined below.

Transportation connections If you can even get a parking spot in a nearby lot, you may have to walk a long way, or catch a shuttle bus to get to a stadium gate. Some stadia have the capacity to park 30,000-plus cars, but require prepaid parking permits. Many stadia have handicap parking in their closest parking lots, but that can still be a long distance if you're mobility-impaired. Some sports venues, particularly downtown arenas, are well positioned near mass-transit connections. Even if a stadium is located far from mass-transit connections, there is usually a game-day express bus or shuttle service that provides linkage. Transit connections need to be clearly marked and some wayfinding signs may be needed to guide people to the

temporary bus loading zones set up near the venue. Parking operations cannot be successful with signage alone. Traffic police usually suspend the traffic signals and direct traffic by hand. A series of flaggers and strategically positioned check stickers direct cars and "stack" the parking aisles. Temporary "tent" signs are usually strategically positioned on local streets to cue motorists at every step.

Vast distances Finding your way around the grounds can be daunting. On game day, a virtual tent city erupts in otherwise barren parking lots. In many cities, football "tailgaters" set up housekeeping early Sunday morning, complete with lean-tos, grills, and ample food and drink. Nearby, exclusive corporate-sponsored tents provide an oasis of hospitality for pregame schmoozing. Navigating your way through this impromptu village can be tricky; usually the best way to provide guidance is to use temporary signage.

Mass ingress/egress The primary design challenge for wayfinding designers is planning for the huge ingress and egress of crowds. To give you an idea of the volume of traffic, a typical major league ballpark seats 40,000–45,000 people and hosts approximately 80 games a year. A sporting event is time-sensitive, which makes getting people in quickly and safely an important mark of success. In addition to the tailgating tradition, venue managers have devised creative ways to smooth out the mass influx of people by offering pregame activities

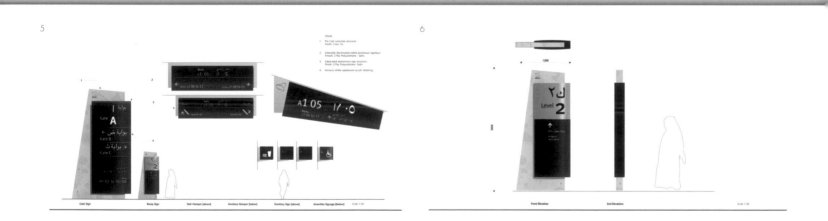

5

6

for the whole family including party plazas, playlands for kids, brunch or dinner in the club restaurants, etc. Not only do they get patrons to run through the turnstiles earlier, they have more time to make money selling drinks, food, and T-shirts.

Disabled access Due to the vast distances people must walk when going to a sporting event, shorter pathways have been developed for mobility-impaired patrons. For example, there may be an elevator accessible at the ground level, which expedites the trip into the stadium for someone in a wheelchair. Under U.S. law, a percentage of handicap seating, in each price category, must be designed into every venue. Because handicap ramps for seating may only occur at selected locations, it is important for signage to indicate which pathway into the seating area the handicapped user should take.

Complex routes As the architectural program for sports venues has become more multifaceted, navigating these buildings has become more complex. With each new project, architects program new amenities, which necessitate new and interesting ways to organize space to accomplish their programmatic goals. The upshot for wayfinding is that there are "dead ends" in some of the concourses. Consequently, spectators may need to understand which gate and which concourse "fragment" will allow them access to their seats. Though the seating bowl may look like a unified contiguous space,

access to these different seating areas may not be from a contiguous concourse. Premium seating areas, which have exclusive club ticket access, may interrupt the public concourse, thereby creating a dead end for regular ticket holders. Therefore, knowing which ramp or stair to take to get to your seat is important. Wayfinding signs, whether static or electronic, are the first line of defense, but ushers can also do a lot to get people on the right path to their seat.

Ushering Signs are the primary way people find their way to their seats, but the role of the ushering staff cannot be underestimated. Wayfinding planners should make sure they are coordinating their routes with operations staff. Predicting bottlenecks and troubleshooting flow problems is an important part of the planning process. Operations staff can usually estimate the volume of ingress they will experience over the course of one hour prior to game time. Pathways that may appear to be legitimate routes on the architectural plans may not be accessible in a real game-day situation, due to security concerns.

Security Signage regarding rules and regulations is usually posted near entrances, to support the safety and security programs enforced by management. Other signs within the facility may help define what spaces are off-limits. Seat section signage posted inside the bowl can help security guards quickly identify seat sections where a disturbance may be taking place.

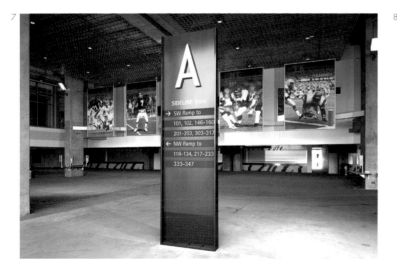

7

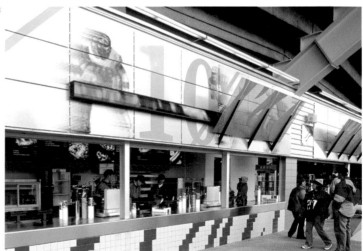

8

Fig 9 Rose Bowl signs and graphics,
Hunt Design Stadium graphics are almost
entirely based on outdoor conditions.
Colors need to stand up to ultraviolet rays,
wind, dirt, and moisture.

Fig 10 Pacific Bell Ballpark, San Francisco,
Debra Nichols Design The design of the
ballpark sign is built to stand the elements
and the test of time, by using extremely
vigorous materials.

Maintenance Putting signs into the environment in a sports venue is a lot like the classic plots in literature: man against nature, man against man, and man against himself.

→ **Man against nature** In open-air stadiums and ballparks, the omnipresent forces of nature soon ferret out the weak materials, the substandard processes, and the poorly conceived details. Ultraviolet rays, wind, dirt, and moisture are on a "search and destroy" mission—and they will find your signs. These insidious forces will conspire to claim whatever they can. There's only one line of defense against them—research.

→ **Man against man** Vandalism is an ongoing concern that has challenged the sign industry to devise evermore ingenious materials. At a sports venue, it is advisable to be proactive with regard to the abuse disgruntled or inebriated fans may dish out. There are many theories about why vandalism occurs, but that is not the subject of this book. However, it has become a well-accepted fact that vandalism left to fester invites more vandalism. It is more easily perpetrated when the area is isolated and hidden from view.

→ **Man against himself** As designers, we are always striving to create exciting, fresh solutions. We may be eager to try a new material or build a sleek structure that defies gravity. With the proper research and design exploration, we may succeed. However, sometimes problems cannot be anticipated. Whether it's the designer's mistake or a fabricator's error, a weak detail can become a maintenance problem. It's reasonable to expect the life span of your sign system to be seven to ten years. However, some materials or processes may not last quite that long. For example, paint finishes may only be good for five years before they begin to fade or dull. Large-format graphics may only last as long as three years before they begin to fade.

→ **Cleaning and repair** When a project is built, it is wise to require the fabricator to provide a "maintenance manual" in which they spell out the ways to care for the sign system. For example, it should explain which cleaning compounds can or cannot be used. The manual may also specify the types of hardware that were used or where replacement parts can be ordered. Some extra parts, typically referred to as "attic stock," may be purchased when the job is built, so as parts wear out, fresh replacement parts are on hand.

Naming rights and sponsorship Over the last few decades, corporations have come to recognize the marketing cache of sports and have sought to tie themselves more closely to team sports as a way of winning more name recognition with consumers. The lucrative practice of selling naming rights to corporations comes with some strings attached. Depending on the size of the deal, the team will have

9

10

Figs 11 and 12 American Airlines Arena, Gottschalk+Ash International More than any other facility, sponsor names must completely integrate with the identity of the stadium to create a successful overall identity.

Fig 13 Lincoln Financial Field, Philadelphia, Catt Lyon Design + Wayfinding Large banners and wraps are a high-impact and less expensive way to quickly brand a stadium.

11

to guarantee a certain amount of exposure for the corporate sponsor. Though it may include broadcast, print, and Internet exposure, signage is always a very large component of the deal. Working out the right balance of naming rights identification and wayfinding information on signage is always a challenge.

Team branding Graphics celebrating the resident team help make the house a "home." It is an extremely important element to building fan appeal. Since the most successful team personalities are a reflection of their fans, there are many natural built-in sources for imagery, including references to regional, cultural, and historical ties. Sometimes there's more than one tenant in a venue. This necessitates a more flexible strategy, so that change-outs for each tenant can be expeditious. Thematic graphics can be embedded into the environment using a range of materials and processes suitable for both exterior and interior use. Materials may include everything from wallpaper, fabrics, tile, and concrete, while processes may involve etching, dying, inkjet printing, sandblasting, and silk screening.

12

13

Fig 14 American Airlines Arena,
Gottschalk+Ash International
Dynamic signs today have the ability to be
configured in any format to meet the
specific needs of the facility.

Fig 15 Paul Brown Stadium,
Catt Lyon Design + Wayfinding
The scoreboard is a focal point for
fans within the stadium.

14

Electronic signage The quickly advancing technology of electronic signage is opening a whole new dimension for variable message signage (VMS), and there's no place more eager for this technology than sports venues. For years, scoreboards have been evolving into evermore sophisticated displays, with each new venue one-upping the previous venue with bigger, brighter displays. Along with the improvements in optics, content management, and integration, software has increased the level of graphic sophistication. The implications for advertising and sponsorship are very attractive. Since most sports environments are already peppered with televisions, the information backbone is already there. The return on investment for an electronic sign system must be weighed against what kind of revenue it will generate. The investment is not just in the hardware and software, it's also an investment of human capital. Fortunately, the people who can program the system and keep it running are probably already part of the scoreboard production team.

15

Fig 16 Soldier Field seating diagram,
Catt Lyon Design + Wayfinding

Figs 17 and 18 Citizens Bank Ballpark,
Philadelphia, The Douglas Group
A well-designed sign system must integrate
the identity of the sponsor, electronic
needs, wayfinding needs, and retail needs
in one seamless package.

Directing to seats

The best strategy for getting people to their seat efficiently is to get people in the right "gate." Interior concourses are usually very congested, so placing maps outside the venue enables people to circulate around the outside of the venue to the right gate. Once inside, it's a seat section number that people are searching for. Seat sections are usually displayed in ranges, based on their geographical locations. The more logical the seat section numbering is, the easier it will be for people to follow the signs. For example, numbers should begin and end at a natural break in the concourse. If the numbers arbitrarily change in the middle of a concourse, the messages will be more cumbersome and take up more space on the signs. Unfortunately, the numbering of seat sections may already be decided by the time the wayfinding designer is hired, making it difficult to change. Because concession stands and restrooms are so ubiquitous in sports venues, they really don't need to be listed as destinations on wayfinding signs. Public telephones are almost anachronistic in this age of cell phones. The important destinations are: seat sections, clubs, suites, ATMs, team store, and first aid.

Design process It takes several years and many millions of dollars to build a stadium, ballpark, or arena. The stakeholders involved may include city and county governments, as well as several different team owners. The architectural/engineering team may also be very large,

Fig 19 Safeco Field, Seattle,
Communication Arts Vernacular
lighting fixtures are cleverly integrated
into the signage.

Fig 20 New American Bank Park,
Corpus Christi, Texas, Catt Lyon
Design + Wayfinding

Fig 21 Reliant Stadium, Houston, Catt
Lyon Design + Wayfinding Coordination
with the interdisciplinary design team is
critical to the successful integration of
interior signage.

involving several different architectural and engineering firms, not to mention all the consultant and subconsultant firms. The construction team may combine several different construction firms forged together into a joint venture. With so many people involved, it is very important that your communications skills are thorough. The challenge for the wayfinding consultant, usually hired by the architect, is to make sure that they get information (and consensus) from all the stakeholders, as well as their client (the architects who hired them). Because the wayfinding signs are integrated throughout the building and may tie into the electrical and data systems, coordinating the wayfinding package with the numerous disciplines is extremely important. Sometimes it's just a matter of physical space; for example, pipes may be running through a space where you thought you would hang a sign. Another challenge to creating and coordinating the sign system is that the signs cannot be placed until the building's design is nearly complete. However, constructors often like to have all the packages (including signage) completed by the same date as the architectural plans. Therefore, the wayfinding designer must be very proactive to make sure all the other disciplines understand the sign system and its implications for their drawings.

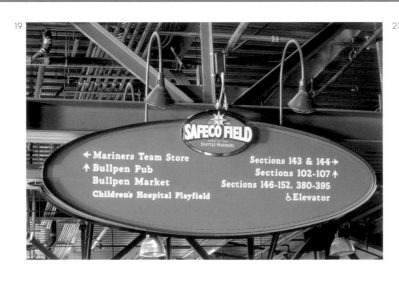

Soldier Field, Chicago, Illinois

Soldier Field has been home to the Chicago Bears since the 1970s, when the team moved from Wrigley Field. Originally built on speculation in hopes of attracting the 1928 Olympic Games, Soldier Field was intended as a venue for track and field events and, consequently, had the capacity to seat 128,000 spectators. As fate would have it, Paris won the right to host the Olympics in 1928 and thus began Soldier Field's odyssey of trying to find its niche. Ironically, by 1926, when Soldier Field opened for business, the Chicago Bears were already playing professional football as one of the National Football League's (NFL) charter teams, but the entire league was still a fledgling enterprise.

Eventually, the team's fan base grew and by 1975 they moved to Soldier Field. The only way to make Soldier Field a viable stadium was with a rather severe alteration—the entire north end was lopped off to make the seating bowl much smaller. The sightlines were lousy, but it was the 1970s and that wasn't really a big consideration in those days. The 1980s brought another round of renovations and the insertion of suites into the iconic colonnades. By 1999, a clever group of architects finally solved the puzzle of how to renovate Soldier Field to improve sightlines, restore the historic colonnades, and make the venue a viable revenue-producing stadium. Essentially, the shell was preserved and a new building was built inside it. The architectural vernacular is completely modern and the juxtaposition of the neoclassical against the modern is an exciting solution.

Design process

Our scope of work was to create a wayfinding and graphics program for the stadium, its parking garage, and the surrounding park.

Our research process for the project began by looking at context. We became intrigued by some of the signature sculptures both in the park and in Chicago's Loop (elevated railway). Alexander Calder's style of construction for his freestanding sculptures became the inspiration for the construction of our signs. Both the original structure and the new building were a series of curves, and therefore we began working with curving faces. We incorporated the perforated back panel to create a lighter, more transparent structure. This same pattern was incorporated into the architecture. In keeping with the architects' minimalist esthetic, we refrained from using colors on the wayfinding signs. We saved the color splash for the sponsorship graphics.

Wayfinding planning

The wayfinding plan for this facility was extremely complicated to develop, because there were many different floor levels. The variance in floor elevations was the result of meshing the old and new buildings. We started by devising a logical numbering of the seat sections. Then we identified every important destination. Armed with this information, we were able to devise typical messages, which helped us identify the amount of space we would need on signs. Once the information

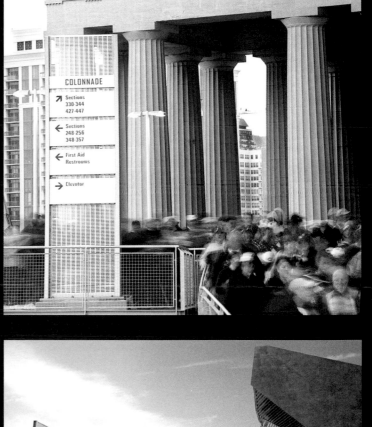

23

Figs 22 and 23 Soldier Field original stadium and renovation, Wood and Zapata with Lohan Caprille Goettsch

Figs 24 and 25 Concourse signage.

Figs 26 and 27 The Cadillac Club graphics are linked with the branding of the home team, the Bears.

requirements were established, we were able to refine a proportional sign system. The underlying proportions are consistent across all the sign types. We developed 3-D models so we could study how the signs looked from different angles. We studied the architectural plans to determine how many different mounting conditions we would need. The eclectic nature of the building necessitated many different sign types, even though the signs looked alike.

Implementation

Every approach to the stadium was studied and planned for, every mode of transportation was anticipated, and every kind of fan is accommodated. The stadium is a series of distinctly different environments, each programmed for a specific function. For example, the premium spaces are organized together on the east side and work synergistically, combining a banquet hall and sports bar with smaller lounges, suites, and club seats. We branded this entire space the Cadillac Club. Cadillac's brand is intertwined with the Bears', thereby creating a strong connection with fans. The north end offers the Miller Deck, an exclusive party deck. The south end offers quick access to the tailgating lot, and the west side offers the exclusive Wrigley deck (best seats in the house) along with general seating. For pregame and halftime mingling, fans can congregate in the Bears' Den. We developed this area to be a history hall complete with graphics, exhibits, food, and media. In the second year of operation, Comcast came in as a sponsor. Soldier Field is an exciting venue offering the best sightlines in the NFL. The project was successful because the entire team knew they were working on a unique building in a spectacular setting.

Sports facilities design recommendations

→ Due to the very large construction team, establish the flow of information with the project team members and all the stakeholders involved.

→ Document every meeting with written notes and circulate to team members and stakeholders.

→ Establish the points of entry and the desired traffic flow for each type of seat holder with architects, operations people, and team hospitality officials.

→ Work with team and tickets specialists to number the seating bowl logically for wayfinding.

→ Develop a visual language that integrates with the building's architectural details and reflects the character of the major sports tenant(s).

→ Integrate sponsorship opportunities into the wayfinding signs early in the design process. Develop zones or spheres of influence for a range of sponsors.

→ Study architectural conditions, develop rough sign types, and quantify and estimate rough budgets early in the design process, before you flesh out too many details.

→ Coordinate the sign package with other disciplines, including architectural, structural, mechanical, electrical, and plumbing, before architectural construction documents are complete.

→ Keep a close watch on construction details as the building takes shape. Note where your signs are scheduled to go and make sure that the built conditions agree with your drawings. If not, take immediate action.

→ Write thorough field observation reports and make sure all changes to your drawings are documented properly.

Appendices

5

Author

Craig Berger is Director of Education and Professional Development for the Society for Environmental Graphic Design (SEGD). Craig started as a preservation architect with John Milner Associates before moving to the Foundation for Architecture in 1996 to manage sign and streetscape programs. In his capacity there, he became an expert in urban sign programs, completing studies and focus-group testing on color, wayfinding, accessibility, and maintenance/management issues. Craig has advised a number of cities around the United States in developing their own urban sign programs on all issues from financing, design, and maintenance, including Lancaster and Philadelphia, Pennsylvania; Washington, D.C.; and Miami Beach, Florida. In his work at the Foundation, Craig conducted a large-scale survey on streetscape issues and the use of permits. This resulted in two educational brochures on the subject. He also developed educational programs on urban design and neighborhood redevelopment.

Working with Lance Berger Associates, Craig developed a software product and consulting service called Talent Reservoir ®. This surveys employees for competency and placement within an organization and recommends training and instructional program reports. The software is currently being used by Sunoco, DuPont, and QVC, among others.

Since joining the SEGD, Craig has developed an educational and training program for the organization based on designer competencies. He has also developed an outreach program in universities and other design associations. Within the SEGD, he has worked to expand design knowledge through an extensive educational program of workshops, lectures, teleconferences, and publications in three specific areas: wayfinding, information design, and exhibit design. He has also established specific courses on accessibility, wayfinding, urban sign systems, and universal design.

Beyond the SEGD, Craig has developed a program to spearhead the placement of environmental graphic design programs in universities. In the process of developing this program, he has taught wayfinding design at Florida International University, Iowa State University, and Kent State University, Ohio, and is currently teaching a program at Temple University Tyler School of Art, Philadelphia. He is also spearheading a testing and educational program with the SEGD to develop a set of universal health-care symbols on behalf of Hablamos Juntos, with the Robert Wood Johnson Foundation.

Craig has a Bachelor of Arts and a Bachelor of Architecture from the Pennsylvania State University (1993), and a Masters of Business Administration from Temple University (1999) with a concentration in International Business.

Contributing Authors

Stuart Ash is a founder and principal of Gottschalk+Ash International. He has 35 years of broadly based experience in the design and production of corporate brand identity programs, environmental graphics and signage, electromedia, print communication, annual reports, and packaging. His work has been exhibited in the Mead Library of Ideas in New York, the National Gallery of Canada, and the Montreal Museum of Fine Arts, and has been published in major design magazines in Japan, the United States, and Europe. Stuart is the recipient of the Canadian Centennial Medal (awarded for the creation of the Canadian centennial symbol), has extensive experience in the financial sector, and designed the identity program for the Royal Bank, Canada Trust, and the Toronto Stock Exchange. He is a pioneer in the area of environmental design, having created the signage and wayfinding elements for Toronto's SkyDome and the AmericanAirlines Arena in Miami. Currently a member of the SEGD, the Society of Graphic Designers of Canada, American Institute of Graphic Arts (AIGA), and the Alliance Graphique Internationale, he is also a former Director of both the Royal Canadian Academy of the Arts and the SEGD. Stuart is a graduate of the Ontario College of Art where he has taught advanced typography.

Jack Biesek heads up Biesek Design, an environmental graphic design firm that he founded in 1980 to specialize in wayfinding and signage systems. Clients include colleges, universities (UCLA, USC, UW, and many others), the National Park Service (including Zion National Park, FDR Memorial, and Carlsbad Caverns), as well as internationally prominent architects (Robert Venturi, Lawrence Halprin, Frank Gehry, Cesar Pelli, Hardy Holtzman Pfeiffer Associates, Moore Rubel Yudell, ACMartin, and many others). The firm has received design awards and professional recognition from organizations such as the AIGA and the SEGD. Their work has been published in several books including *Urban Identities*, *Environmental Graphic Design*, *Sign Communications Two*, *City Signs*, and *Sign Design*. The firm has also been profiled in design publications such as *Communication Arts* and *Identity* magazine. Jack has served on the Board of Directors of the SEGD and was President of the Society in 1990–1991. He has led workshops on sign-system master plans and digital technology, and lectures extensively about planning and implementing wayfinding sign programs.

John Bosio is the Managing Principal of Environmental Graphic Design at Hillier, where his work combines planning, architecture, industrial design, lighting, interiors, and graphic design. His projects include wayfinding, signage, map design, donor recognition, and identity development for health-care institutions, cities, libraries, universities, and corporations. John is currently completing work for the New York City Health and Hospitals Corporation, including the development of a multilingual strategy and interior signage standards manual for limited English proficiency visitors. John's early career focused exclusively on health-care wayfinding programs. Recent work includes wayfinding programs for Frankford Hospital in Philadelphia; Good Samaritan Hospital in Lebanon, PA; urban wayfinding systems for downtown Dallas, Texas; Miami Beach, Florida; and Jersey City, New Jersey; a wayfinding master plan for the University of Alaska, Anchorage; and the signage, donor, and branding system for the new Princeton Public Library, New Jersey.

Chris Calori is a Principal in Calori & Vanden-Eynden Design Consultants, in New York. She has extensive experience in signage and identity design for a wide range of project types. Chris developed the firm's overall managerial approach to signage program design, originating their pioneering services of master planning signage programs for large-scale, phased-implementation sites, and of formulating signage policy guidelines to promote an owner's interest in maintaining signage quality and equity over time and among many parties. She is committed to design education; she served as Assistant Professor at the Fashion Institute of Technology in New York City and taught visual communication design at Ohio State University as Associate Professor. Chris received her MA in design planning and her BS in industrial design with a visual communications major from the Ohio State University. She holds membership in the AIA and the SEGD. Her work has received awards from the SEGD, AIA, IDSA, AIGA, and the City of New York. Her work has been featured in numerous national and international periodicals and books, including a special issue of Japan's *IDEA* magazine, "Women Designers of America."

Jerome Cloud has been Principal in charge of design at Cloud Gehshan Associates in Philadelphia since its inception in 1986. He has won numerous awards for his work in identity and branding, environmental signage and wayfinding, interpretive systems, and print communications. He is a founding member and former Officer of AIGA/Philadelphia, the first chapter in America. He earned his BFA from the University of the Arts, where he lectured in the graphic design program, and his MPS in design management from Pratt Institute in New York City. Working with the National Park Service and the Delaware & Lehigh National Heritage Corridor, he developed one of the early prototypes for identity, signage, and interpretation for this 154-mile (c. 250km) corridor in Pennsylvania. He has created comprehensive sign programs for Winterthur Museum and Gardens, Tyler Arboretum, Ohio & Erie National Heritage Canalway, and the Fairmount Park System in Philadelphia. He is currently leading an effort to brand, sign, and interpret the Benjamin Franklin Parkway, an important civic and cultural gateway to Philadelphia.

Jeffry Corbin established Corbin Design in 1976, joking that he moved to northern Michigan to raise raspberries. He went on to pick a top-notch staff of designers who have helped him turn the firm into a pioneer in the fields of wayfinding and information design. Corbin's wayfinding and information design expertise have made him a popular public speaker before a wide range of organizations, including the American Hospital Association, American Institute of Architects, International Downtown Association, Society for College and University Planning, and Symposium on Healthcare Design. A founding member and past National Chairman of the SEGD, Jeff is also a past President of the Association of Professional Design Firms. He also serves on the Advisory Council for Design Michigan, a program dedicated to improving Michigan's places, products, and communications through design.

Gretchen Coss is Director of Business Development for the signage division of Gallagher & Associates. The firm specializes in environmental graphic design, museum/exhibition design and print/collateral. Previously, Gretchen served as Principal of Douglas|Gallagher Chicago. Her experience also includes positions with Gensler/LA as Director of Graphics and owner/Principal of Coss Creative. She has extensive experience in print graphics as well as signage and large-scale wayfinding projects, and museum/corporate exhibitions across the country. She has participated in collaborative teams designing communications systems for mass audiences in children's museums, international airports, and the rapidly changing business and entertainment environments. Clients include Sony, Dreamworks/SKG, ABC Entertainment, Western Digital Corporation, and The National Archives. Gretchen served as a Director for the SEGD for six years and she is past President of the organization. Her affiliations include AIGA, NAME, SMPS, and IIDA. Gretchen received her Bachelor of Fine Arts degree from Arizona State University.

Juanita Dugdale is a writer based in Maine and New York whose articles have appeared in international magazines including *I.D.*, *Print*, *Graphis*, *Domus*, *Interiors*, and *Communication Arts*. Also a consulting editor, she developed a history of environmental graphic design for the SEGD and a special EGD issue of the *AIGA Journal of Design*, and collaborated on a book celebrating 40 years of design by Chermayeff & Geismar. Her ongoing research encompasses diverse subjects such as carved lettering, sacred space, land art, and village life. Before establishing Dugdale Projects, Juanita was a Principal and cofounder of Two Twelve Associates. A graduate of Yale University's graphic design program, she has served as Vice President of the SEGD and AIGA/NY.

Ken Ethridge, AIA, RIBA has been associated with ASHModulex in a variety of marketing and communications capacities for over 20 years; his career also includes 10 years of architectural practice in Europe. His involvement in the architectural sign industry dates from 1978, when he founded Diseñal, the first firm in Spain to focus exclusively on architectural

signage. He is coauthor of the SEGD's ADA White Paper and has represented the SEGD to the ANSI 117.1 standards committee on site and building accessibility since 1993. He was also appointed advisor to the Federal ADAAG Review Committee that proposed changes to the present regulations. Ken has published and spoken widely on codes and regulations, advocating practical, enforceable standards. He received a B. Arch from the University of Arizona and later studied at the Architecture Association in London. He is registered as an architect in California and serves as Vice President of family-owned Diamond-E Ranches in his native Arizona, even though he never learned how to rope very well.

Patrick J. Gallagher is President and founder of Gallagher & Associates, a professional design services firm serving clients in the United States and abroad. His design teams combine multiple disciplines to create superlative visitor experiences through museum master planning and exhibition design, environmental graphics and wayfinding, and corporate identity and print. The firm's accomplishments include a wide spectrum of visitor experiences such as public- and private-sector museum projects, visitor centers, learning facilities, science centers, traveling exhibitions, and corporate experiences. Patrick has built a strong reputation in museum planning and exhibition design and has extensive experience in environmental graphics/wayfinding and corporate identity/print communications. His work has received numerous industry awards and has appeared in a variety of design periodicals. Patrick has served as an adjunct professor and participates frequently in workshops and lecture series both nationally and internationally.

Joel Katz is internationally known for his award-winning information design and wayfinding systems. With 35 years in the field of graphic design, he and his work have been the subject of numerous articles, publications, and lectures. Katz's articles have appeared in the *AIGA Journal of Design*, *Visible Language*, *Print*, and the *Philadelphia Inquirer*, and he speaks at numerous universities and professional design conferences. As one of 12 "information architects" contributing to the book *Understanding USA*, he presented his work at the TED-X (Technology Entertainment Design 10) conference in Monterey, CA. Katz's annual calendars of his photography are eagerly anticipated, and his photographic work has been shown in Philadelphia and Rome.

Kelly Kolar, Principal of Kolar Design, has more than 15 years of design experience. As Principal Designer, she has been on many project teams, serving as Project Manager, Design Director, project professional, and member of an alliance design firm. She has directed her firm in a wide range of design projects including Cincinnati Children's Hospital, Main Street for the University of Cincinnati, and the global headquarters for Procter & Gamble. Her understanding of the architectural and environmental design industry is key to her success as she has gained in-depth knowledge of architectural graphics and wayfinding through consultation with a variety of firms, public institutions, and cities. Kelly is a graduate of the University of Cincinnati's College of Design, Architecture, Art and Planning. She has been an Adjunct Professor at the University of Cincinnati and The College of Mt. St. Joseph.

Jan Lorenc established Jan Lorenc Design in Chicago, then relocated to historic Roswell, Georgia, at the same time renaming the firm Lorenc+Yoo Design in acknowledgment of the partnership with Chung Youl Yoo. The firm includes a multidisciplinary team with broad experience in industrial design, architecture, interior design, graphic design, furniture design, and journalism, collaborating in crafting a narrative for each client and each project that is then realized through the design of various complex environments. The firm undertakes projects of varying complexity and magnitude involving museum planning and design, visitor center design, trade show exhibits, and a variety of environmental graphic programs. Their mission is the unification of the arts where all of the images, spaces, and details of each project are coordinated seamlessly into a complete design statement imparting a singular narrative specific to the project goals. Jan holds a Bachelor of Science degree in industrial design and a Master of Science in visual design, both from the Institute of Design at IIT in Chicago, and a Master of Science in architecture from Georgia Tech. He is currently a board member of the SEGD and on the Advisory Board for the Georgia Tech College of Architecture Industrial Design Department.

Donald T. Meeker, Principal of Meeker & Associates, Inc., is involved in many public design projects including the Franklin D. Roosevelt Home and Presidential Library, the design of a wayfinding and visitor information program for Grand Canyon National Park, and information signage for parks in Hawaii. Don developed the national sign standards for the 4,500 recreation projects of the Corps of Engineers and recently completed the new UniGuide Program standards for the National Park Service. He also prepared the signage master plan for 11 heritage regions in Pennsylvania. Don initiated an applied research study on Legibility and the Aging Driver, with the resulting design of the 12-font ClearviewHwy® Typeface System. He has received many awards for his work from the AIGA, SEGD, and Print Casebooks, and twice received the Federal Award for Design Excellence from the National Endowment for the Arts.

Douglas Morris is a Principal of Poulin + Morris, an internationally recognized multidisciplinary design consulting firm. He is responsible for the development, design, and implementation of visual communication programs for clients such as Bank of America, Baruch College, Battery Park City Parks Conservancy, Brooklyn Botanic Garden, Carnegie Hall, CNN, Columbia University, Freedom Forum/Newseum, Gwathmey Siegel & Associates Architects, Hyatt Hotels and Resorts, New York University Medical Center,

Penn State University/Smeal College of Business, Polshek Partnership Architects, Skidmore Owings & Merrill, Time Warner, UBS Paine Webber, United Nations, University of Massachusetts, and The Wharton School of Business. Doug's work has been published in numerous periodicals and books and has received awards from American Corporate Identity, American Institute of Architects, the AIGA, Boston Art Directors Club, and the SEGD. In 2002 he was elected President of the SEGD. He is a member of the AIGA and the SEGD. Doug received a Bachelor of Fine Arts degree from Rhode Island School of Design.

David Vanden-Eynden is a Principal in Calori & Vanden-Eynden Design Consultants of New York and has more than 25 years of experience in the design profession. He has a broad range of design and management skills for a wide variety of project types and is highly experienced in 3-D design and sign fabrication methods. He was instrumental in developing the firm's techniques for conceptualizing, detailing, and documenting the physical components of sign programs. David served as a member of the Board of Directors of the SEGD and as President of the SEGD's Education Foundation. He is former Secretary of the AIGA/NY and former executive board member of Architects, Designers and Planners for Social Responsibility (ADPSR). He has been a visiting instructor at Yale University and the University of Cincinnati, and taught environmental graphics at the Fashion Institute of Technology in New York City. His work has been awarded honors by the SEGD, AIA, IDSA, the AIGA/NY, and the City of New York. He received his BS in industrial design with a visual communications major in 1974 from Ohio State University.

Roger Whitehouse was trained as an architect in England before coming to the United States in 1967 to teach design at Columbia University School of Architecture. He is a member of the Architectural Association, an associate of the Royal Institute of British Architects, and is licensed as an architect in the United Kingdom. He is a past Director and fellow of the SEGD and a past Director of the AIGA. After practicing as an architect, he formed Whitehouse & Company in 1976. Since then, as an environmental graphic designer, he has completed projects including the High Museum in Atlanta, Lincoln Center, The Metropolitan Museum of Art in New York, the Condé Nast and Reuters buildings, and the Flagship Subway entrance on 42nd Street in New York City. His pioneering work for The Lighthouse on wayfinding for individuals with vision impairment or blindness forms the basis for the signage components of revisions to the ADA.

Massimo Vignelli, born in Italy, has pursued much of his career in the United States, while maintaining strong ties with Europe. Massimo studied architecture at the Politecnico di Milano from 1950–1953 and later trained at the Universita di Architetttura, Venice. His first professional position was as a designer of glassware for Venini, and from 1950–1960 he taught design at the Institute of Design, Chicago. In 1971, Vignelli Associates was established in New York and subsequently designed corporate identity programs for Knoll, American Airlines, Bloomingdales, Xerox, Lancia, Cinzano, and Ford Motors. The company also designed glassware for Venini, Steuben and Sasaki, and showrooms for Artemide and Hauserman. Vignelli also turned his attention to designing furniture for Sunar, Rosenthal, Morphos, and Knoll, including the well-known Handkerchief Chair and Paper Clip table for Knoll. There is little that he has not conceived and executed, including directional signage for the New York and Washington, D.C. subway systems, and for the Guggenheim Museum in Bilbao, Spain, designed by architect Frank O. Gehry.

Udo Schliemann is one of Gottschalk+Ash International's most skilled Senior Designers specializing in corporate and exhibition design, and signage programs. Udo has more than 15 years' experience in identity development, sign design, programming, materials and finishes specification, and project management. A native of Germany, Udo graduated from the Technical College for Design in Würzburg in 1982, and also served as a guest lecturer from 1993–1998. Some project highlights include winning the logo competition for the City of Berchtesgaden's 1992 Winter Olympics bid, and designing the exhibition introducing the German Stock Exchange. In addition to his professional and teaching experience, Udo has also been published in various design magazines. Before coming to Gottschalk+Ash International, Udo was Studio Manager for the design firm Stankowski+Duschek in Stuttgart, Germany.

Lance Wyman, Principal of Lance Wyman Ltd., a New York–based environmental graphic design office, is a specialist in branding/wayfinding systems for public environments, and credited with helping to define the field of environmental graphics. His graphic system for the Mexico 1968 Olympic Games is cited as "... one of the most successful in the evolution of visual identification." His early work includes branding/wayfinding systems for the Mexico City Metro, Washington Mall, and Minnesota Zoo; maps for the Washington, D.C. Metro; identity and wayfinding signage for skywalks in Calgary and Edmonton, Canada; and the American Museum of Natural History in New York. He recently completed branding/wayfinding signage systems for the Amtrak High Speed Rail facility at Penn Station, New York, and the LG Arts Center in Seoul, Korea. Lance has received awards from the AIGA, SEGD, Art Directors Club of New York, and the Milan Triennial. His work has been published in the *New York Times*, *Life*, *Time*, *Progressive Architecture*, *Graphis*, *Print*, and *ID*, and has been exhibited in the Museum of Modern Art, the Louvre, the Smithsonian Institution, and the Poster Museum of Warsaw. He co-conducted the first Interdisciplinary Environmental Design Seminar at the University of Cincinnati in 1990, and has taught at the Parsons School of Design since 1973.

Photography Credits

All photos © the photographer or the lending institution

Chapter 1

Fig 2 Andrew Gunners/Digital Vision

Fig 5 University of Pennsylvania

Fig 6 Bauhaus Archive

Fig 8 Peter Mauss/Esto

Fig 9 Hertz Corporation

Fig 12 Jim Simmons/A.D.Z.

Fig 13 ESI Design

Fig 16 Peter Mauss/Esto

Figs 17 and 18 Jim Simmons/A.D.Z.

Chapter 2

Fig 2 Art Institute of Chicago

Fig 4 Barry Goyette and Jack Biezeck

Fig 5 Joe Harrison

Fig 15 Jim Simmons/A.D.Z.

Fig 17 RTKL, Whitcomb

Figs 19 and 20 Alan Karchmer

Fig 23 Graham Uden

Chapter 3

Fig 1 Georgia State Archives

Fig 6 Courtesy of the New York City MTA

Chapter 4

Fig 4 J. C. Abbott

Fig 11 Jon Bosio

Fig 15 Matt McCormick

Fig 16 Courtesy of Neokraft Signs

Fig 19 Sussman/Prejza & Company, Inc.

Fig 20 Courtesy of Neokraft Signs

Fig 21 Brian Burnett, Kathy Osborne

Fig 23 Jim Simmons/A.D.Z.

Fig 24 Ryon Rizzo Creative Sources Photography

Chapter 5

Figs 1 and 2 Danny Roberts

Fig 8 Ryon Rizzo Creative Sources Photography

Fig 9 William P. McElligott Photography.

Figs 13, 14, 17, and 18 Coco Raynes

Chapter 6

Fig 1 Courtesy of Jian Shuo Wang

Fig 4 Chad Holder

Fig 10 Courtesy of Gladys Brennar

Fig 12 Jim Simmons

Fig 13 Courtesy of Karlsberger © Robert Benson

Figs 23 and 24 Chermayeff & Geismar

Fig 25 Scott Francis

Chapter 7

Figs 5–7 Elliott Kaufman

Fig 19 Sherman Takata

Fig 20 Peter Mauss/Esto

Figs 22, 23, and 25–28 William P. McElligott Photography

Chapter 8

Fig 1 Foundation for Architecture Archive

Figs 4 and 5 David Omer

Figs 10 and 12 Kevin Burke

Fig 13 Gary Knight + Associates, Inc.

Fig 15 John Sutton Photography

Fig 16 David Omer

Chapter 9

Fig 3 Chermayeff & Geismar

Figs 4 and 5 Alan Shortall Photography Ltd.

Figs 7 and 8 Alise O'Brien

Fig 9 Colin McCrae

Fig 10 Chermayeff & Geismar

Fig 12 Jim Simmons

Figs 14 and 15 Jeffrey Totaro Photography

Fig 16 Adrian Wilson Photography

Figs 17–22 Jeffrey Totaro Photography

Chapter 10

Fig 1 Wyatt Gallery

Fig 2 Barry Halkin

Fig 3 Wyatt Gallery

Fig 4 Aker/Zvonkovic

Fig 5 Wyatt Gallery (referenced photos were developed by former principals of Douglas Gallagher, Inc.)

Figs 12–14 Ken Hickey

Fig 20 Peter Mauss/Esto

Figs 15 and 16 Wyatt Gallery

Fig 18 Aker/Zvonkovic

Figs 21–23 Wyatt Gallery (referenced photos were developed by former principals of Douglas Gallagher, Inc.)

Chapter 11

Fig 2 BigFoto

Fig 3 Wyatt Gallery (referenced photos were developed by former principals of Douglas Gallagher, Inc.)

Fig 10 Dan Francis

Fig 12 James D'Addio

Fig 13 Hoachlander-Davis Photography

Fig 14 James D'Addio

Fig 15 Hoachlander-Davis Photography

Fig 18 Erik Kvalsvik

Fig 27 Joel Katz

Fig 28 Compliments, Center City District of Philadelphia

Chapter 12

Fig 18 Hoachlander-Davis Photography

Fig 27 Anton Grossel

Fig 28 Bruce Forster

Fig 29 Rick Raymond

Fig 32 Chermayeff & Geismar

Figs 36–41 Tom Crane

Chapter 13

Fig 1 JH Photo

Figs 4 and 5 Robert Probst

Figs 13–17 JH Photo/Joe Harrison

Fig 18 Biesek Design

Figs 19–24 Barry Goyette and Jack Biesek

Figs 25–28 Elliott Kaufman

Chapter 14

Figs 6 and 7 Charlene Catt Lyon

Fig 9 Phil Toy

Figs 10 and 11 William P. McElligott

Fig 14 William McDermott

Fig 16 Charlene Catt Lyon

Figs 19 and 20 Ben Van Hounten

Figs 21–26 Charlene Catt Lyon

Index